Encaustic Painting Techniques

THE WHOLE BALL OF WAX

Patricia Baldwin Seggebruch

NORTH LIGHT BOOKS
Cincinnati, Ohio
CreateMixedMedia.com

contents

Waxing POETIC

The beauty of art: Isn't that what's drawn you to this book, to this medium, to painting at all? The splendor of it? The simple pleasure of looking at a beautiful painting and feeling your heart respond, your soul wake up? Not your mind—it's been working on overtime with life's tasks—but your heart and soul.

So it was for me upon discovering the joy of encaustic. It is where I found, and continue to find, my closest connection to the world at large—and to the smaller one on the inside. This medium is a dynamic one where anything goes and the possibilities are endless. If you are seeking creative release and experimentation, you will find it in this medium.

Encaustic literally means "to burn." In its most basic interpretation, then, encaustic is hot, melted (or burned, if you will) wax. It can be as simple as beeswax melted and applied to an absorbent surface. Ancient beginnings harken back to Trojan ships sealed with pigmented wax; the original intent to make them watertight evolved into a means of decorating and personalizing each ship. The modern-day revival of encaustic and the experimental anything-goes nature of today's art world have allowed for a tremendous resurgence of painting in hot wax, experimenting with any and all techniques in it.

My goal is to bring the encaustic workshop to you in your own studio as I walk you through each step in creating beautiful encaustic paintings. If this is your first taste of encaustic, begin with the simple application of wax to the board. Then, once you're comfortable with the basics, begin exploring all the possibilities in the medium, step by step. Delve into incising, try your hand at collage or jump into image transfers. Each chapter provides new techniques that will further enrich and enliven your encaustic painting and your own enjoyment of working in this versatile medium.

If you have experience with encaustic and have come to this book with the hope of finding new and exciting techniques to enhance your work, skip to the chapter headings and pick one to inspire you to fresh approaches to the medium. Then try them all. Play, experiment and discover the rich, organic nature of the medium.

And, as I do in all my workshops, I invite you to keep in touch. Feel free to ask me the question that's got you puzzled or simply to share your experiences in encaustic with me by visiting PBSartist.com.

At the end of all the toe-tapping, blood-pumping fun technique chapters in this book, I've included an Inspiration Gallery filled with examples of my paintings that combine the techniques outlined in this book in new and interesting ways. I hope it shows you that this is just the beginning of what you can accomplish in encaustic! And remember, creativity happens in the pauses; pause, take a deep breath and turn the page. Let's begin!

> "You agree—I'm sure you agree, that beauty is the only thing worth living for."
>
> **Agatha Christie**

TOOLS AND MATERIALS

Oftentimes artists will shy away from encaustic because they fear a costly investment to get started or a messy setup that will take over their studios. Neither fear is warranted. The cost can be kept minimal by investing in hardware products from home stores or hardware stores (which work just as well as more specialized products), and the mess is nonexistent. The product is self-contained in its cooled state, and all tools and surfaces can be cleaned by simply melting the wax away. In fact, if you're using brushes and other tools specifically for this medium, they need not be cleaned at all!

You need only a few basic essentials to begin encaustic painting. I've listed them here, along with a few of my favorite tools, to get you started. As you begin to explore the techniques in this book you will realize that the possibilities for tools and materials compatible with encaustic are endless. Anything goes! Once you master working with the basic elements of the medium, the sky is the limit.

WAX

Refined beeswax is the standard in encaustic painting. It has been treated to remove the natural yellow of the beeswax. It produces a clear, glass-like painting when used with or without damar resin. Refined is a better choice than bleached beeswax as the bleached wax can yellow over time due to the chemical processing it's gone through.

Natural beeswax is a gorgeous choice for rich, organic painting because it is still in its natural yellow state, and it lends that quality to the finished work.

Damar resin can be added to the beeswax to add a bit of durability and luminosity to the encaustic painting. But this additive is not required, and some artists work strictly in beeswax and obtain durable, luminous results.

Medium is the name given to the combination of beeswax and damar resin. You can make your own, but premade medium is the most advantageous choice for ease of use. This is a combination of refined beeswax and damar resin that has been designated the optimal combination by the producer. All that is required of you is to melt it down and paint. The choice between refined beeswax, natural beeswax and medium is a personal one, and I encourage you to experiment with each to find your preference.

There are many sources for encaustic wax out there, from your local beekeeper producing natural wax to international companies creating beautiful refined waxes for clear, white application. I encourage you to explore your options, but if you are a beginner, I recommend using refined beeswax or medium from R&F Handmade Paints. R&F has been perfecting its products for decades and is dedicated to producing the best encaustic products for artists. This, combined

Here you can see the difference in appearance between natural beeswax, at the top, versus refined clear medium, shown just beneath it.

6

with the fact that its customer service representatives can answer any questions a beginning encaustic artist may have about product and technique, makes R&F a fabulous resource for all things hot wax.

PALETTE AND TINS

The palette in encaustic work is where the wax is melted, mixed with colored pigment and kept fluid. Any flat surface that can be heated will suffice as a palette, but it is important to have a regulated heat gauge, rather than one with simple "low, medium and high" settings, in order to control the wax temperature. The temperature of the palette needs to be around 220°F (104°C) to maintain an optimal melted wax temperature of 180°–220°F (82°–104°C).

Two great palette options are an anodized aluminum palette designed specifically for this purpose or a simple griddle from the small appliance section of any home store. The anodized aluminum palette is great for mixing colors directly on the surface, as it has a clear surface that maintains true color representations in mixing. But this surface does require a separate electric stove element placed underneath the palette to heat it. The griddle is not an advisable surface for directly mixing colors, but it is fairly inexpensive, has a nice, large surface area, and heats up evenly and automatically all on its own.

The cleanest and most efficient way to have multiple colors of wax melted at the ready at one time is to use tins arranged on the palette to hold different encaustic paints. I prefer 16-ounce (473ml) seamless printmakers' ink cans from Daniel Smith Art Materials, but anything similar would also work. I have found these cans to be indispensable in my encaustic setup because they allow for large volumes of wax to be at the ready—and for my brushes to remain upright in

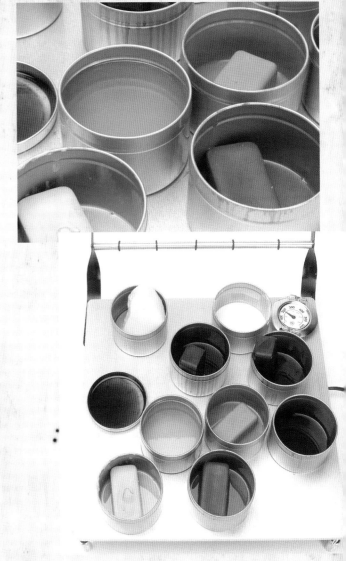

This typical palette setup features printmaking ink cans filled with colored wax and uses an anodized aluminum palette from R&F Handmade Paints; the palette thermometer helps monitor the wax temperature.

their designated cans. You can mix a different color in each one, and if you need just a small amount of a color, you can even use the lids to mix limited quantities.

The palette setup described here is wonderful for an easy cleanup; just turn everything off and let it cool down. When beginning again the next day, simply warm the palette: Wax melts, brushes loosen and painting can begin again.

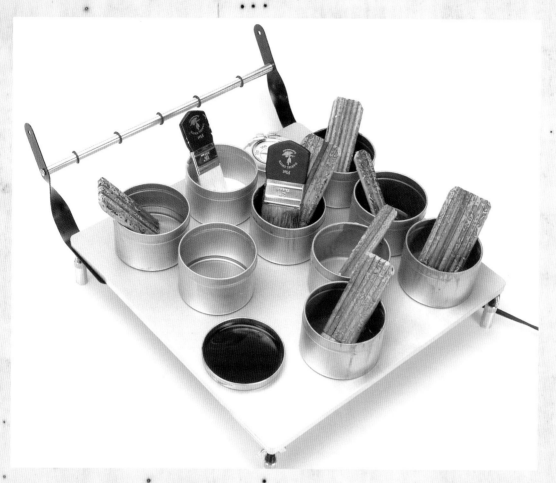

When the wax is completely melted on the typical palette setup, simply assign a natural bristle brush to each color for easy painting and hassle-free cleanup.

FUSING TOOLS

Fusing is the reheating of each applied layer of wax so that it bonds with the preceding layer, thus ensuring a cohesive surface to your encaustic painting. The heat gun is my tool of choice for fusing because it offers control and ease of use. R&F sells a nice one, and others are available from other encaustic sources and hardware stores. I have a preference for the Wagner Heat Gun. It offers variable temperature control separate from a variable air flow control.

Alternative fusing tools are propane torches, irons and tacking irons. The propane torch offers a strong, concentrated flame and works well for spot fusing, but offers less control for fusing an entire surface. The iron and tacking iron both work well for either spot fusing or surface fusing, but I find I have less control with these tools than with the heat gun because the irons apply the heat directly to the wax. For this reason, they must be set at exactly the right heat setting so as not to melt any of the wax away from the surface.

SURFACES

Two rules here: rigid and absorbent. It is important that the surface on which you paint in encaustic is rigid, meaning it cannot be flexible. The wax cools hard and will chip off of a surface that has any give to it, such as paper or canvas. If you enjoy these surfaces, you can paint in encaustic on them as long as you first adhere them to a board support.

The surface also needs to be absorbent. The wax has to have something to grab hold of in

order to establish a solid foundation on which to build with more wax and additional elements.

My favorite boards to use for encaustic are Ampersand's Claybords. They have a luminous white clay surface that receives wax beautifully and establishes a vibrant foundation for color. The board itself comes in a flat panel ¾" (2cm) cradle or 2" (5cm) cradle. Encaustic is very conducive to the 2" (5cm) cradle as it allows for no framing, and this contemporary look maximizes the finished encaustic product.

Birch plywood panels from the hardware store are great encaustic surfaces as well. They come in different widths, can be cut to any size you choose, and tend to be the most white of the natural board surfaces available. But any unfinished, untreated wood, such as plywood or even scrap wood, will work as a surface for encaustic painting.

BRUSHES

One rule: Go natural. Synthetic brushes will melt in the hot wax. My favorites, both from Daniel Smith Art Materials, are hog bristle brushes in assorted sizes and hake brushes (also known as sumi painting brushes). Avoid using brushes with nailed metal handles, as the heating and cooling of the wax eventually loosens those nails and causes the bristles to fall out. Brushes ranging in size from 1"–3" (3cm–8cm) work well for all the techniques shown in this book.

OTHER TOOLS

I enjoy experimenting with anything that I think could have an interesting effect on the wax. For incising—or cutting design elements into the wax—I turn to pottery tools, awls, styluses, cookie cutters, hardware store putty knives and filing tools. From the scrapbooking stores I collect stamps, interesting stickers, embellishments and rub-ons. My favorite burnishing tool is a simple spoon, but bone folders and scissor handles work well, too. Other tools I have readily available for use in my encaustic studio are a metal ruler for straight line incising, a small propane torch, assorted screens and stencils for incising, and extension cords to allow for maximum reach with my heat gun.

MIXED MEDIA

Art supply and craft stores are great places to collect interesting collage papers, foils, leafing, oil paints, pastels, charcoals and photo transfer papers for use with the various encaustic techniques you will learn in this book. Likewise, scrapbooking stores offer a nice selection of rub-ons, papers, items to embed in your work and even unique incising tools.

I scour hardware stores, fabric stores, salvage yards, thrift shops and garage sales for interesting materials to use in my encaustic work. Look for one-of-a-kind items to embed, from vintage buttons to rusty coils. You may even be surprised by effective treasures found lingering in your junk drawer.

Leave no stone unturned in your search for innovative materials to use in your encaustic work. I can't begin to list them all, and I'm willing to bet that once you get started, you will find some I have yet to discover.

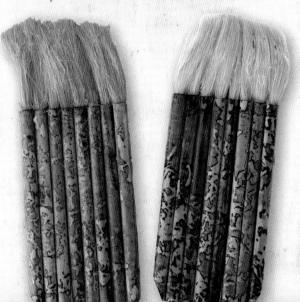

consider don't work well when small

These hake, or sumi painting, brushes are my personal favorites for encaustic work, but any natural bristle brushes will do.

Color
IT UP

Without color, there is a limit to art— and encaustic is about creating without limits! There are several options available to mix colored beauty into plain beeswax. Each artist has his or her own level of interest, patience, skill and, yes, even time that will indicate which coloring option works best for him or her. The three explored here—pigmented medium, oil paint additive and dry pigment—are all viable and equally effective options. Pigmented waxes are my personal medium of choice; I find them easy to use and enjoy working with their reliable, consistant colors. But I encourage you to experiment with them all and determine your own personal favorite. There is no right or wrong method to choose.

*"*We can't take any credit for our talents. It's how we use them that counts.*"*
Madeleine L'Engle

CREATING COLORED WAX

There are three main types of color you can add to wax for encaustic painting: pigmented medium, dry pigment additive and oil paint additive. All can be beautiful mediums for achieving colorful encaustic artwork.

PIGMENTED MEDIUM

This is my steadfast favorite option. Not only is it the easiest, neatest and safest, but the array of color options and consistency of color are an easy sell. These premade colors are sold through many encaustic producers, but I use R&F Handmade Paints in illustrating the techniques throughout this book. These encaustic paints come in rectangular blocks that fit nicely into the large printmakers' ink cans from Daniel Smith Artists' Materials that I use for quick melting.

Encaustic manufacturers have machines that produce a beautiful color in the wax by milling the colors to a very fine consistency. Pigment suspension in the wax is optimal with these products. And their intensity can be varied simply by adding medium.

DRY PIGMENT ADDITIVE

You can also make your own colored wax by adding dry pigments to medium to create customized colors. This method should be used with caution, because it involves working with loose particles that can be very dangerous to inhale. Also, getting a consistent color throughout a batch—or re-creating a color exactly as you created it before—can be difficult. I try to stay away from this technique because I favor the consistent hue and ease of use of the ready-made pigmented medium, but many artists find mixing their own encaustic paints to be highly satisfying.

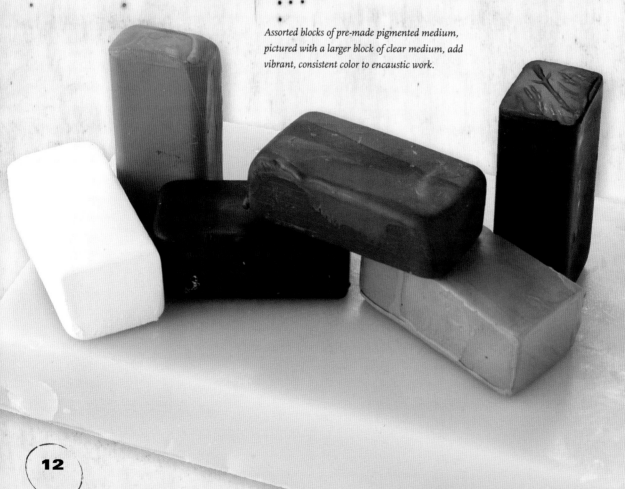

Assorted blocks of pre-made pigmented medium, pictured with a larger block of clear medium, add vibrant, consistent color to encaustic work.

OIL PAINT ADDITIVE

A third choice for coloring wax is to add oil paints or oil paint sticks to the medium. This, too, can be effective and enjoyable if you like to create your own colors. I have found that oil paint sticks work better than traditional oil paints because the greater oil content in the traditional paints can dilute the medium, but you can use either successfully if you follow the steps below.

Prepare oil paint overnight

Squeeze oil paint onto a paper towel and let it sit overnight so the excess oil leaches from the pigment. This will allow the pigment to blend more easily into the medium.

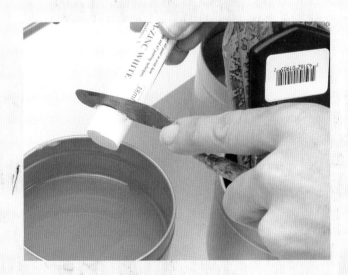

Add paint to melted medium

Add a bit of the paint directly to some hot wax medium. Experiment with the concentration, being conservative at first and gradually adding more, to achieve the desired color intensity.

Opt for oil sticks

The oil content of pigment sticks is much less than that of traditional oil paints, so they can be added directly to the medium without the paper towel leaching process in step 1, above. Simply cut them directly into the hot wax medium. Here I am using an R&F Handmade Paints oil stick.

ENCAUSTIC PAINT

The paints I choose to use and teach with are from R&F Handmade Paints. These highly pigmented, wonderfully lush paints have been manufactured to be the best possible for the encaustic artist. The color selection and depth of pigmentation just can't be beat! They can be used straight up in their full concentration or diluted with encaustic medium to extend the product and to offer a bit more translucency. If one wishes to, encaustic paints can be made by adding oil paint, pigment sticks or dry pigments to encaustic medium. Although these methods of paint creation are quite viable, I continue to return to R&F's products because of their quality and consistency. Many other manufacturers have entered the encaustic paint-making arena in the past few years, and I encourage you to explore the options and find the products that best suit your personal creative direction.

Ritratto d'un Asino Suerno 3£ — — — — — — — — — £ — 10 —

Ritratto di 4£ Aug 3£ — — — — — — — — — — 44

Ritratto d'un Cores p£ — — — — — — — — — 27 — 5 —

Ritratto d'un Montone p£ — — — — — — — — 1 — — —

ARE WE THERE YET?

Set
IT UP

The most basic technique one needs to learn when working in encaustic is how to work with the hot wax. In this medium the play of paint on the brush and how it can be applied works differently from other mediums. Because the wax is hot, and needs to remain so in order to continue to be workable, the brush must be returned to the paint pot at fairly regular intervals. The way you move the brush can also create varying applications of wax. You can alter your approach to create a simple priming layer, a thick or thin application of wax, a smooth finish or a highly textured surface. All will be explored in this chapter. The techniques demonstrated here should serve as a jumping-off point for all other encaustic techniques. Refer to these pages as often as you need to as you work your way through the many methods illustrated in this book.

"I'm still learning that there are no mistakes, only discoveries."

Fernando

Ferreira De

Araujo

PRIMING AND FUSING

Pick up your brush and begin! Grab your beeswax and come join me! Yes, it's that easy. Encaustic is just another paint medium, ready to be manipulated by the creative spirit within each person who has the dream to watch it flow.

How do you keep support from moving? Holding it uses up one hand —

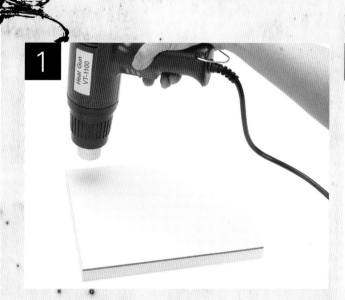

1

2

Heat surface

Many of the projects in this book begin with a prime layer of medium. To accomplish this, warm the board with the heat gun. Hold the gun perpendicular to the surface, about 2" (5cm) away, and slowly sweep the heat back and forth across the board from top to bottom. The objective is to achieve a consistently warm-to-the-touch surface (about 30 seconds).

NOTE: Keep the gun moving or you risk creating a hot spot that will resist the application of wax.

Apply the wax

Using a large, flat brush, apply a sweep of wax across the board, covering the whole surface in this way until an even layer of wax exists.

NOTE: Avoid overlapping strokes so that fusing will result in a smoother, more consistent layer.

NOTE: Returning the brush to the hot wax after each stroke will create a smoother application and help the brush move more easily since the wax remains warm and fluid.

— make a holder for each size
— but IT could move unless clamped —

"The best way to make your dreams come true is to wake up."

PAUL VALERY

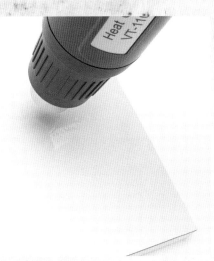

Fuse base layer

Using the heat gun, fuse this prime layer of wax by again sweeping the gun back and forth over the layer of wax in slow, even strokes.

NOTE: When the wax transforms from a dull matte finish to a shiny gloss, it has fused. It is not necessary to melt the wax completely to achieve a fuse; achieving this gloss is sufficient.

is there a limit to how thick a layer can be to be fused when shiny?

Re-fuse incomplete areas

If any areas are unwaxed after the first application, simply apply additional wax to those areas and re-fuse them with the heat gun.

brush up

This same technique of wax application may be continued with additional medium to build up a thick foundation, or you may move to the application of pigmented encaustic paints at this point. Once this base of priming has been established, any technique can begin. You are ready to try your hand at encaustic painting, collage and indulgent experimentation!

This prime layer is not mandatory to paint in encaustic. It is only a helpful suggestion so that once you begin in color, your more expensive, pigmented paints do not disappear into the board because of the sheer absorbency of the unprimed surface. Many of the techniques in this book begin with foundations on the surface before any wax is used. This priming technique is put into play after these foundations have been established.

Fix any final flaws

If you see any stray hairs or particles in the wax, gently pick them out with a needle tool. Reheat to smooth the disturbed wax.

VARYING THICKNESS

Varying degrees of color intensity are desired in the basic paint application in any medium. With encaustic it is easy to achieve different shades of color simply by adding medium to the color of choice. Here I'm using Quinacridone Magenta to illustrate the degrees of opacity and transparency achievable with this method.

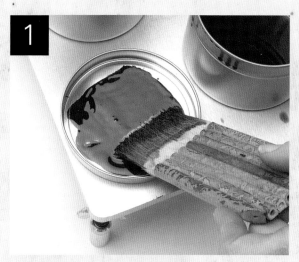

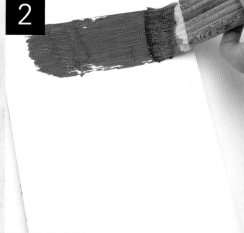

Prepare pigment

To change the intensity of the color, simply add varying amounts of the clear medium to the solid pigment. In this example I have begun with straight pigmented wax (no additional medium). In its purest form, the color is very dense and opaque.

Paint surface

Brush the color onto the surface.

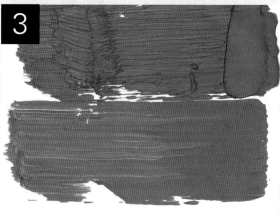
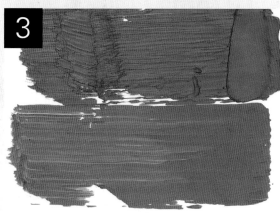

Add a bit of medium

Here I've added one part medium to the straight color, then brushed it onto the board. You can see it is thinner and slightly more transparent than the pure color brushed above it.

Experiment with mixing pigment and medium

The more medium you add, the more transparent the color. The final, most transparent application shown here was produced by mixing 1 part color to 3 parts medium.

Sign up for the free newsletter at CreateMixedMedia.com.

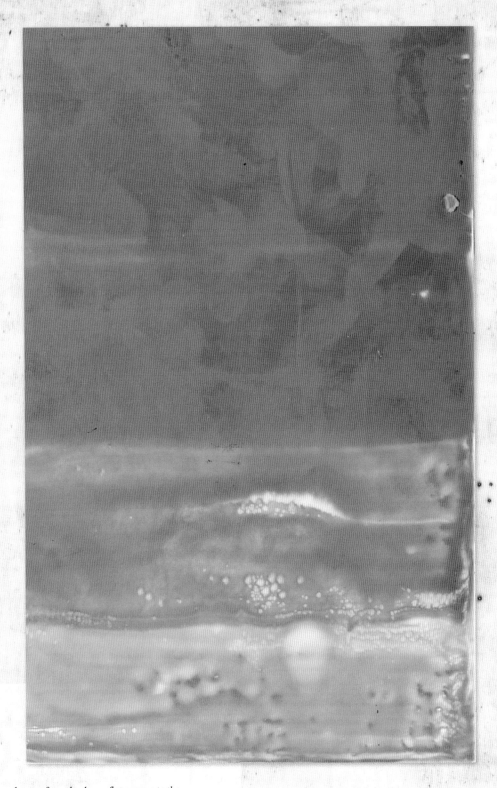

VARIEGATED

The depth of color in this piece changes from the dense, flat opaque to the thin, transparent hint of color, creating a fading effect from top to bottom. Beyond more abstract work, varying opacity in this way can be used effectively for painting encaustic sunsets and landscapes.

ACHIEVING TEXTURE

Texture is what working with encaustic is all about. Whether you want to create a finish that's as smooth as glass or to produce a deep, three-dimensional image, you can accomplish it with wax. On the following pages, I will show you the basic smooth application and the basic texture application. Then we'll experiment with adaptations of each throughout the rest of this book.

SMOOTH APPLICATION

Smooth layers varying in thickness can be used to create a finished look as well as to embed and layer images, papers, elements and words. Here you'll see the effects you can create by simply painting two layers of color and fusing between each application. Any number of layers can be applied to create varied effects. Just keep in mind that each layer needs to be fused before the next is added.

WHAT YOU'LL NEED

Primed board

Encaustic paint in color of your choosing

Heat gun or other fusing tool

Paintbrush

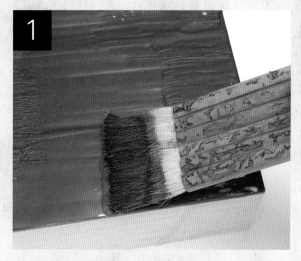

Apply color to warm surface

Begin this process with a warm board. Brush a fairly even layer of color over it, trying to not overlap the application too much. (An uneven layer of color can make the fusing process more difficult.)

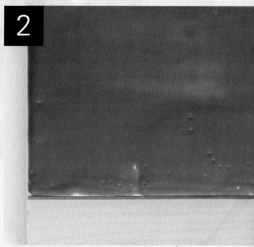

Fuse painted surface

Fuse the layer with a heat gun. You may see some uneven areas or even those missing color; that's OK for now.

Apply a second layer and re-fuse

Brush on a second layer of color and fuse to create a consistent, solid layer of color. This second application often takes care of any unevenness or missed spots from the first layer.

TEXTURED APPLICATION

This technique can be used to add depth to any encaustic painting. At a less abstract level, it can be used to produce interesting foliage, branches, grass and landscaping details. It can even be used with small hog bristle brushes to create beautiful ethereal trees.

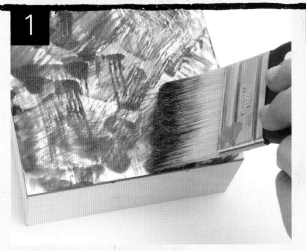

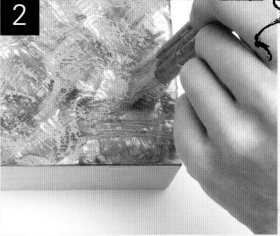

Apply color to cool board

Start with a cool, primed board. (If you start with a warm board, the texture you're able to create using this technique is more limited.) Using a dry, coarse brush (this one is made from hog bristle), apply color over the board, varying the directions of your brushstrokes.

Fuse, cool and apply second coat

Fuse the layer of color with a quick hit of the heat gun, just enough to change the appearance from dull to shiny. Let it cool completely. Apply a second color using the same dry-brush action used in the first application. Let the surface cool.

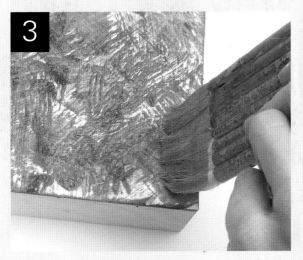

Layer colors and fuse

Continue applying layers of color, fusing and letting the board cool between each layer. I prefer to work my colors from light to dark, creating a "glow" of light color coming through the deeper color layers, but feel free to experiment with different effects.

Continue until texture is rich

Continue until you create a look you like. Here I've used just five layers to create this beautifully rich and textured effect.

WHAT YOU'LL NEED

Primed board ✳ *Encaustic paints in colors of your choosing* ✳ *Heat gun or other fusing tool* ✳ *Brushes of varying sizes*

MINTY

This piece is another example of the visual and tactile texture that can be created using the textured application technique shown on the previous page.

PASTELS

This alternate example of the textured application shows how, by building layers, deep crevasses and thick hills can ultimately be created.

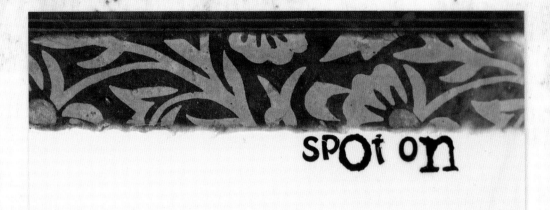

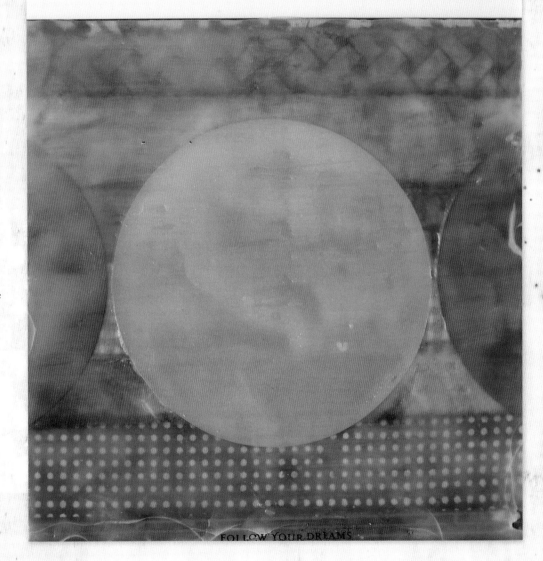

SPOT ON

In contrast to the pieces on the opposite page, this encaustic collage is created with papers layered in the encaustic and covered with a thick, smooth application of medium. Most of the pieces throughout this book exemplify the smooth application technique.

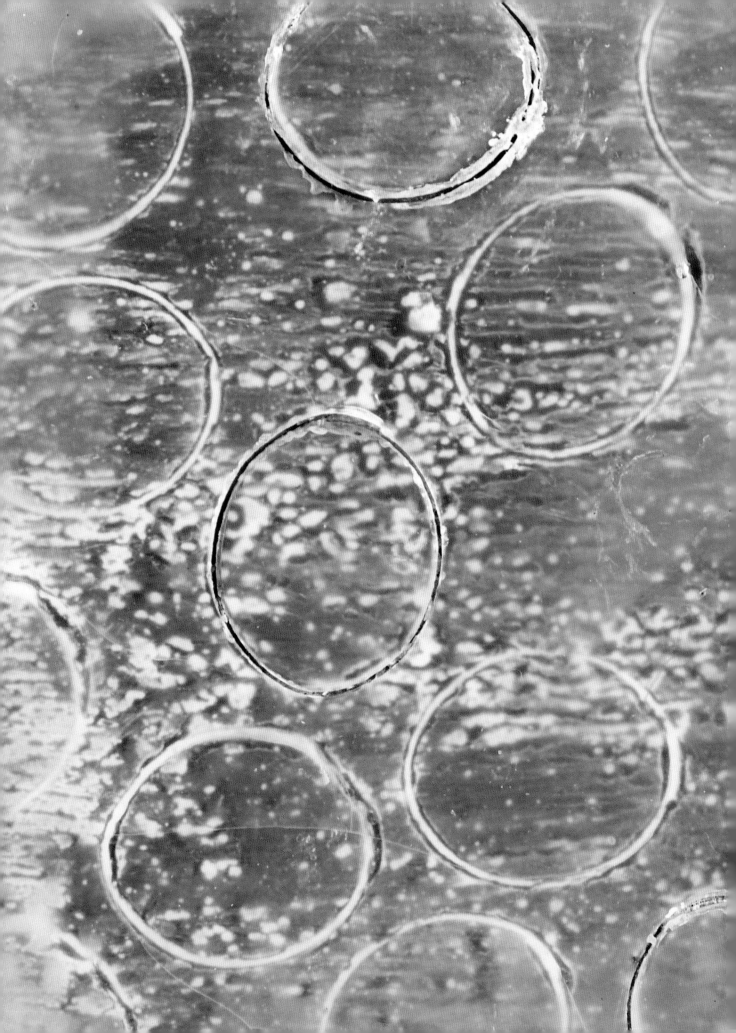

Cut
IT IN

The organic, pliable nature of beeswax can create an effect of depth that other mediums cannot. Incising, or cutting into, the wax can be done as simply as a thin straight line or as intricately as a detailed portrait. Glazing and filling the incising with paint, or even colored wax, enhances the cut lines and adds richness to the encaustic painting, whether used as a stand-alone technique or incorporated into a painting in combination with other methods. On the following pages you'll learn techniques for incising with several different metal tools in fine lines as well as thick cuts. Then you'll learn how to use metal stencils to add texture to your work. Finally, you'll see how layers of colored wax can be scraped away to achieve deep, rich effects unlike those created by any other medium.

"A lot of it's experimental, spontaneous. It's about knocking about in the studio and bumping into things."
Richard Prince

INCISING

Any metal tool that can be used to cut into the wax lends itself to this most versatile of techniques. Tools that I've tried with great success include awls, cookie cutters, styluses, razor blades, wire brushes, pottery tools, palette knives, metal combs and nails or screws. Look for inspiration in textures; find tools at craft stores, hobby shops, flea markets, salvage yards, pottery stores, hardware stores and just about anywhere else you can find interesting metal objects. I've even found one-of-a-kind objects along the side of the road on my morning walk that have become some of the best items for incising in my encaustic paintings. It is not imperative that you know exactly how the objects will incise the wax or precisely where they will be best used in the painting. It is much more satisfying to let the wax and incising tools inspire the painting as you begin using them together.

INCISING FINE LINES

Any metal tool with a sharp tip or a thin edge will incise the wax with fine lines that can be used to add detail or subtle texture and color to any work of encaustic art.

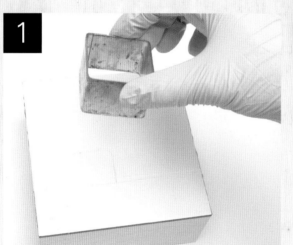

Layer wax and make impressions

Over a primed board, apply one or two layers of clear medium or colored wax; fuse after each layer. While the top layer is still warm, press shapes into the wax; here I'm using a cookie cutter.

Scrape lines into wax

To scrape lines into the surface, use a needle tool or pick. A metal straightedge can be used to create a straight line. For a more organic look, simply work freehand to create interesting, moving and flowing lines as well as straight ones.

brush up

Even if they're "clean," encaustic tools should remain exclusive to encaustic work to ensure no transferring of wax, particles or other materials between mediums, or heaven forbid, food!

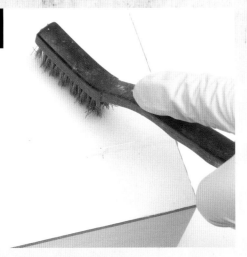

Add additional texture with a wire brush

Experiment with using a wire brush in the wax to create incised texture. It is more effective to allow the wax to cool before beginning this particular incising technique, as the bristles are so compact they tend to make a gummy mess of warm wax.

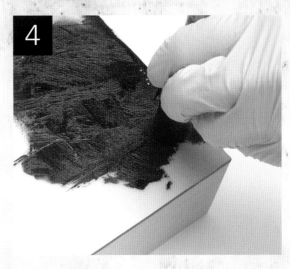

Apply color to textured areas

After you have achieved the desired texture, let the wax cool. (Otherwise, you'll smush the wax in step 5.) Add some color with an oil paint stick or oil paint. I am using an R&F paint stick in Alizarin Crimson.

oil pastel or WC

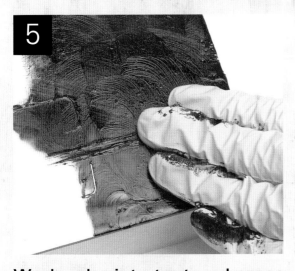

Work color into textured areas

Wearing gloves to protect your skin and to make for easy cleanup, rub the color into the board with your fingers.

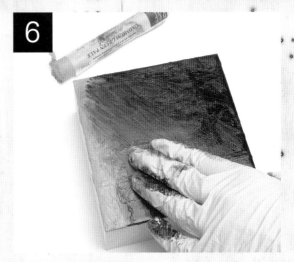

Layer and blend colors for further texture

Add additional colors to the textured areas if you'd like, blending them directly on the board.

brush up

To easily remove the burrs created when scraping in line work, let the medium cool and then just brush them loose.

Remove excess

After blending in the desired colors, wipe off the excess with a shop towel or paper towel. Be sure to remove as much of the excess color as you can. If too much oil paint/stick is left on the wax, the wax may resist adhesion to the subsequent layers, and you'll have sliding artwork.

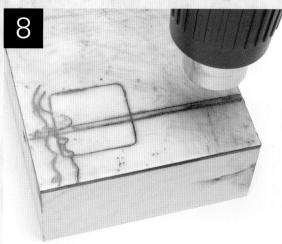

Fuse surface

Even though this is not an additional wax layer, the incised area is an added layer and needs to be fused. A quick fuse is sufficient.

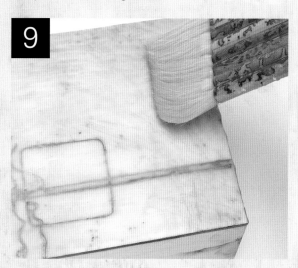

Layer medium and fuse again

Brush on a layer or two of medium, fusing between layers. Don't worry about leaving brushstokes, as this can add more incising texture.

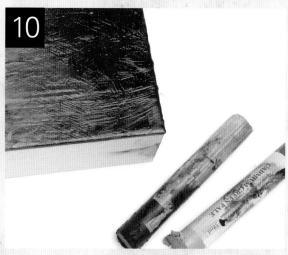

Glaze with color

Apply a new layer of glaze (here I'm using oil paint sticks) over the fused medium, working the color over the textured areas that were incised by the brushstrokes in the last step.

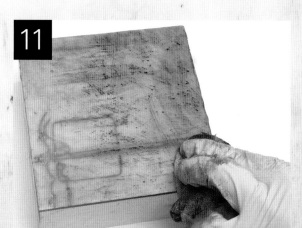

Wipe and fuse

Again, wipe off the excess color. Fuse the new layer a final time to complete the piece.

INCISING THICK LINES

Pottery tools can be used to incise with more dramatic effect. Since they tend to take away a larger concentration of wax, oil paint can be less effective in coloring the incisions. By carefully applying colored wax to the area, then gently removing the excess with a scraping tool, a thick, colorful line is revealed.

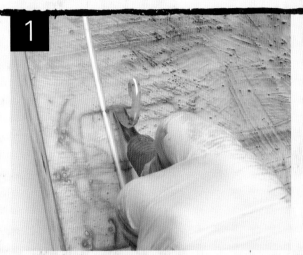

Carve deep lines in wax
Use pottery carving tools to create deep lines in the wax.

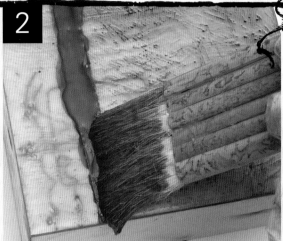

Overfill area with wax
With warm wax in the color of your choice (I'm using Sap Green here), fill the area in and around the carved line. Overfilling—laying the paint on thickly—is necessary to give you a surface to carve back through.

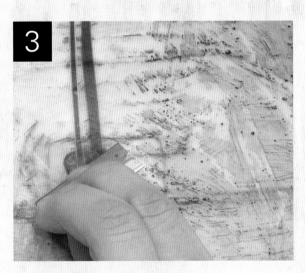

Scrape cool wax away
Let the wax cool completely. With a razor blade or another scraping tool, gently remove the excess wax from the carved line. Use a gentle hand and scrape continuously until the line is revealed to your desired clarity.

A CLOSER LOOK

A closer look shows the full effect created by incisions in encaustic.

WHAT YOU'LL NEED

Primed or previously painted board ✳ Encaustic paints in colors of your choosing ✳ Paintbrush ✳ Pottery carving tool ✳ Razor blade or other scraping tool, such as a palette knife or putty knife

ABCs

In this piece I used metal punch letterpresses to create a fun compostition by randomly pressing the letters into the wax. I then rubbed varying concentrations of an oil paint stick over the impressions, completely coloring some while allowing the previous layers of encaustic paint to show through others.

GOLDEN

The oil paint and paint stick glazing on this incised piece emphasizes both the incised lines and the textural brushstrokes of the dry-brushed wax application.

ALIZARON

I created this piece first by incising heavy brushstrokes into layers of encaustic paint, then by rubbing oil paint into the textured lines.

BORDER BRICK WALL

This piece was created as part of a series about the United States/Mexico border fence. The series features fences, walls and Southwestern icons that represent the two sides of the border. I used a bookbinder's needle tool to incise the bricks in this piece, then I rubbed dark oil paint into the grooves.

Visit CreateMixedMedia.com/encaustic-painting-techniques for bonus content.

MAKING IMPRESSIONS WITH A STENCIL

In addition to removing areas of wax for texture, you can build up layers through the using a metal stencil, which makes an impression in one layer of wax as you apply another to add further texture and interest. Stencils can be anything from products specifically designed for the purpose to interesting lace, screening or, as I've used here, punchinella.

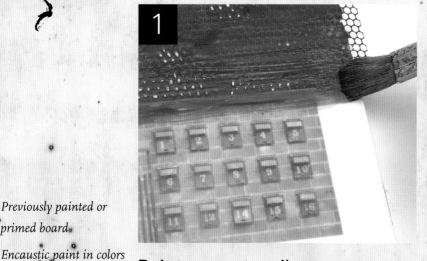

Paint over stencil
Choose something to serve as a stencil to add texture to your piece, and brush over it with a solid color of encaustic paint. Here I've chosen a piece of punchinella and a Burnt Umber encaustic medium.

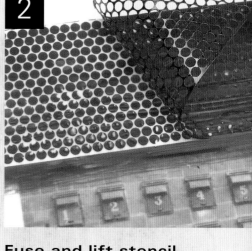

Fuse and lift stencil
Give the wax a quick fuse with the stencil still adhered in order to maintain the sharp edges the texture will offer. Then peel the punchinella back while the wax is still warm to reveal the texture it created.

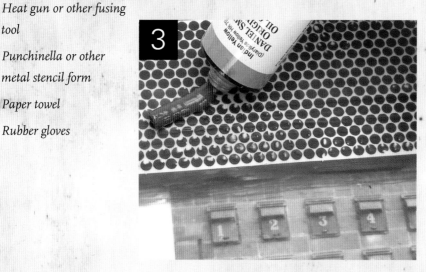

Apply coordinating color to textured area
Apply oil paint (straight from the tube or from an oil paint stick) over the texture created by the punchinella.

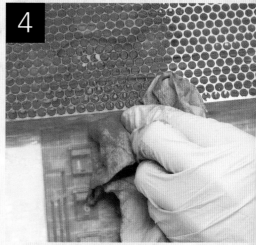

Rub in color and remove excess
Wearing rubber gloves to protect your hands, rub the color into the light areas of the board wherever you'd like. Remove the excess oil paint with a paper towel.

Sign up for the free newsletter at CreateMixedMedia.com.

A CLOSER LOOK

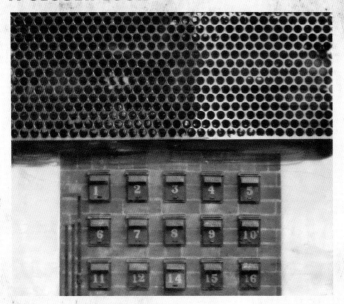

A closer look at the finished piece shows the layers of color over the punchinella's impressions.

1ST ENCOUNTER

I used punchinella and drywall seam tape—as well as a great deal of textural brushwork and square cookie cutters—to create a highly textured surface in this painting, which I then glazed with oil paint. In addition, I added letter stickers to establish a focal point and add a bit of meaning to the piece.

SCRAPING

Scraping is simply the removal of built-up layers of wax. Using pottery scraping tools, putty knives or razor blades, you can use this technique to work through five to eight layers of wax (any fewer and it's not as interesting, any more and you'll tend to get back to the original color), applying gentle strokes with the scraping tool until you achieve the desired visual effect. This technique can be meditative and relaxing. It can also create beautiful paintings and backgrounds for future work.

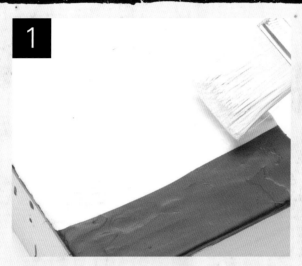

Layer color and fuse

Apply several layers of color, fusing between each one (here I layered a total of six colors). Vary the texture as you add the wax—that is, resist the urge to work it completely smooth; this will allow for more visual interest once you begin employing the scraping technique in the following steps. Once you're satisfied with the look you've created, let the board cool completely.

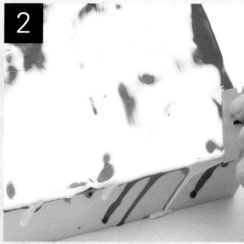

Scrape surface to reveal layers beneath

After the board has cooled completely, begin scraping off the top layer with a razor blade. Don't try to remove too much in one scrape. Take your time and apply a steady, even hand.

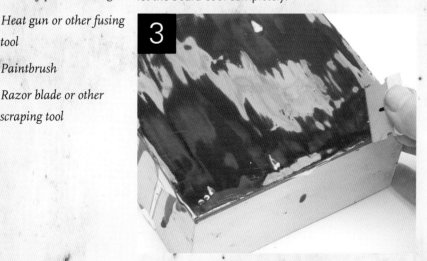

Finish textured effect

Continue scraping. Vary the direction of your blade and of your stroke, until portions of each color show through in an effect you like.

brush up

Put the painting in the refrigerator or freezer to speed the cooling process. I often work several pieces at once so that I can work on one while the other cools.

Primed board

Encaustic paints in 5-8 colors of your choosing

Heat gun or other fusing tool

Paintbrush

Razor blade or other scraping tool

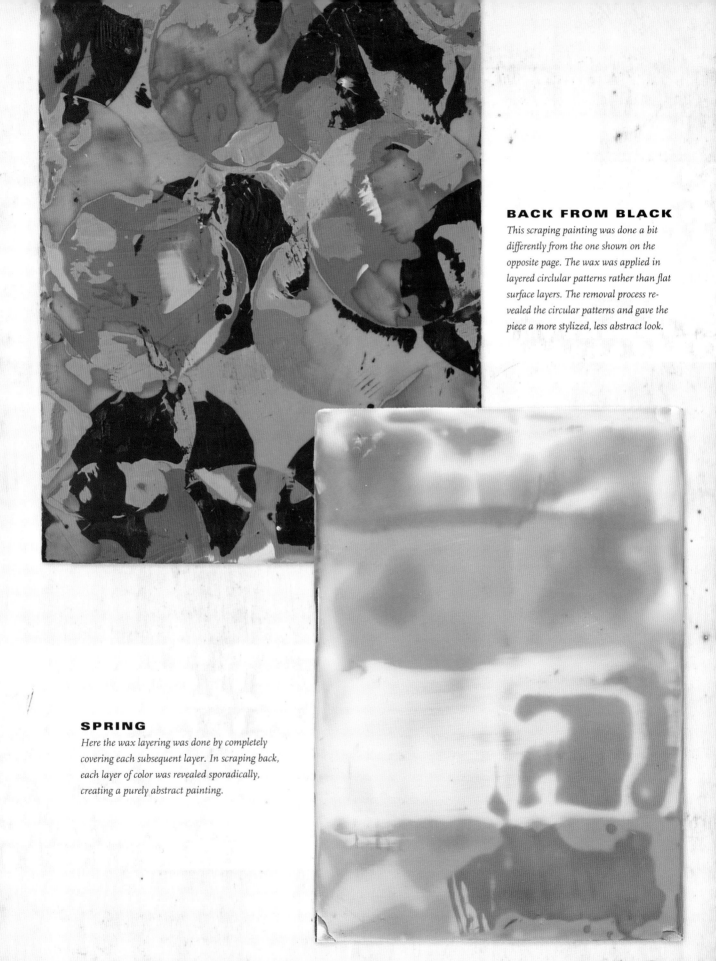

BACK FROM BLACK

This scraping painting was done a bit differently from the one shown on the opposite page. The wax was applied in layered circlular patterns rather than flat surface layers. The removal process revealed the circular patterns and gave the piece a more stylized, less abstract look.

SPRING

Here the wax layering was done by completely covering each subsequent layer. In scraping back, each layer of color was revealed sporadically, creating a purely abstract painting.

Visit CreateMixedMedia.com/encaustic-painting-techniques for bonus content.

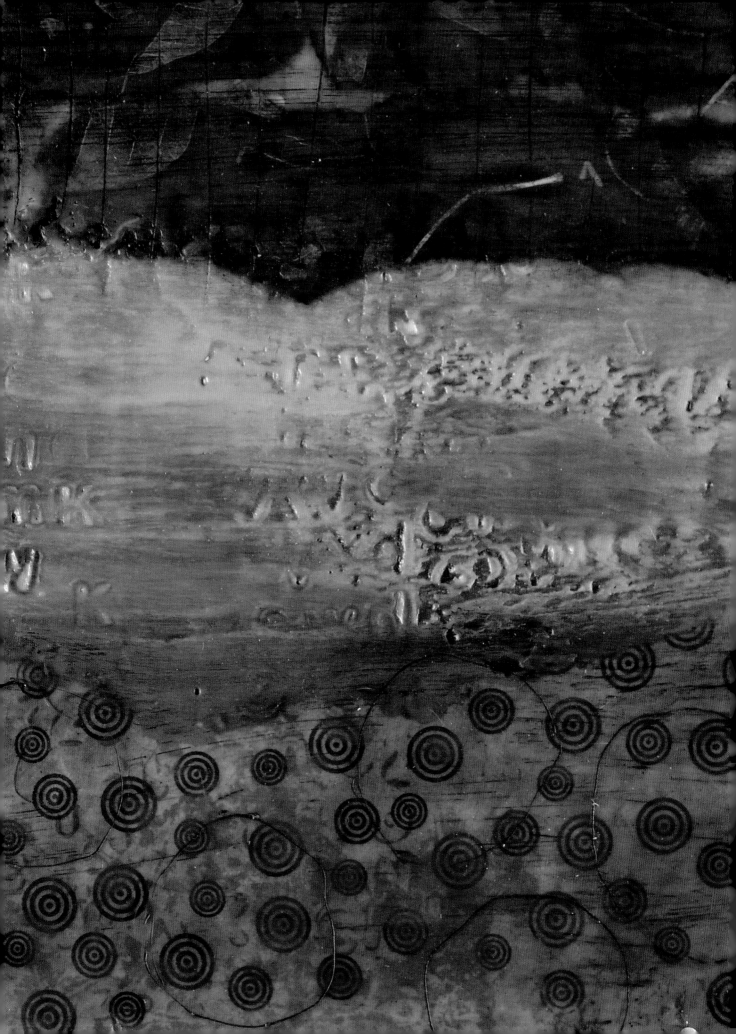

Lay
IT ON

Collage in encaustic can open up your eyes to a whole new arena of possibilities. When layered with clear medium, richly colored, textured or patterned papers can take the place of pigmented wax in adding color and interesting depth to encaustic painting. Lightweight tissue papers become virtually translucent "drawn in" images; scraps of paper, strings and other found objects are rejuvenated with new life once embedded in the wax. In this chapter, we'll explore how easy it is to create layered and meaningful collages with encaustic as your glue.

"The prize is in the process."
Baron Baptiste

LIGHTWEIGHT PAPER AND STICKERS

When it comes to gathering supplies for this technique, I must confess I adore the scrapbooking department of the craft store. So many patterned papers—not to mention interesting stickers and doodads—have been created for scrapbooking and it's hard to resist using them in encaustic collage work. Explore your local aisles, and you'll get hooked by all the possibilities. You can create a wonderful encaustic collage by layering lightweight papers. They lie down nicely, even on top of one another, and those that become transparent in the wax offer an unexpected delight in the creation.

Not at all,

WHAT YOU'LL NEED

Primed board

Clear medium

Heat gun or other fusing tool

Paintbrush

Lightweight paper(s) of your choosing

Stickers

Razor blade

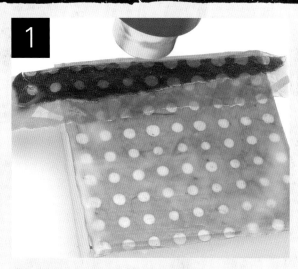

Begin layering papers
Position your first layer of paper, apply a coat of medium, fuse the coat of medium, then move on to the next layer.

Continue to add layers
Continue building layers, applying a clear coat of medium and fusing after each one. Here I've added a vertical strip of paper and established a very satisfying combination of color.

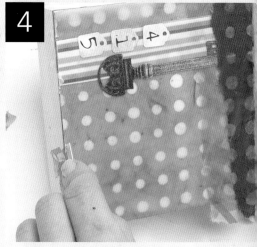

Add interest with stickers
Add stickers to create an interesting focal point in the wax. Simply place the stickers on the cooled wax surface and fuse them to the layers of paper and medium beneath. It is not necessary to apply a final layer of medium, but if you choose to, it will help reinforce the surface of your piece.

Clean up edges
Once the painting has cooled, use a razor blade to trim the excess paper from the edges.

A CLOSER LOOK

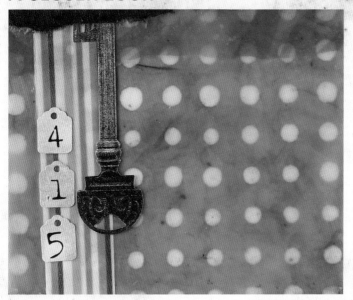

A closer look at the finished piece shows how lightweight papers and stickers can enhance an encaustic composition.

SUBURBAN SUN

In Suburban Sun, *the color comes from lightweight papers embedded in the wax. The composition was further enhanced by techniques you'll learn on the following pages.*

TISSUE PAPER AND PASTELS

Using dry pastels, oil pastels or charcoal on Japanese silk tissue or another type of tissue paper is a great way to let your creativity shine and to incorporate interesting line work and drawings into your encaustic work. Again, the tissue virtually disappears in the wax, making it seem as if your drawing is part of the wax painting.

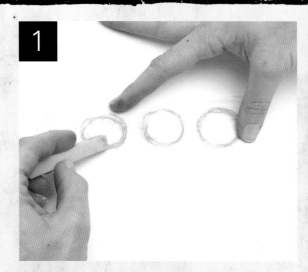

Create design on paper
Draw the design or subject of your choice on the silk tissue with several layered colors of dry pastel.

Add paper to primed surfac
On a warm, primed board, lay the tissue onto t wax and gently press to eliminate any air bubb|

WHAT YOU'LL NEED

Primed board

Clear medium

Heat gun or other fusing tool

Paintbrush

Silk tissue

Dry pastel, several colors

Brush on medium and fuse
Finish with another coat of clear medium. The pastel has a tendency to run a bit in the hot wax, so be mindful of your brushstrokes, depending on whether or not you like the blurred effect. (I like to brush my coat of clear medium in one direction only.) Re-fuse the layer.

brush up

In perfecting this technique, apply the wax in one direction with even, complete strokes to draw the pastel consistently through the painting. Here I worked from top to bottom to pull the wax through the pastel and down the board.

40

ALL

In this more elaborate piece, you can clearly see how the "disappearing" tissue technique demonstrated on the opposite page makes it look as if the pastel drawing had been done directly in the wax.

and why not draw directly?

ORANGE; BLUE

These pieces feature a variation of the technique shown on the opposite page. For this effect, rather than starting with tissue paper, simply coat the board's surface with a layer of medium and then, while it's still warm, "drag" the pastels through the surface. The hot wax pulls the pastel down into the layer as it's applied, resulting in a slightly less defined look.

LIGHTWEIGHT INK-JET PRINTS

I am an avid amateur photographer—aren't we all in this digital age?—so I was thrilled to find a way to incorporate ink-jet printed images in encaustic work. Japanese silk tissue paper and sumi paper work beautifully for creating a surface that will disappear into the wax and fluidly integrate the photo into the painting. To print photos on lightweight paper, simply cut the paper of your choice to 8½" × 11" (22cm × 28cm) and adhere it, with clear tape across the top edge, flush to a piece of text-weight paper. Then feed it through the printer.

WHAT YOU'LL NEED

Primed board ✳ *Medium* ✳ *Heat gun or other fusing tool* ✳ *Paintbrush* ✳ *Printed piece of sumi or tissue paper*

Press image into warm, primed surface

Start with a primed board and, while it is still warm, press your piece of printed sumi or tissue paper into it, then apply additional medium over the top to seal it in. Fuse the medium.

FABRIC

Fabrics are fun to use for varied effects in encaustic collages. Having been sewing since an early age, and having a large collection of fabric on hand, I adore textiles as much as I do papers and have discovered this new use for them with great joy. Try this technique to incorporate a single fabric as a background for a section or the entire surface of your work, or combine different fabric scraps to make a sort of collage. You'll want to experiment with various thicknesses of medium to see how you can let the true textures and colors of the fabric show through and, conversely, how you can mask them in the depths of your wax.

WHAT YOU'LL NEED

Primed board ✳ *Medium* ✳ *Heat gun or other fusing tool* ✳ *Paintbrush* ✳ *1 or more scraps of fabric*

Layer wax and add fabric

Prime your board with plenty of wax layers; I recommend laying the wax on thick up front to compensate for the absorbency of the fabric. Then press the fabric gently into the warm wax surface to ensure there are no air bubbles. Brush medium over the fabric and fuse. It may require several additional layers of medium to embed fabric thoroughly into the piece, especially if you're working with heavyweight fabrics that absorb a lot of wax.

Sign up for the free newsletter at CreateMixedMedia.com.

TRIPLICATE

*Combining contrasting weights of fabrics can make for a finished piece with
a nice sense of depth. In this piece, the background fabric is a heavyweight
burlap, the front is a lightweight silk and the final, almost invisible, fabric is
a thin sheer weave. All three scraps were left behind by students of one of my
workshops in Mendocino. Incorporating significant items into your work
can commemorate a memory of where you've been.*

Visit CreateMixedMedia.com/encaustic-painting-techniques for bonus content.

HEAVYWEIGHT PAPER

I recommend moving on to this technique only after you've conquered the techniques for working with lightweight paper outlined on the previous pages. Heavyweights tend to have a mind of their own and will often want to lift out of the wax, resist lying flat and, quite frankly, drive you crazy. But once you're ready for a challenge, you can create some wonderful effects that are worth the hassle.

WHAT YOU'LL NEED

Primed board

Encaustic paints in color(s) of your choosing

Medium

Heat gun or other fusing tool

Paintbrush

Heavyweight paper

Needle or other pointed metal tool

Create a thick wax base

Apply several layers of a solid color of wax paint onto your surface to ensure a secure base for the paper to set into. Here I've painted layers of Sap Green. Then come back over with medium to prevent the color from bleeding into the paper when you lay it into the wax (unless, of course, that is the effect you want).

NOTE: The medium will look milky while it is warm but will become clearer as it cures and cools. Depending on how many layers have been applied, this can take as little as an hour to as much as several days.

Add heavyweight paper

While the wax is still warm, set the paper into the wax and press gently to ensure no air bubbles are trapped underneath. (Here I've used a piece of a watercolor painting that was done on 140-lb. [300gsm] watercolor paper.) Apply another coat of medium over the paper.

brush up

If your heavyweight paper is not cooperating and is resisting your efforts to get it to lie flat on the surface, consider letting the paper have its own way. The curling corners lend a spontaneous look to the finished piece.

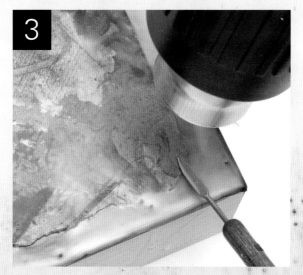

Fuse while securing paper

Heavyweight paper has a tendency to curl at the edges and lift up off the wax. To make it lie flat, fuse the surface again while using a pointer tool to hold the corner down gently as you work. Be careful: Using a lot of force will only damage the wax underneath.

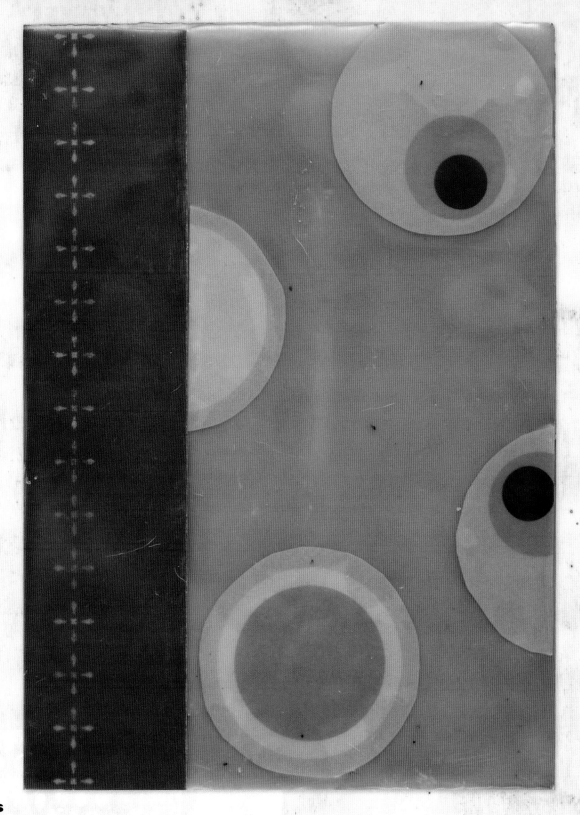

MEASLES

This painting combines several heavyweight papers in the wax, including circles cut from a patterned paper and a favorite red scrap from my collection. Here you can see that with a little finessing, all the papers behaved and laid down flat in the wax.

METALLIC LEAF

I have a confession: I had never experimented with metallic leaf before deciding to try it in my encaustic work, so I can't make any firsthand comparisons between incorporating this fun substance into wax and other mediums. But I can tell you that I loved the results. You can leave the finish shiny or coat it with thick layers of medium for a more subdued look.

Press primed board onto leaf

Open a sheet of metallic leaf from its original packaging and lay it facedown on your surface. (There is no need to remove it from its backing or to add any of the traditional leaf adhesive.) Place a warm, primed board facedown onto the leaf, and press firmly on the board. The warm wax will grab the leaf and create a gentle adhesion.

Fuse slowly

Using a low airflow setting, fuse the leaf to the primed layer.

brush up

If you opt to brush medium over the top of the leaf, let the medium cool, then buff it up to bring back some of the shine.

Coat with additional wax (optional)

The leafing can then be covered with more hot wax or simply left as the shiny final layer. Here I've added wax to half of the finished surface so you can see both end results. As you can see, the luminosity of the metal leaf is lost under the wax, but it still lends an interesting element to the painting. If you choose to leave the leaf exposed, keep in mind that it will be fragile and susceptible to scratches.

WHAT YOU'LL NEED

Primed board

Heat gun or other fusing tool

Sheet of metallic leaf

Medium (optional)

Paintbrush (optional)

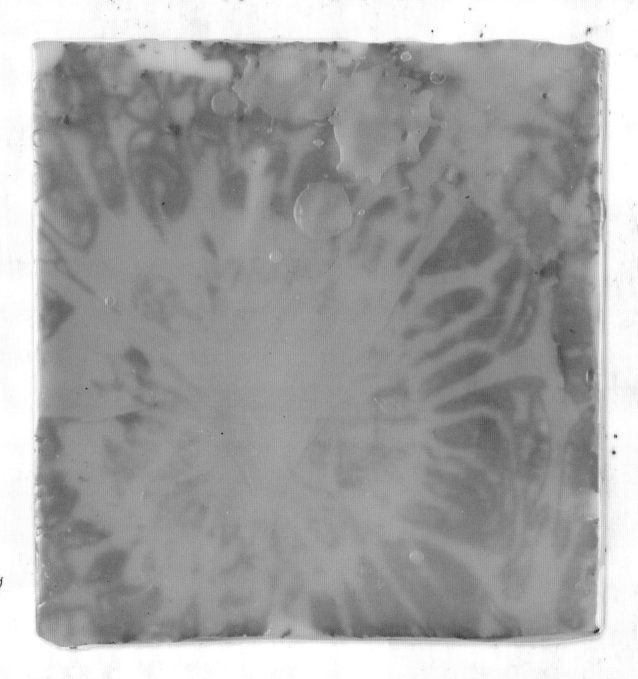

RED METAL

This painting began with a variegated red metallic leaf. Even with layers of beeswax over it, the variegated tones show through, and the metallic still shimmers a bit. I love the visual texture you can achieve with this technique.

FOUND OBJECTS

Dimensional elements can be really fun to incorporate into wax. Experiment with adding any odds and ends you'd like to feature in your artwork. This technique lends itself to being combined with others to create a multilayered work. Here I began with the piece I created using tissue paper and pastels in the Lay It On chapter. Then, to add interest and depth, I included some objects I discovered while walking in my neighborhood. You might also consider incorporating store-bought items, such as embellishments found in the scrapbooking aisles of your local craft store.

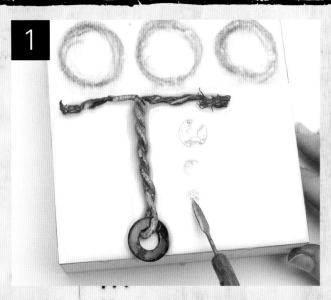

1

Build thick layer of wax and press in objects

Start with a primed board and add medium to the depth you desire for your objects. Embedding objects can require extra wax for adhesion, depending on the size and weight of the object. Fuse between layers. Once this foundation has been established, press the objects into the warm wax.

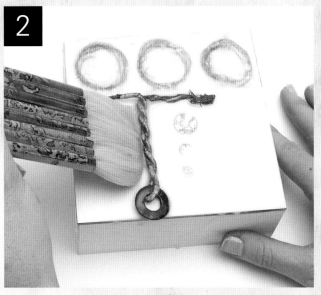

2

Embed items in wax

Brush additional medium over and around the objects to help hold them in place. Some objects may be thin enough to simply coat once, but others, like this one, require several applications.

WHAT YOU'LL NEED

Primed or previously painted board

Medium

Heat gun or other fusing tool

Paintbrush

Found objects of your choosing

brush up

If you are trying to paint over elements and they're moving around too much, try drizzling the medium over them instead, then overfusing. This should keep them in place and allow you to achieve a thick but smooth surface.

48

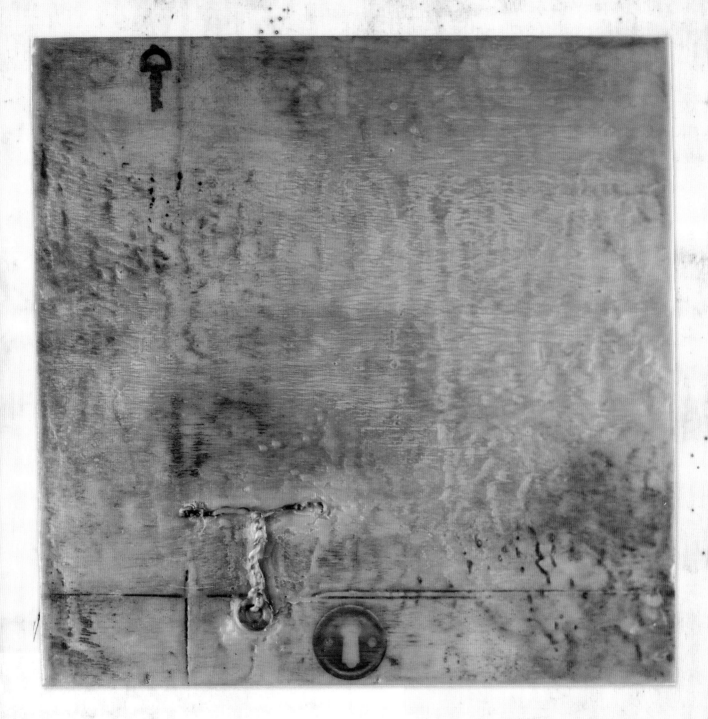

PERFECT FIT

Using the work I created on the opposite page as inspiration, I made this larger composition by using a similar found object, adding key and lock stickers, incising, subtly transferring an image and adding texture by drybrushing. All of this was done with natural, unrefined beeswax—rather than the clear, refined wax—in order to utilize its natural yellow coloring.

FIBERS

Textile elements of all kinds lend themselves to inclusion in your encaustic works—and that means more than just fabric. String, yarn, ribbons and raffia can all create interesting layers in your wax. I find this technique wonderful for showing the unique depth of encaustic; where the threads overlap, you can see one literally suspended in wax above the other.

Lay first layer into warm, primed board

Start with a warm primed board and press the fibers of your choice into it just as you'd do with paper or fabric. Here my goal is to create a grid pattern of strings that will showcase the visual depth achievable in hot wax.

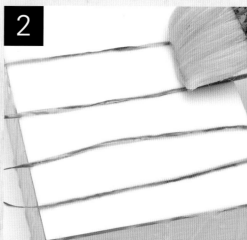

Coat first layer with medium

Brush a layer of medium over the strands. Fuse the surface.

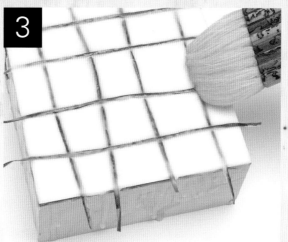

Press second layer into warm wax

Add another layer of strings (here I'm working in the opposite direction to showcase the depth of the work). Brush on additional medium, and fuse again.

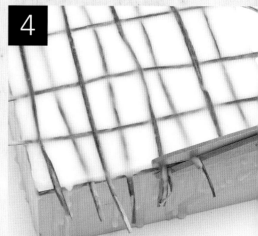

Continue to layer string with medium

Continue in this manner, adding layers of string and medium, until you've created the depth you want in the layers. Once the final coat of medium has been applied and fused, trim the excess string from the edges with scissors or a razor blade.

Sign up for the free newsletter at CreateMixedMedia.com.

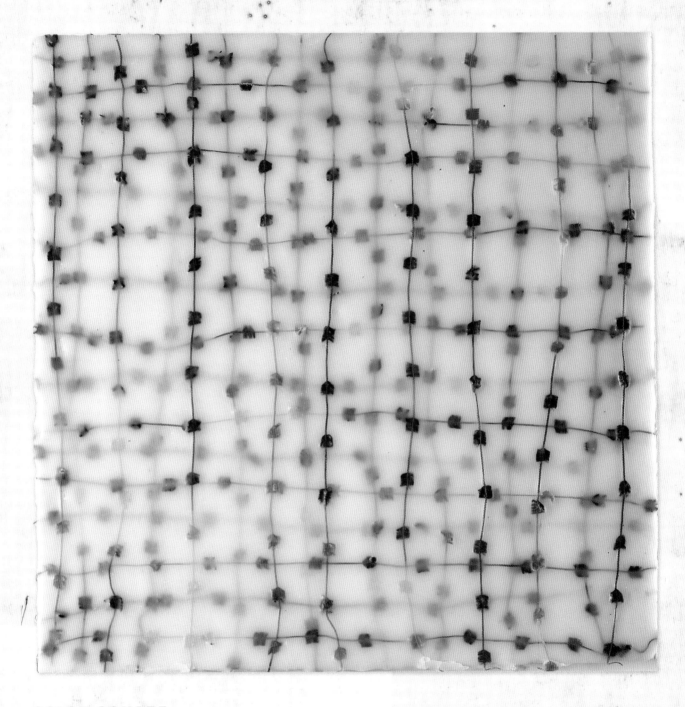

COLOR SQUARE

You can create even more depth by layering a more dimensional fiber—like this rainbow-colored string yarn with fiber "flags"—in between layers of clear medium.

NATURAL ELEMENTS

Adding natural elements to your encaustic works is one of the purest ways to enhance the organic look and feel of the beeswax medium. Literally anything you can encase in wax can be added to an encaustic painting, so keep your eyes peeled for interesting leaves, stones, shells and feathers to include in your work. You never know what interesting effects you can create until you try. Here I've used some shells, small stones, sand and a leaf skeleton.

WHAT YOU'LL NEED

Primed board

Clear medium

Heat gun or other fusing tool

Paintbrush

Natural elements

Wax paints in the color(s) of your choosing (optional)

Dirt, ash, sand or soot (optional)

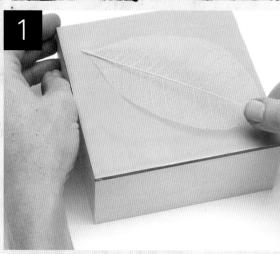

1

Press object into warm wax
Start with a warm, primed or re-fused encaustic surface and gently lay your first natural element into position. Here I've started with a coat of King's Blue wax paint and set a leaf skeleton gently into the surface.

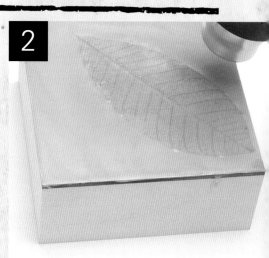

2

Coat and fuse
Brush a layer of clear medium over the top of the object and re-fuse.

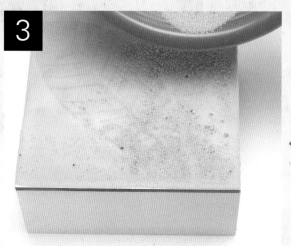

3

Add additional elements
Add texture and increase the organic appearance of your piece by sprinkling elements such as dirt, ash, sand or soot into the second coat of warm wax and re-fusing. When re-fusing elements like sand, keep the heat gun at a distance from the surface (and on a low speed, if possible) to avoid blowing it all away; the wax should still warm enough to absorb and adhere the sand.

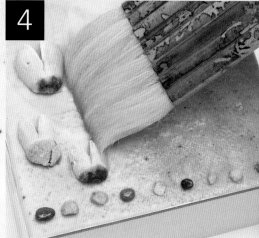

4

Add largest items last
Finally, add larger, more dimensional elements as your final layer, with coats of additional medium brushed around them to hold them in place.

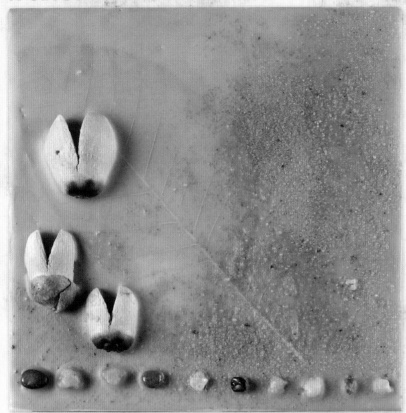

A closer look at the completed piece shows the lovely organic texture and composition that can be created by adding natural elements to encaustic art.

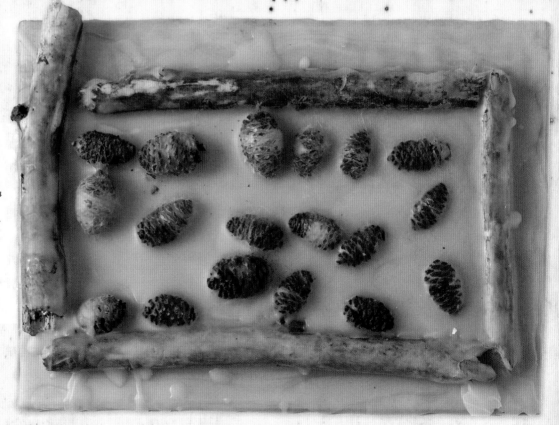

SITKA

This piece was created with objects collected on a trip to the Oregon coast. The sizes and textures of the sticks and pinecones fit in nicely with the yellow tone of the natural, unrefined beeswax.

KISS

KISS \KIS\ V. I. TO TOUCH SOMEBODY OR SOMETHING WITH THE LIPS 2. TO TOUCH OR BRUSH AGAINST SOMETHING LIGHTLY

kiss

IMPORTANT! **FOLLOW THESE EASY DIRECTIONS STEP BY STEP**

Rub
IT IN

If you're like most mixed-media artists and crafters, at some point you probably have tried your hand at one or more image-transfer techniques. Polaroid, gel medium, chemical: There are many different methods, and you probably already know that they're not all consistently successful or mess-free. So I invite you to join the encaustic image transfer revolution. You'll find the techniques in this chapter so easy, so satisfying and so beautiful that soon your imagination will overflow with ideas for your own work. We'll start by learning a traditional image transfer. If you're an avid photographer like me, chances are you'll enjoy transferring your own original photos to your encaustic work as much as I do—but you can also experiment with clip art, words and numbers, maps, blueprints and even graphic designs. We'll then move on to see how rub-ons, charcoal rubbings, graphite paper and even metallic leaf can be used to transfer simple images, characters or accents to your work.

> "It is not what you see that is the art: Art is the gap."
> **Marcel Duchamp**

IMAGE TRANSFERS

To get the best image transfer using this technique, I recommend using a fresh photocopy of an ink-jet printed image, but laser-printer images also work. Be mindful that the image needs to be carbon or toner based rather than ink based; otherwise, the ink will just smear on the wax rather than transferring clearly. I love the effects created by transferring black-and-white images with this method, but it also works well with color images. Experiment with both and see what you like best.

1 Trim image and place face-down in warm wax

Trim the photocopied image to the desired size. Begin with a warm, primed surface and lay your image facedown into the wax.

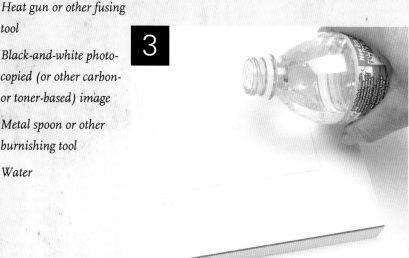

2 Burnish thoroughly

Burnish the image. I like to use the back of a metal spoon because of the concave shape and, of course, because metal tools make for easy use and easy cleanup. Be sure to burnish the entire image, as any missed areas will not transfer. There's no need to be gentle; if the wax is the right temperature, you will not damage the surface. A firm hand is needed to ensure a good carbon transfer.

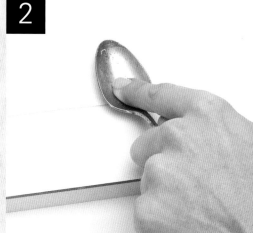

3 Saturate paper with water

Pour enough water on the back of the paper to saturate it. The water is needed to remove the paper from the transferred image itself.

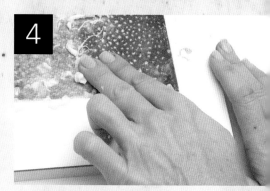

4 Burnish wet paper and remove pulp

Let the water sit on the paper for a minute or so to allow the paper to absorb it, then burnish again with the spoon. This will begin to pulp the paper and reveal the image set in the wax. Once this happens, begin rubbing the paper off with your fingers.

Sign up for the free newsletter at CreateMixedMedia.com.

Fuse transferred image

Once the paper has been removed, fuse the transfer. The heat will warm the wax and cause any small paper fibers to become absorbed and disappear.

Transferring a color image

Use the same technique for color transfer. To best illustrate the different effects, I've used different versions of the same image—a close-up of some interesting mushrooms I found in my front yard—in both transfers.

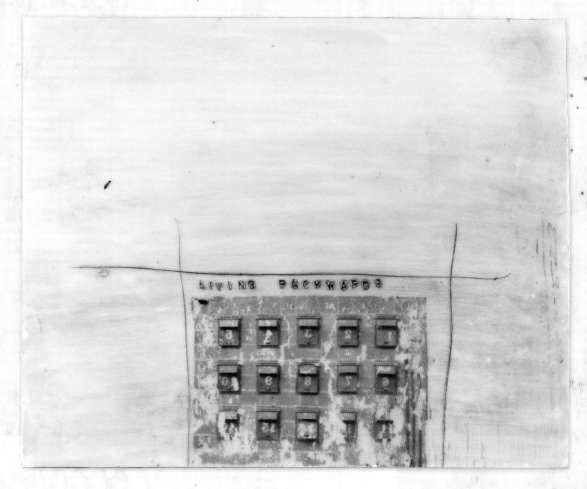

LIVING BACKWARDS

Image transfers can be used to add meaning to a work. Here I've intentionally placed the transfer in reverse to exemplify the place I was at in my life during this painting period.

MY NEIGHBOR'S FORT
This piece began with a landscape blueprint transfer with interesting line work and loosely defined images. It allowed me to maintain my abstract, emotional painting while developing an interesting focal point.

13

This piece is a result of experimentation with image transferring, layering and depth. The landscape design was done in the first layer of encaustic, followed by several layers of medium, then the image transfer was added. The result shows depth while maintaining clear imagery at each layer.

SANTA FE

This piece features a color transfer of a photograph I took in Santa Fe. The top is textured with a stencil. The flecks of color come from bits of wax that were embedded in the stencil and melted into the wax as I painted over the stencil. I really like the unintentional effect!

INTUITION

The simple inclusion of an image transfer in this encaustic collage serves as a gentle focal point for the bright, strong colors of the patterned papers that add a great deal of punch.

RUB-ONS

Rub-ons are another of my favorite finds from the scrapbooking aisles of my local craft store. Transferring these oh-so-cool ready-made elements—featuring words, numbers, scrolls and pretty much anything else you can imagine—is as simple as removing the backing and burnishing the image with the tool provided. The result is an amazingly clean and seamless look.

WHAT YOU'LL NEED

Primed or previously painted board with a cool wax surface ✳ *Heat gun or other fusing tool* ✳ *Rub-on embellishment* ✳ *Craft stick or other burnishing tool*

Apply rub-on and re-fuse

Rub-on lettering or imagery can be burnished onto a cool board quite simply by using the craft stick that is included in the package. Fuse your surface once the rub-on is completely transferred. Here I'm rubbing some text onto the image-transfer piece I created earlier.

METALLIC LEAF TRANSFERS

Oh, the joy of a pop of metallic glitz! Even if a shiny finish isn't normally your style, you may be surprised to find that just a touch of some cleverly applied gold or silver leaf can add that oh-so-perfect final touch to your encaustic works. Rather than embedding the leaf, this time we'll rub it onto the surface for an entirely different effect.

WHAT YOU'LL NEED

Primed or previously painted board with a cool wax surface ✳ *Heat gun or other fusing tool* ✳ *Metallic leaf* ✳ *Scribing tool or ball-end stylus*

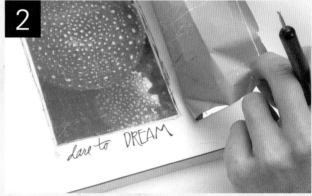

Reveal transfer and fuse

Peel up the leaf to reveal the transfer. If you are satisfied with how it looks, fuse this section of the surface. If you don't like the result, simply scrape it off and begin again.

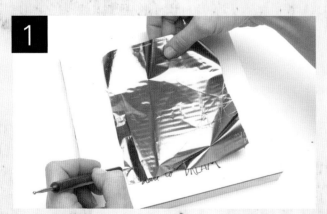

Impress leaf into wax

Lay the leaf onto a cool wax surface. Use a scribing tool or a ball-end stylus to impress the foil into the wax in the desired areas.

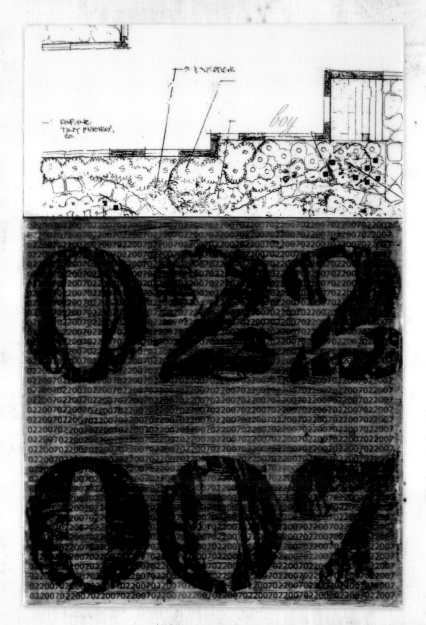

022007

For this black-and-white composition, I began with multiple photo transfers: first the landscape design, then the numbers from a collage paper that I scanned, and printed as a toner-based copy. The subtle rub-on transfer of the word "boy" added depth. Finally, I incised the surface with a bit of textural brushwork, then glazed the surface with black oil paint to emphasize the texture.

ROUGHING IT

Sometimes happy accidents can make for unexpected works of art. By simply laying the metallic leaf over this piece's rough, textural surface, then burnishing the whole area, I created these sporadic metallic touches. The effect wasn't what I was trying to achieve, but I came to love the look and decided it was a finished piece.

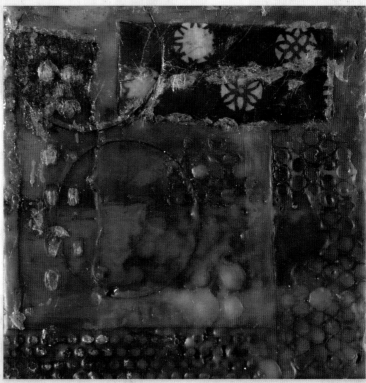

GRAPHITE AND CHARCOAL RUBBINGS

Using vellum and a graphite or charcoal stick, you can create abstract rubbings of virtually any surface you like and then transfer them to encaustic works for a look that is both distressed and dimensional. Do you remember doing grave-marker rubbings in elementary school? They're back!

WHAT YOU'LL NEED

A finished piece ✳ Wax ✳ Paint in the color of your choosing ✳ Heat gun or other fusing tool ✳ Paintbrush ✳ Razor blade (optional)

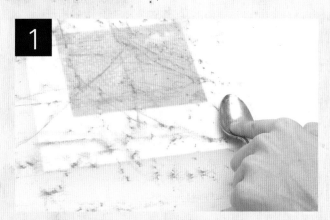

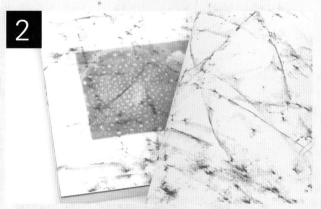

Burnish rubbing onto cool wax surface.

Create a rubbing or drawing on vellum with charcoal or graphite. Pictured is a charcoal rubbing of the texture of an adobe wall in Sante Fe. Set the vellum facedown on a cool, primed or painted board. Burnish with the back of a spoon or a similar burnishing tool.

Reveal transfer and fuse

Peel off the paper to reveal the transfer. If you're not happy with the effect, simply place the vellum back on your surface and continue rubbing. When you've created a look you like, re-fuse.

CARBON AND GRAPHITE PAPER

Art supply stores carry graphite and carbon papers in their drawing supply areas. Pick up a box—they come in colors!—and start experimenting with this fun and simple transfer technique.

WHAT YOU'LL NEED

primed or previously painted board with a cool wax surface ✳ carbon or graphite paper ✳ stylus or other scribing tool

Transfer as you would metallic leaf

Carbon (shown here) or graphite paper can be used to quickly and easily transfer sketches or writing onto a board. Simply use the same technique described earlier for the application of metallic leaf. Here I'm using this technique to add further detail to an image-transfer piece I created earlier.

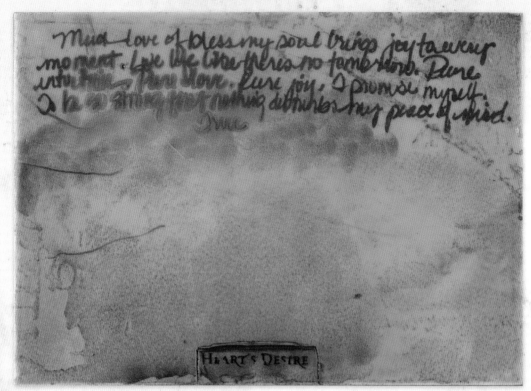

MUCH LOVE

In this piece, I used a ball-tip stylus to journal some stream of consciousness thoughts on a sheet of graphite transfer paper placed directly on the painted wax. I then overfused the words with a heat gun, causing some of the graphite to disperse and make the enclosed message more subtle and partially hidden.

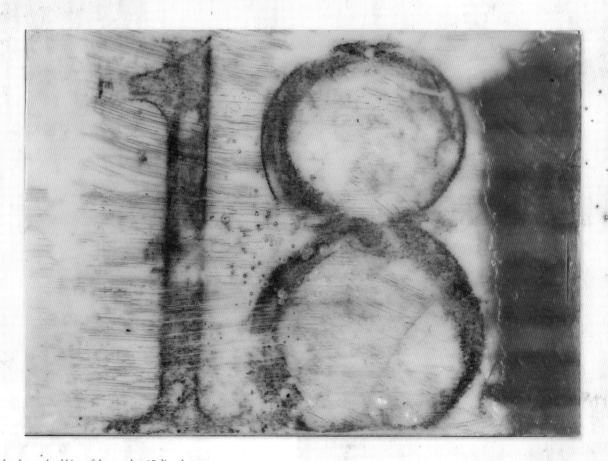

HOME

Here I applied the charcoal rubbing of the number 18 directly to the cooled, primed surface. I then added the collage element of the medium-weight colored paper. Finally, I used Quinacridone Rose oil paint to glaze the entire surface and to fill the incised brushstrokes with additional color.

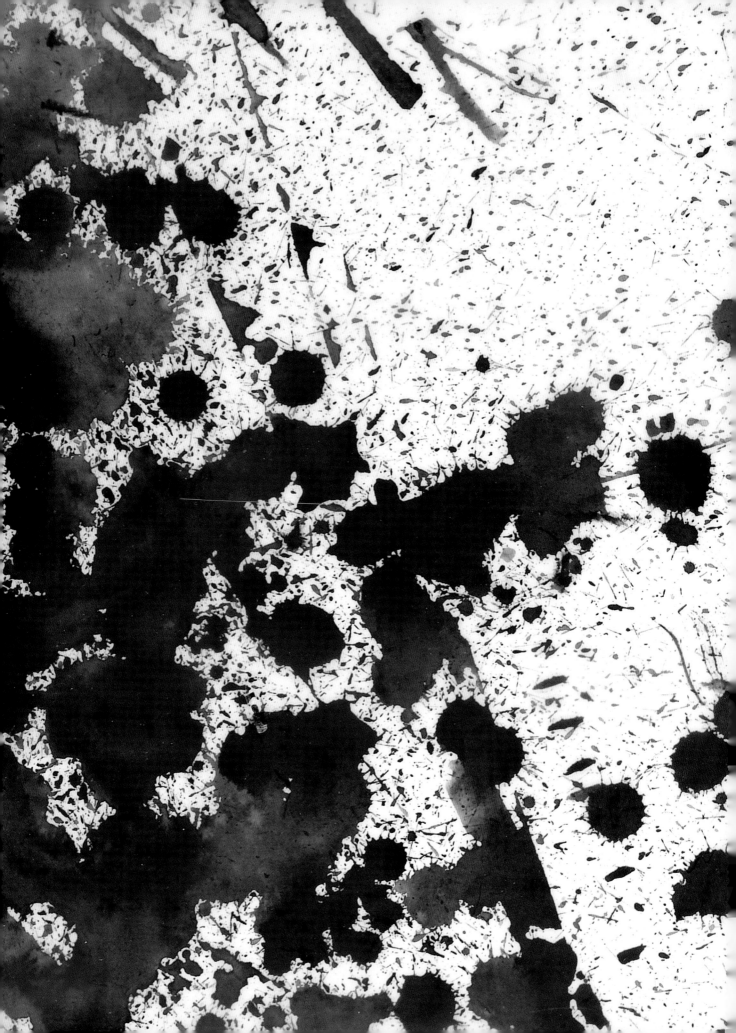

Break
THE RULES

Admit it: You experiment with your art. Otherwise, you wouldn't be interested in this book. Now that you've learned some of my most tried-and-true encaustic techniques, it's time to join me as we test the boundaries, push the limits, explore every "What if?" and play, incorporating everything from watercolor paint to shellac in encaustic experiments. That is where invention begins. Any artist who works from the creative side that says "Why not?" and "Who says I can't try it?" has dipped a toe into the experimentation that leads to creative invention and surprises of unpredictable beauty. It has been enlivening to explore the boundless possibilities in encaustic. But I'm sure I haven't broken all the rules myself—yet. Don't limit yourself to the ideas you find in this chapter, what you learn in a workshop or what other artists tell you: Explore and push the envelope of your own creativity. You may be pleasantly surprised with the results.

"There is no must in art because art is free."

Wassily Kandinsky

CHARCOAL *this was never a rule —*

Who says you can't combine mediums in encaustic? Drawing with charcoals, pastels or graphite onto your surface before you've even primed the board is a lot of fun. I have always enjoyed doodling (thanks, Mom and Dad!) and tend to come away from a meeting or conference with scribbles and marks down the margins of all my note pages. If you're a doodler like me, or if you enjoy sketching, you'll love this technique.

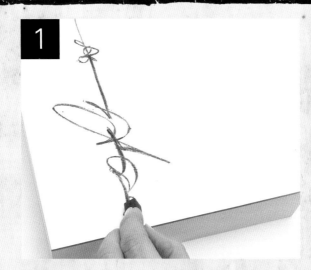

Draw on unprimed surface
Draw directly onto an unprimed board with charcoal, pastel or graphite. I tend to favor free-flowing organic lines like those shown here.

Heat surface and add medium
Heat the board as if to prime it, and apply a coat of medium. The charcoal, graphite or pastel may smear a bit, but this can have wonderful effects—use it to your advantage! Fuse to finish, or add additional layers of medium, transparent colors or other elements, treating this as an underpainting for a more in-depth work.

WHAT YOU'LL NEED

Unprimed board

Medium

Heat gun or other fusing tool

Paintbrush

Charcoal, pastel or graphite

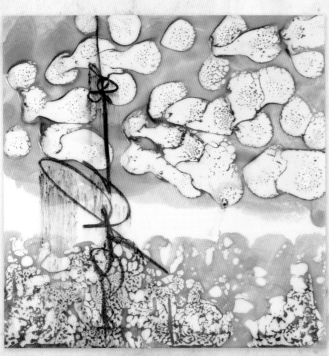

Turn to the Shellac technique in the Break the Rules chapter to see how this charcoal work became an underpainting for a piece using the dry shellac technique.

Sign up for the free newsletter at CreateMixedMedia.com.

BLOBS

For this piece, rather than sketching right on the unprimed board, I doodled with charcoal on watercolor paper, then adhered it to the board and applied a coat of encaustic medium to create this effect.

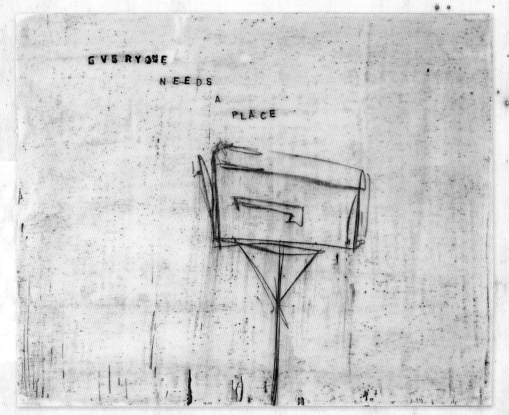

EVERYONE NEEDS A PLACE

A graphite pencil drawing directly on the board created the focal point for this gentle piece. Metal letter stamps pressed into a top layer of medium pair with brushstroke incising and black oil paint glazing to complete the effect.

STAMPS

I had never used stamping in my work until I decided one day that I wanted to use some abstract stamped images as an underpainting. I asked some scrapbooking wizards which ink to use; they recommended a pigment dye ink, and that's what I've gone with ever since. If you are familiar with stamping and all the options available, or if you carve your own stamps, use this technique to incorporate those images into base layers in your encaustic painting.

WHAT YOU'LL NEED

Unprimed board

Clear or tinted medium

Heat gun or other fusing tool

Paintbrush

Rubber stamp

Ink

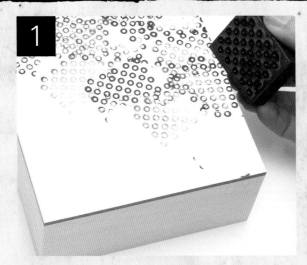

Stamp unprimed surface
Stamp directly onto an unprimed board with a rubber stamp and pigment ink. (The ink will not work well on a primed, waxed surface.)

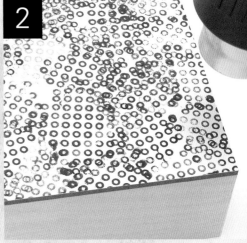

Heat surface
Heat the surface, heat-setting the ink and warming the board for priming all at once.

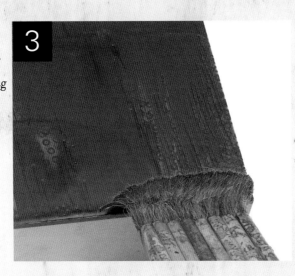

Brush on medium and fuse
Apply a layer of clear or tinted medium and fuse. Here I've opted for a transparent Quinacridone Magenta to exhibit how the stamped underpainting can show through and create a more subtle layered effect.

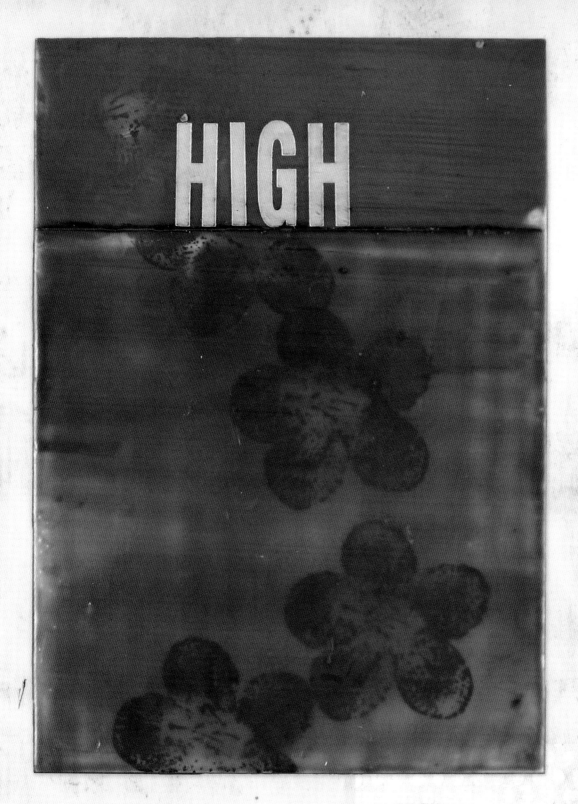

HIGH

This painting was created with the intent of using color and still maintaining the underpainting of stamped flowers. By diluting the color with clear beeswax to a mix of 1 part color to 6 parts beeswax, I was able to layer two applications of wax over the stamped Claybord without loosing the imagery. I love the way the image becomes distorted yet remains visible.

Visit CreateMixedMedia.com/encaustic-painting-techniques for bonus content.

COLLAGE & STAMP

An easy alternative is stamping over your wax, especially fun when combined with collage papers.

Heat surface
Heat the board with the heat gun. Apply encaustic medium to the board.

Collage board
Apply collage papers to the board, applying encaustic medium between layers.

Fuse layers
Brush on an overall layer of medium. Use the heat gun to fuse the layers together. Set aside to cool.

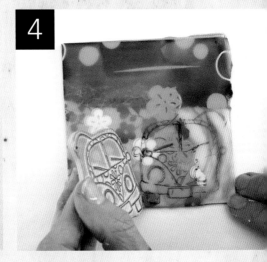

Apply ink
When the wax is cool, ink up the rubber stamp and apply it to the surface.

Sign up for the free newsletter at CreateMixedMedia.com.

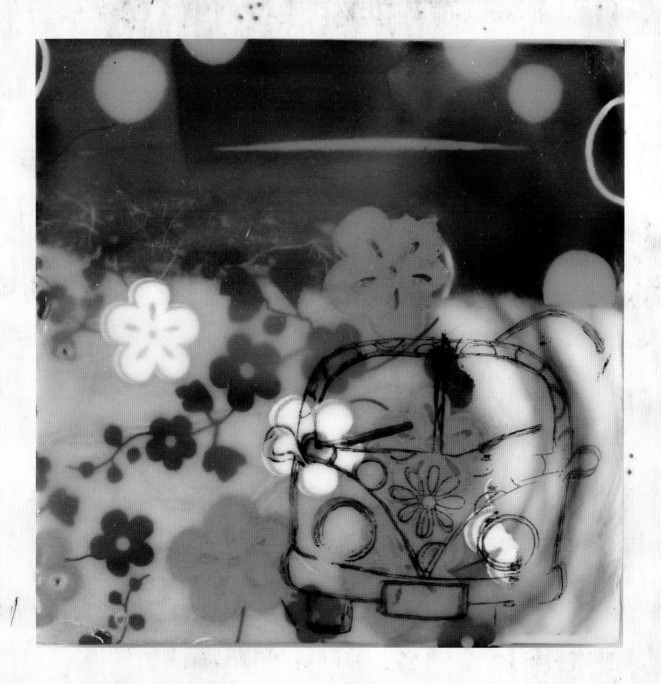

ALCOHOL INKS

Varied interesting effects can be created by adding alcohol inks to encaustic work. The alcohol dries so quickly that it lends itself to a few different techniques.

GLAZING

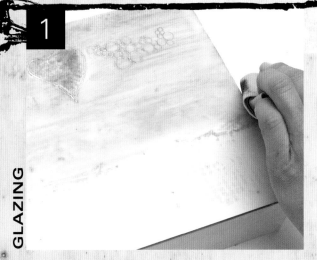

1

WHAT YOU'LL NEED

*Primed board * Alcohol ink * Paper towel*

Add transparent color to primed surface

To create a transparent glaze of color on a primed surface, first squeeze some alcohol ink onto a paper towel, then rub it over the medium. This method allows you to really rub the color into the wax, creating a beautiful transparency. (An added bonus is that you aren't left with caked bristles or other tools to clean!) If you have created texture in the wax before adding the ink, the textured areas will pick up the ink more than the smooth areas do, offering a variance of color.

UNDERPAINTING

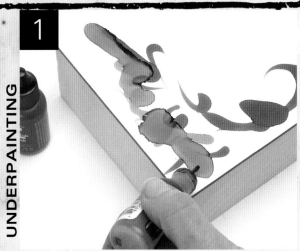

1

WHAT YOU'LL NEED

*Unprimed board * Medium * Heat gun or other fusing tool * Paintbrush * Alcohol ink*

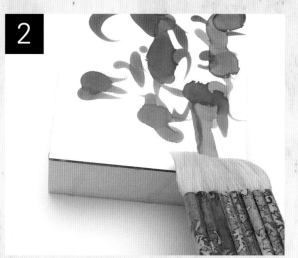

2

Apply ink to unprimed board

Apply ink to an unprimed board in any way you'd like. You can paint it on with a brush or apply it directly from a bottle with an applicator tip.

Heat surface and apply medium

When the ink is dry, heat the board to set the ink and simultaneously prepare the board for priming. Apply a layer of clear or tinted medium to create the desired effect. Fuse to complete the work, or move on to add more layers.

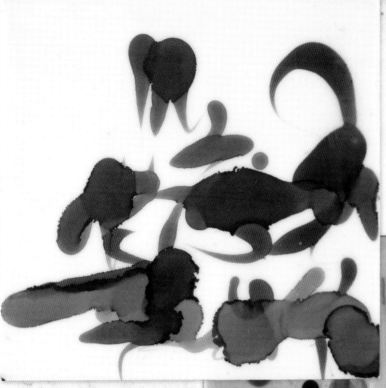

A closer look shows the wonderfully free-form effects created by applying alcohol ink straight from the bottles.

DOTS AND DASHES

This experimental piece resulted from simply playing with the ink on the board. I used a dropper and left each drop of ink thickly applied. Then, to finish the piece, I incised some detail lines into the piece and glazed the surface with a contrasting color of alcohol ink. The addition of a few collage elements balanced the composition.

WATERCOLOR

I am a watercolor junkie! I really enjoy fluid watercolors and try to use them in any application I can.
Here is a great way to incorporate more than one medium into encaustic work with vibrant results.

WHAT YOU'LL NEED

Unprimed board

Medium

Heat gun or other fusing tool

Paintbrush for encaustic

Tubes of watercolor paints

Watercolor paintbrush (optional)

Water

Pool water on unprimed board

Start by pooling some water directly onto an unprimed board.

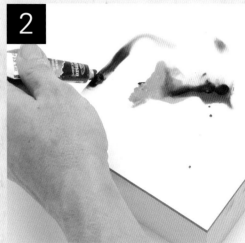

Apply watercolor directly from tube

Squeeze some small dollops of watercolor directly from the tube into the pool of water on the board. Add as many colors as you'd like; I've added 3.

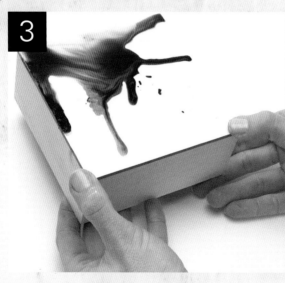

Blend and spread paints

Use a brush to spread the color around and blend it together with the water, as you choose. Or, you can also simply tilt the board to make the colors run and create some different effects, as I'm doing here..

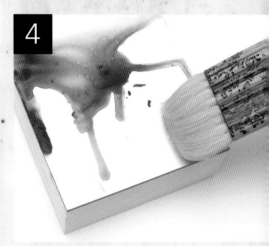

Let dry, apply medium and fuse

When the watercolor is dry, apply a layer of medium over the board and then fuse it. This can be a finished work or an underpainting for more layers of encaustic.

74

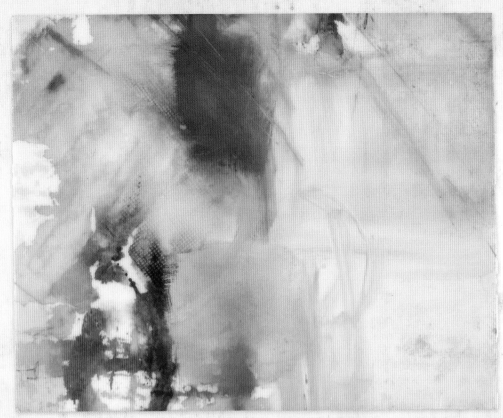

DOAK

In brushing encaustic over a watercolor painting, as I did here, the watercolors become richer and transform into a wonderful foundation for further techniques or a luminous glazed painting in and of itself.

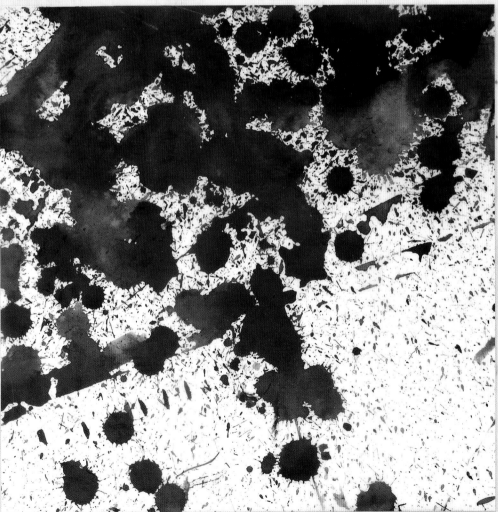

SPLATTERED

By dropping watercolor into puddles of water on the clean, unprimed board, I achieved color in this piece through watercolor abstraction. Then I coated it with medium to heighten the colors and serve as a varnish.

Visit CreateMixedMedia.com/encaustic-painting-techniques for bonus content.

SHELLAC

Shellac may seem like an odd component to add to encaustic. After all, no sealant or finish is necessary in the encaustic medium, and shellac is stinky, caustic and messy. But by using these three variations on the shellac technique (all of which use the materials listed on the opposite page), you can combine the mediums while keeping the organic nature of encaustic.

Of all the methods for adding shellac to encaustic, this one offers the most control in the process.

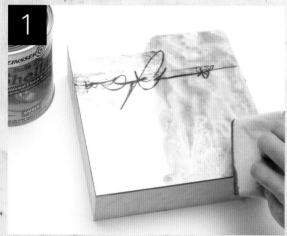

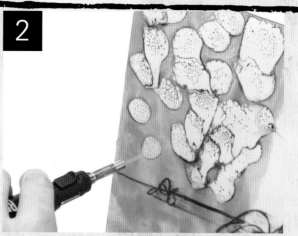

DRY

Dab shellac onto fused surface

Using a paper towel, dab shellac over a desired area or, if you prefer, over the entire primed board. (Here I am working over the piece I began with a charcoal scribble. It has been covered with a layer of medium and fused.) Allow the shellac layer to dry.

Burn holes into shellac

Use a butane torch to burn holes into the shellac layer. Begin by moving the torch directly into the shellac at a gentle rate until it begins to form one of the organic circles shown here. Pull the flame away once the circle is the size you desire. Continue in this way until you've worked the board to the desired effect.

WET

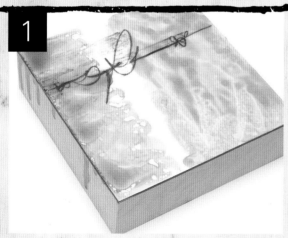

The wet burn of shellac has become one of my all-time favorite techniques—it's spontaneous and unpredictable.

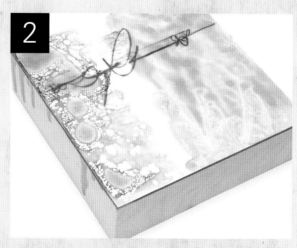

Apply and ignite shellac

Use a paper towel to dab the shellac on the primed board. Immediately light a match or use the torch to ignite the wet shellac.

Let it burn

Let the shellac burn until it burns itself out or, if you prefer, blow it out as soon as you like the effect.

76

WHAT YOU'LL NEED

Primed board ✳ *Medium* ✳ *Paintbrush* ✳ *Shellac* ✳ *Mica powder (optional)* ✳ *Butane torch* ✳ *Matches* ✳ *Paper towel*

1

Apply medium

Apply a layer of medium over the surface. This is especially important if you're starting with a painted board, because it creates a barrier between the pigmented encaustic and the mica; otherwise, the color picks up the mica and dilutes its luminosity.

2

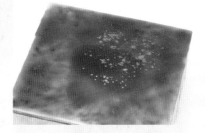

Add shellac and mica powder

Use a paper towel to dab shellac over the surface of the board. Sprinkle mica powder into the wet shellac.

brush up

When working with shellac, be cautious. If you are wary of open flames or potentially toxic fumes, this may not be the technique for you. To limit your contact with toxic substances, use paper towels for shellac application so you don't have to clean a brush with solvent. Just be sure to dispose of the dirty towel properly, as shellac is flammable.

3

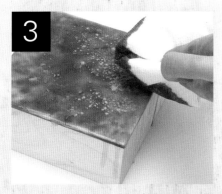

Blend the powder and shellac

Use a paper towel to blend the mica powder into the shellac. (True to its unpredictable nature, sometimes the shellac picks up the mica powder on its own, in which case, you can skip this step.)

4

A CLOSER LOOK

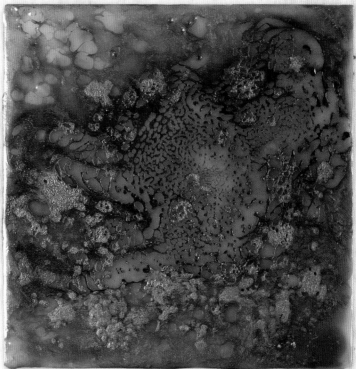

A closer look shows the sparkle mica powder adds to the wet shellac technique.

Burn shellac

Ignite the shellac with a match or the torch flame. Allow the shellac to burn out on its own, or blow it out yourself once you've achieved results you like.

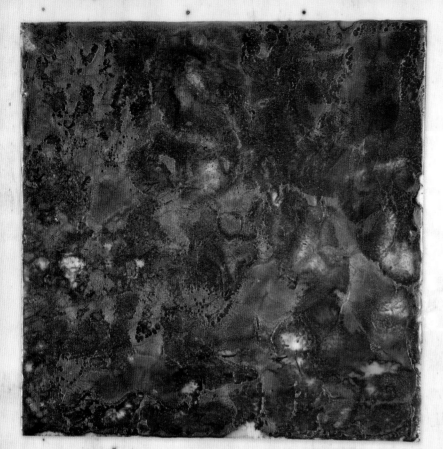

FIRE

A wet shellac burn was used in this aptly titled example. The beautiful, unpredictable nature of the wet burn leads to very organic, loose imagery.

ICE

This second example of the same technique shows that no two wet shellac burns are alike.

SNAIL TRAIL

In this dry shellac burn, more control and predictability are exemplified through this specific spot-burn technique.

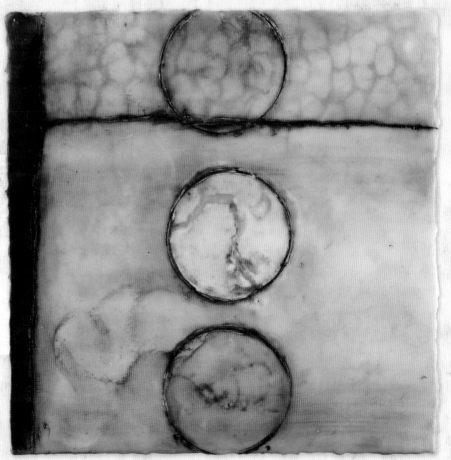

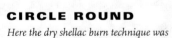

CIRCLE ROUND

Here the dry shellac burn technique was used in combination with incising and oil paint glazing as well as scraping to create a unified piece.

Visit CreateMixedMedia.com/encaustic-painting-techniques for bonus content.

WHITE GLUE AND INSTANT TEA

I love any technique that creates new uses for things you probably already have around the house. You'll be amazed at what you can do with just some glue and instant tea!

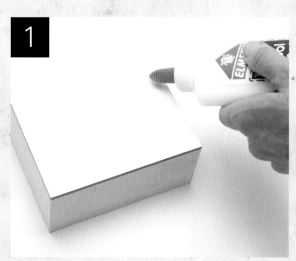

1 Apply glue
On an unprimed board, squeeze out a puddle of white glue.

2 Sprinkle tea into wet glue
While the glue is still wet, sprinkle instant, unsweetened tea into it.

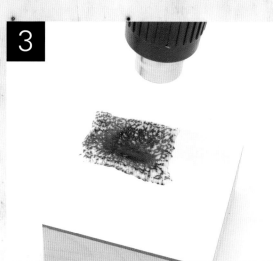

3 Heat to create texture
Heat the concoction with a heat gun until it begins to bubble. Continue heating until you've created the amount of texture you desire. It will begin to dry and burn in interesting patterns that can lend an intriguing start to your encaustic painting.

4 Prime surface
When the glue has dried completely, prime the board with a layer of medium. For an alternate look, I've found that using natural beeswax for priming the surface yields a beautiful finished product.

brush up
Try using wood glue for this technique for a different effect; its yellow tint can achieve a more organic look.

A CLOSER LOOK

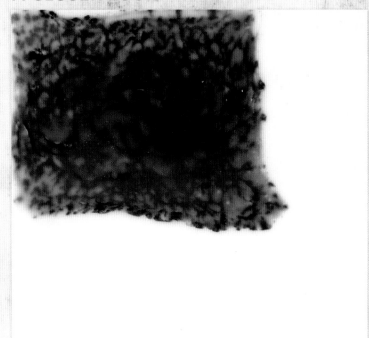

A closer look shows the interesting textures created by tea in the wax.

TEA FOR TWO

In this piece I applied the glue in a deliberate two-part division. I then sprinkled the tea over these two separate areas and burned just the larger area. I like how the two areas differ yet are of the same technique. The letters are stickers I simply positioned on the surface, then covered with medium, letting the edges peek through.

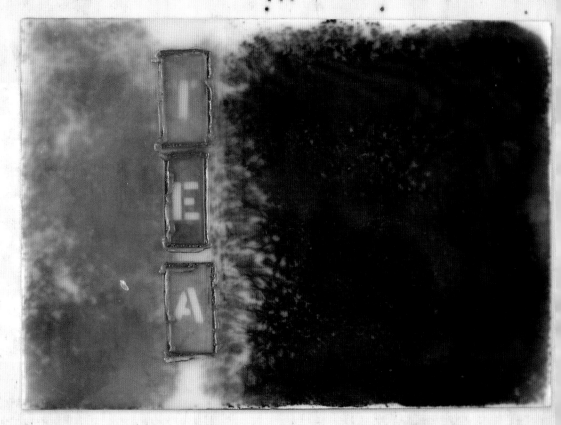

WOOD GLUE

I touched on the use of Elmer's glue in my first book, *Encaustic Workshop*, but I have made wild new discoveries since then. The surface texture and visual interest this product lends to wax painting compares to nothing else I've seen. I went beyond for *Encaustic Mixed Media* by bringing wood glue into play, as well as some serious torch work. These two together play into my love of the amber, just as shellac has done (and continues to do). Burning this glue produces a rich, tawny-to-black glow. Stopping early in the process, burning for an extended period or maintaining the glue-flame connection until the glue has completely dried each results in varying degrees of color. I rarely stop at the first hit of the torch, and I encourage you to do the same. Explore a full burn before settling into your favorite point in the color range. Employing encaustic medium in layers, masking off, scraping back and building texture pull this alternative foundation technique together. The result is a rich, organic, dirty wax painting. Jump in and let's get burning!

WHAT YOU'LL NEED

Unprimed board

Medium or natural beeswax

Paintbrush

Heat gun or other fusing tool

Instant tea, unsweetened

White glue

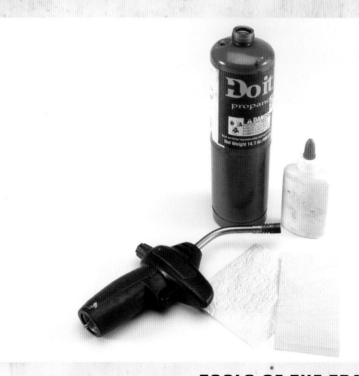

TOOLS OF THE TRADE

Torch, glue, wood—a great combination! Embossed wood paper adds even more visual impact to this heavily burned wood-glue piece.

"Creative minds are rarely tidy."

ANONYMOUS

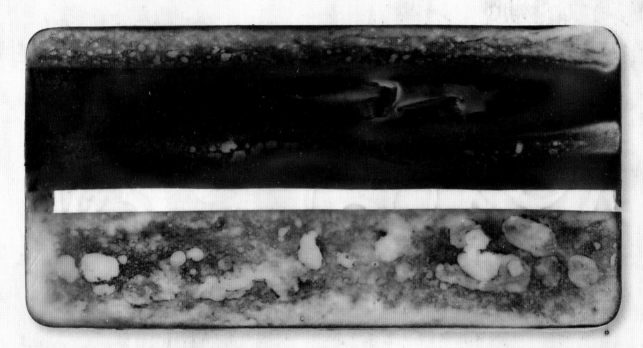

AMBERGLOW

1

Apply tape to panel

Apply masking tape to the wood panel so as to preserve a portion of the natural wood to burn later.

2

Drizzle glue on panel

Apply wood glue to the panel's surface.

3

Smear glue evenly

Smear the glue evenly over the surface.

4

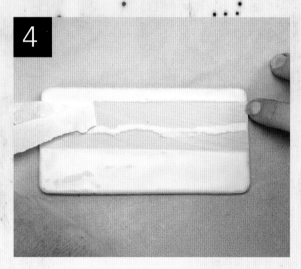

Remove tape

Remove the masking tape. The glue should hold its shape.

5

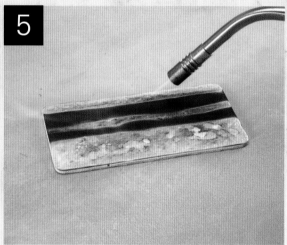

Burn glue and board

Place the wood panel on a fire-retardant surface, and use the torch to burn both the surface of the board and the glue. Allow the wood panel to dry thoroughly before moving onto encaustic.

6

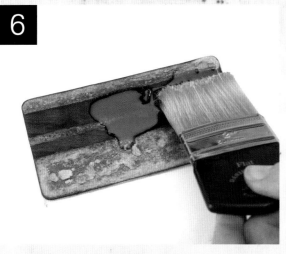

Preserve areas and apply medium

If you have interesting areas of dimension caused by the burn—as I do here—dripping medium over that area rather than brushing it on can help preserve it. Once you have preserved any interesting dimensional areas, apply medium over the entire surface of the panel.

7

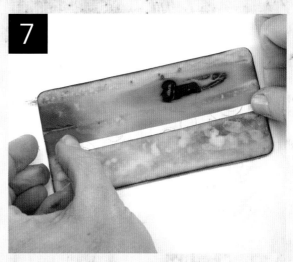

Apply wood paper

Apply a strip of embossed wood paper.

8

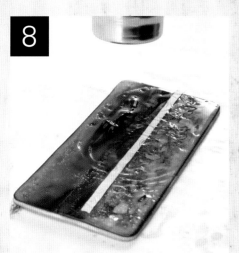

Fuse layers

Run the heat gun over the surface to fuse the layers.

9

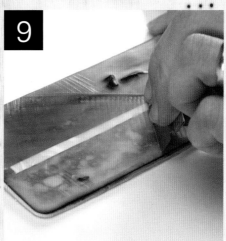

Scrape excess wax

Apply layers of medium until you have achieved the desired effect. Using a razor blade, carefully scrape off any excess wax, particularly around dimensional areas where you may have dripped the wax.

10

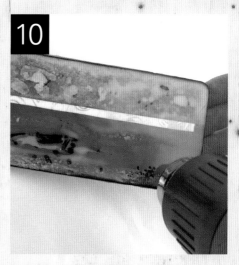

Soften razor marks

You can also melt the wax around the dimensional areas to thin it and soften any razor strokes.

NOTE: Wax will pass through several stages of transparency. While fluid, it will be transparent, then become cloudy when warm, and then return to more transparency when it's dry again. If it's really thickly applied, it will be less transparent simply because of the depth of the wax.

GOUACHE

Gouache and tempera applied over a primed board can offer an interesting, albeit unusual, look in the encaustic. When you heat the initial layers of wax, the gouache breaks up and creates interesting cracks and fissures. These can be put to use as organic, visual texture layers as more medium is applied.

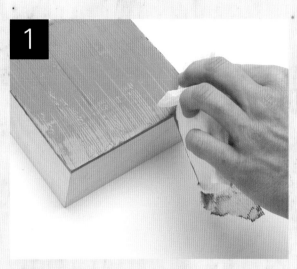

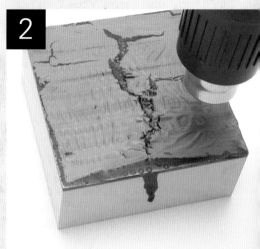

Squeeze gouache onto surface
Apply gouache directly from the tube onto a primed, painted or underpainted board of your choice. Spread it with paper towel or a brush to cover the surface.

Heat surface
Dry the paint on the wax with a heat gun. Continue in this manner until cracks develop. Play with the heat reaction until you are satisfied with the results.



WHAT YOU'LL NEED



Primed, painted or underpainted board

Heat gun or other fusing tool

Gouache

Paper towels

Paintbrush (optional)

A CLOSER LOOK

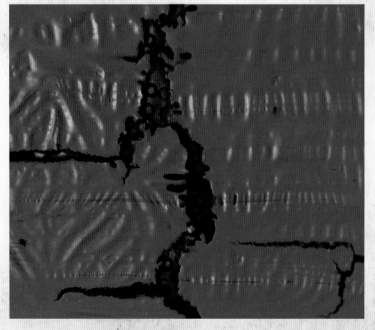

A closer look at the complete effect shows the opacity and texture of the gouache on this stamped background.

Sign up for the free newsletter at CreateMixedMedia.com.

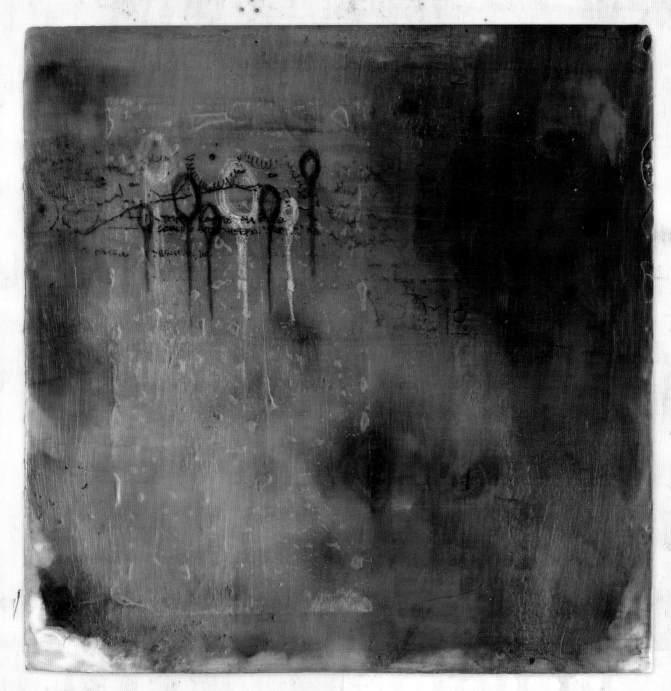

CITY FOLK

*The color in this piece comes from experimenting with a
combination of wax, gouache layering and oil paint. The
transfer of the landscape design adds a focal point, while
figures sketched on Japanese tissue paper lend meaning to
the piece. The loose movement of the colors happened as I
was working over the warm surface and keeping my brush
moving in the warm layers, rather than letting each layer
dry, and therefore suspend, separate from the others.*

Visit CreateMixedMedia.com/encaustic-painting-techniques for bonus content.

BLEACHED PAPER

The effects created by bleach on black paper are gorgeous; there's no other way of putting it. I currently favor circles, as you can see in this example, but any design can be created with the cooler-than-cool bleach pens you can find in the laundry aisle of the grocery store.

WHAT YOU'LL NEED

Unprimed board

Medium

Heat gun or other fusing tool

Paintbrush

Black paper or cardstock

Bleach pen

Clear medium or gel medium (depending on the paper's weight)

Paper towels

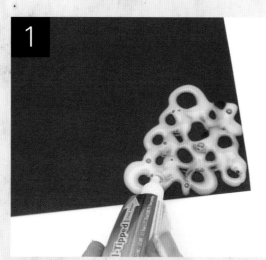

Draw design with bleach pen
On a piece of black paper or cardstock, create a design with a bleach pen.

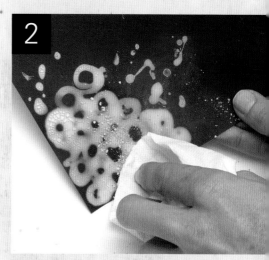

Let it dry and brush off surface
Let the piece dry completely. Then, brush the dried bleach bits off of the surface with a paper towel.

Apply medium
If your paper is thin, like rice paper, adhere it to your board with clear medium. If it's heavier, glue it to your surface with gel medium, let it dry, then apply a layer of medium and fuse.

brush up

The result of this technique is not a lightfast creation, even with the encaustic top layer, so keep in mind that some change in color and intensity will occur over time.

Sign up for the free newsletter at CreateMixedMedia.com.

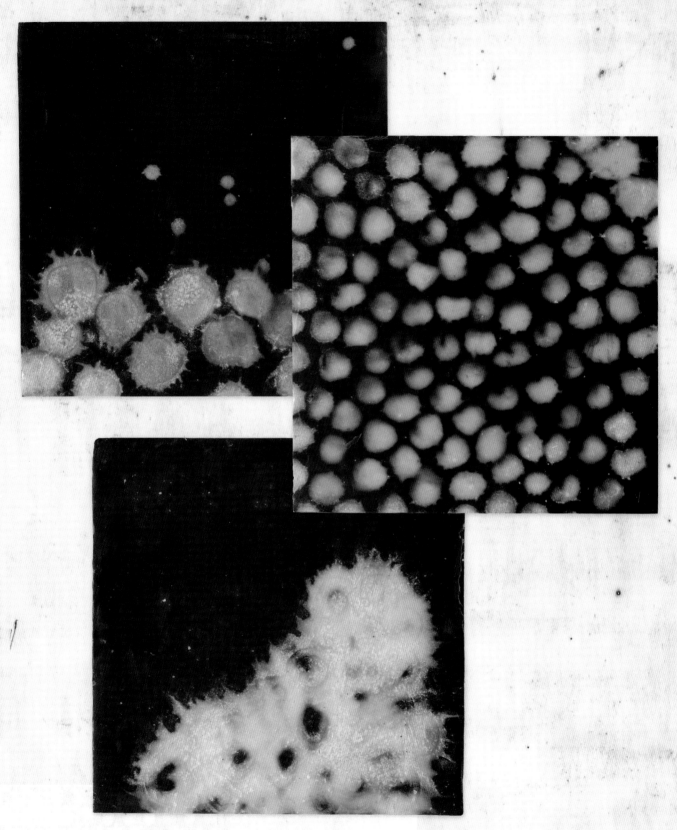

BLEACH TRIPTYCH

I created this triptych, a piece of three separate works intended to be displayed as one, on 5" × 5" (13cm × 13cm) Claybords. The use of the bleach paper technique made them very ethereal and resulted in pieces that can be effectively arranged in any number of combinations for a varied display.

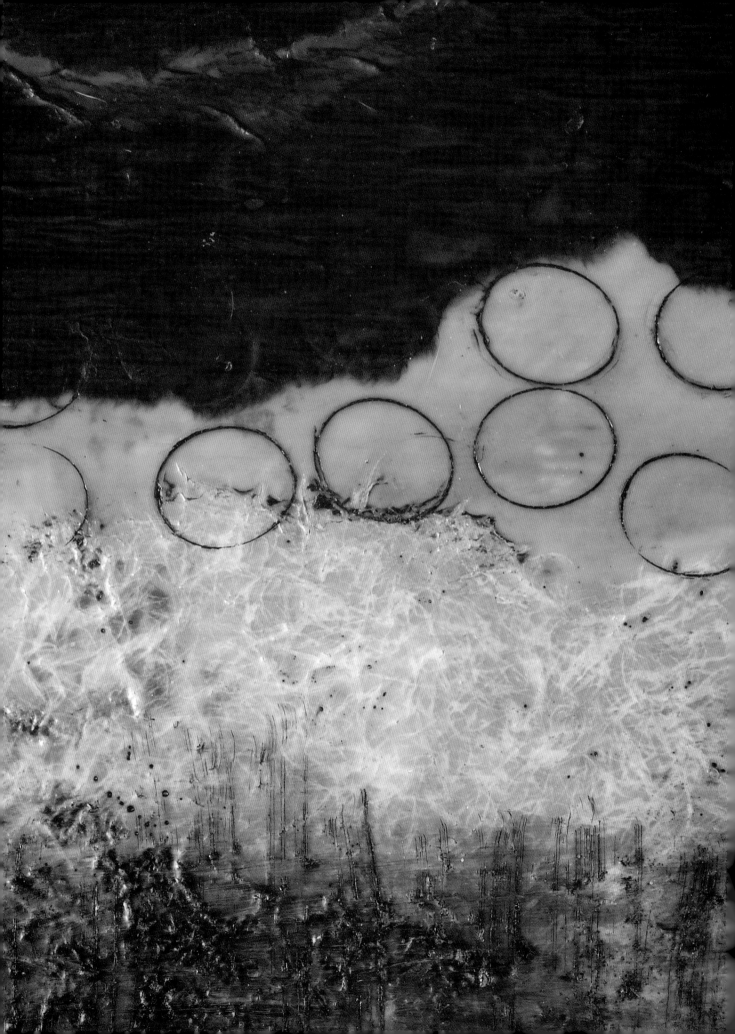

Show
IT OFF

Deep wooden boards like the Claybords shown throughout this book are ideal for simply wiring and hanging without frames. They lend a contemporary look to the painting that enhances the effect of the encaustic medium. I always use Claybords with a 2" (5cm) cradle (meaning the sides are 2" [5cm] deep and the back is hollowed out) for this reason. Not only does it make the Claybord a cost-effective option, it is gorgeous! If you prefer the ¾" (2cm) cradle, you can simply wire and hang it, though the option to frame it in a canvas floater frame is also available.

The first step in readying a Claybord or wood-based piece for hanging is finishing the sides. There are numerous ways you can do this. My favorite is to clean the edges on the palette and let the resulting swirl of absorbed pigment stand on its own. Leaving the edges unfinished works well if you're opting for a raw look, but there are also several ways to achieve a more polished presentation. Try the six options outlined on the following pages and pick the one you like best, or let them inspire other finishing techniques of your own.

"A sincere artist is not one who makes a faithful attempt to put on to canvas what is in front of him, but one who tries to create something which is, in itself, a living thing."

William Dobell

WAX OFF

Before you finish your edges, you will want to remove the dripped wax from the wood. I must admit that cleaning the wax off the edges and simply leaving the exposed wood is my finish of choice. It's easy and clean, and it gives the painting neat, fresh edges. Regardless of your preference, if your painting dripped pigmented wax down the edges of your board, be aware that this technique tends to leave behind any color that was absorbed into the wood. If this bothers you, you'll definitely want to finish your edges with another method after you've removed the wax.

or tape sides first – (wolff)

WHAT YOU'LL NEED

Finished piece ✳ *Hot palette* ✳ *Paper towels*

Warm and remove wax

To remove the wax that has dripped down the side of the box, set it on the hot palette for a moment, then remove it and wipe the edge with a paper towel.

WAX ON

Simply waxing the sides of the box is the easiest way to achieve a finished edge. If you decide to use this method, though, be aware that the wax can be fragile, and if it gets bumped or scratched it will come off and could damage the painting as well.

WHAT YOU'LL NEED

Finished piece ✳ *Wax* ✳ *Paint in the color of your choosing* ✳ *Heat gun or other fusing tool* ✳ *Paintbrush* ✳ *Razor blade (optional)*

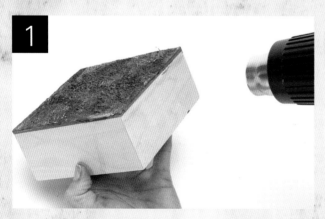

Remove drips and warm sides

Begin by using the Wax Off technique (above). Then heat the sides of your board with a heat gun until they are warm to the touch.

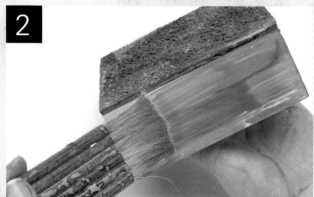

Brush on tinted medium and fuse

Brush on a colored medium. If you apply too much, you can scrape away any excess with a razor blade. Fuse to finish.

PAINT

Painting the sides is simple, as well. Begin by using the Wax Off technique (opposite). Then you can use oil, acrylic, gouache, tempera or even latex house paints to finish your edges in the color of your choice.

WHAT YOU'LL NEED

Finished piece ✳ *Acrylic or other paint in a color of your choosing* ✳ *Paintbrush*

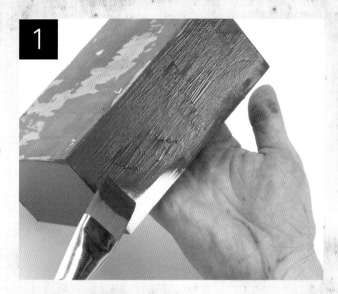

Paint edges

In this example I am using acrylic paint, but the same technique can be used for any type of paint. Since acrylic paints tend to be opaque, they are a great option for hiding any stains or drips on the raw wood. Simply paint a color that complements your finished piece onto the sides with your paintbrush of choice and allow it to dry.

STAIN

Finishing your edges by staining them achieves a transparent look that allows the wood grain to show through. Begin by using the Wax Off technique (opposite). Then you can stain your edges using a color of ink that complements the colors in your finished piece, as shown here, or you can keep it real by opting for a natural wood stain finish.

WHAT YOU'LL NEED

Finished piece ✳ *Ink or stain* ✳ *Paper towels* ✳ *sandpaper or buffing tool (optional)*

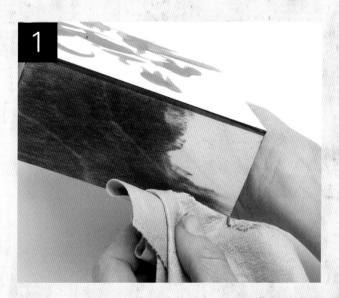

Apply ink or stain to sides

Apply ink or stain to a paper towel or other applicator of choice, then rub it over the box sides to stain the wood. (I'm using alcohol ink here, but any kind will do the job.) If a second coat is needed, sand or buff the surface before giving it a second coat.

SHELLAC

If you've taken on the shellac challenge and given it a try in encaustic, then you have this on hand already. Apply it as you would a stain (see previous page). The main difference will be the shiny finish that results.

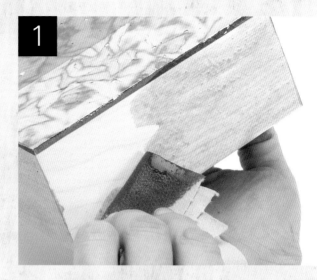

1

WHAT YOU'LL NEED

Finished piece ✳ *Shellac* ✳ *Paper towels*

Use paper towel to apply shellac to clean edges

Be sure to remove all wax drips using the Wax Off technique. Then simply use a paper towel to coat the box sides with shellac.

FLOATER FRAME

Canvas floater frames are perfect for framing shallow-profile Claybord, flat panels and hardware store wood. They come ready-made at some frame shops, and most can create custom-made floaters, too.

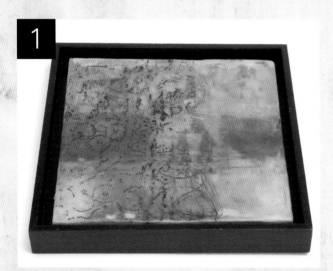

1

Frame finished piece

Here I've chosen to display my piece in a ready-made wooden floater frame. First use L brackets to secure the painting in the frame, then use wire to hang it.

WHAT YOU'LL NEED

Finished piece ✳ *Ready-made wooden floater frame of appropriate size* ✳ *4 L-brackets*

caring for your encaustic work

To care for your encaustic art, simply dust the surface with a feather duster or clean lint-free cloth. Occasional polishing with a clean, soft, untextured cloth will bring out depth and shine. Encaustic paintings should be shipped and stored in a temperature-controlled environment and should always be protected from extreme heat and freezing. Do not hang this or any art in direct sunlight. Any framing of encaustic prints should be done without the use of heat. Do not allow the surface to contact any glass portion of a frame.

Sign up for the free newsletter at CreateMixedMedia.com.

HANGING WIRE

If you are familiar with using wire for hanging framed work, you'll find that wiring a cradled Claybord isn't all that different. In fact, cradled Claybords offer great profiles to hide the wiring within, and they allow each painting to hang flush on the wall.

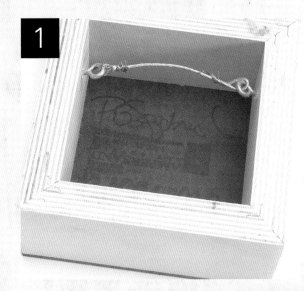

1

WHAT YOU'LL NEED

No

*Finished piece * 2 eye hooks or framing brackets * length of wire, about twice the width of your Claybord *drill (optional)*

Attach wire to insides of inner frame

Add a simple framing wire using eye hooks or framing brackets attached to the inside of the sides of the Claybord. If you're using eye hooks, pre-drill holes a quarter of the way from the top edge of your painting for best results.

GOT IT ALL
For this painting I combined the techniques of image transfer, incising and scraping, and enclosed the finished piece in a floater frame for display.

Get It
TOGETHER

Now that you've mastered a varied set of individual techniques, you're ready to start experimenting with combining them in different ways. The possibilities for creating a fluid, multi-technique encaustic painting are limitless.

This chapter demonstrates your opportunities with a selection of step-by-step projects to get you started. Not only will you learn how to create more advanced pieces, you'll also learn how to combine the finished works to create a larger, more comprehensive unit with two multipiece projects: a diptych and a triptych. Finally, you'll find an inspiration gallery to further enliven your senses and inspire you to imaginative creativity in your own encaustic work. The rest is up to you!

> "The artist never entirely knows. We guess. We may be wrong, but we take leap after leap in the dark."
>
> **Agnes de Mille**

SMALL SCALE

This is a quick, fun project for incorporating another piece of artwork into an encaustic work. I used a portion of a watercolor painting as an underpainting to create depth of color under layers of medium. I then embellished the surface with a combination of techniques. You can try this approach to enhance any other types of works you've done; small collages, oil paintings and even colorful pastel drawings can become wonderful underpaintings.

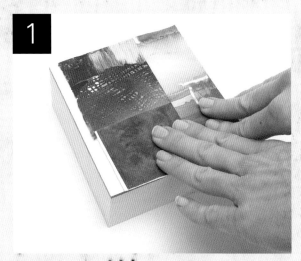

1

Adhere underpainting
Choose an original watercolor or mixed-media work you'd like to use as a base/background for an encaustic painting. Begin by adhering the paper to the board using gel medium.

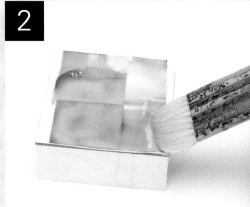

2

Layer medium
After the gel medium has dried completely, warm the board and begin applying wax medium, fusing between each layer. Continue until you've created an effect you like. I applied four layers of medium to add some depth.

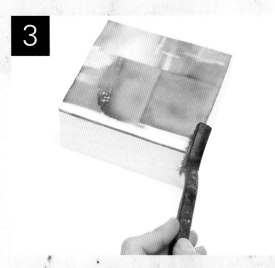

3

Add texture
Once the medium has cooled, add texture to the outer edges of the surface with a wire brush.

98

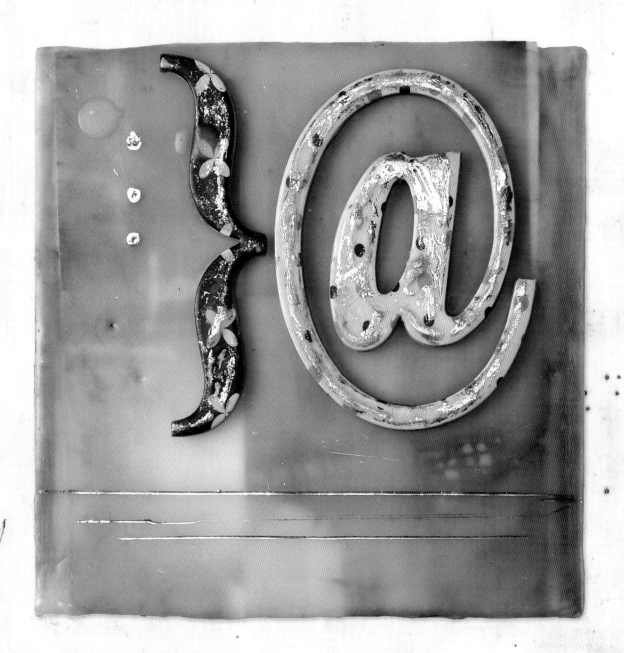

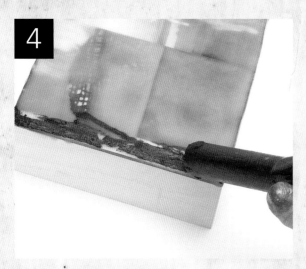

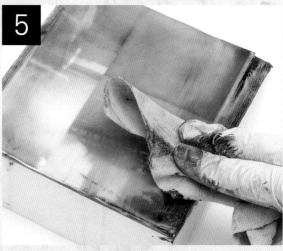

Add oil paint to incised areas
Rub an oil paint stick (or regular oil paint) into the areas where you added texture with the wire brush.

Rub and remove excess paint
Wearing rubber gloves to protect your hands, work the paint thoroughly into all the grooves. Remove the excess paint with paper towel.

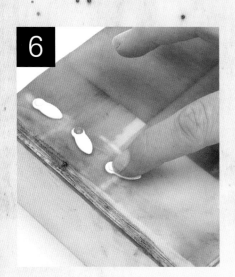

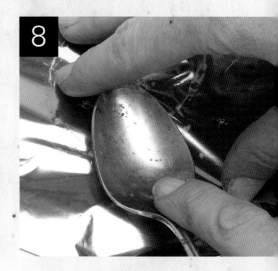

Add embellishments
Press the embellishments or additional elements of your choice into the wax. It is best to imbed items into warm wax, so if necessary, reheat the surface until it is warm. Re-fuse the surface.

Add wax to chipboard
Apply wax over the top of a few chip-board embellishments that you'd like to coat with foil and add to your piece in the following steps.

Burnish gold leaf
Use the back of a spoon to burnish a sheet of metallic leaf over the waxed chipboard embellishments.

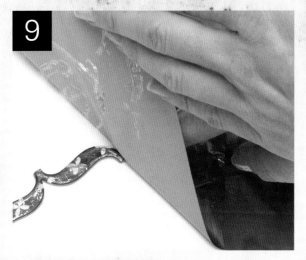

Complete leaf transfer

Peel the leaf off to reveal the transfer and see if you wish to burnish any uncovered areas. Don't worry about covering the chipboard completely; it's OK if some of the original pattern on each piece shows through.

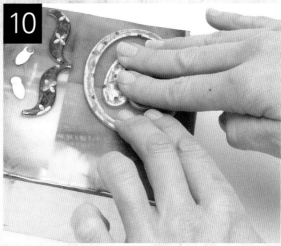

Adhere embellishments

If your chipboard pieces are self-adhesive, peel off the backing and stick them to the board. If they aren't self-adhesive, use a small amount of wax to adhere them.

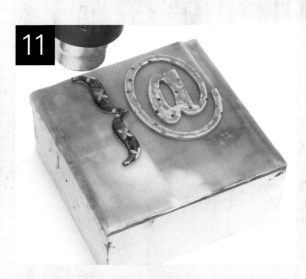

Make adjustments and re-fuse

If you decide there is an element in your piece that isn't working, pop it off and simply re-fuse to erase the indentations in the wax. Here I decided I didn't like the buttons, so I removed them.

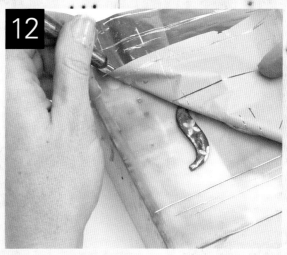

Add finishing touches

Add any final touches. I used a ball stylus to impress dots of metallic leaf into the wax and to add some line work along the bottom for visual interest.

Visit CreateMixedMedia.com/encaustic-painting-techniques for bonus content.

SINGULAR

Using an 8" × 8" × 2" (20cm × 20cm × 5cm) Claybord, I created this piece by combining some of my favorite techniques: sketching on Japanese silk tissue, oil glazing, incising, texturing and coffee ground inclusion. I love how the end result shows off the unique properties of the wax.

WHAT YOU'LL NEED

8" × 8" × 2" (20cm × 20cm × 5cm) Claybord

Medium

Heat gun or other fusing tool

Paintbrush

Japanese silk tissue

Oil paint or oil paint stick

Fine art marker

Coffee grounds

Incising tools

Metal spoon

Paper towels

Razor blade

Rubber gloves

Linseed oil (optional)

Create sketch
Create a small doodle or drawing on a square of Japanese silk tissue paper. I am using a permanent marker, but you can use any art medium you choose.

Add medium, fuse and incise
Brush one layer of medium over the surface to prime it, and fuse it. Let it cool. Set the drawing on a cool, primed board to establish its placement. Then add incising lines around the edges by tracing around the bowl of a spoon.

Add oil paint
Remove the tissue paper drawing from the board. Squeeze out a small amount of oil paint and, wearing gloves, work it into the incised areas.

Sign up for the free newsletter at CreateMixedMedia.com.

Troubleshoot any oil stains

Rub off excess oil. If oil remains on the wax, use a bit of linseed oil to take it off, all the way back to just the incised lines. (Make certain you remove all the oil afterward, or it will cause the next layer of wax to resist adhesion.)

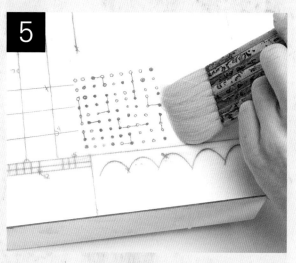

Adhere drawing

Use clear medium to adhere the tissue drawing in the position you determined in step 2.

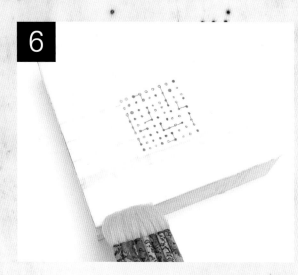

Layer medium and fuse

Brush one layer over the tissue and re-fuse. Then build up several layers of medium on the board, working around the tissue to frame it in with a thicker surrounding area of medium. Re-fuse between the layers.

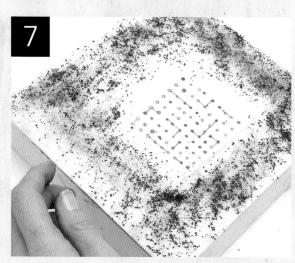

Add coffee grounds to frame area

Once you've created the depth of "frame" you desire, sprinkle coffee grounds onto the still warm wax.

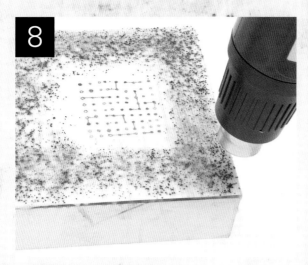

Carefully fuse coffee grounds

Fuse the grounds to set them into the wax. Use a gentle airflow to control the wax melt and to keep the grounds from blowing away.

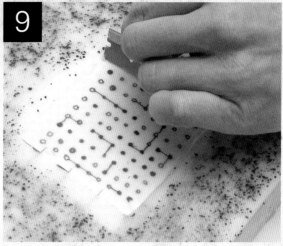

Incise to define frame

Once the wax has cooled, give the frame area more definition by running a razor blade along the edges.

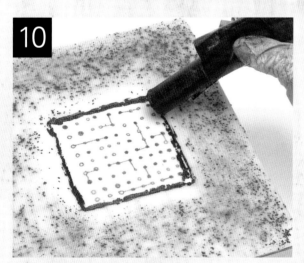

Add oil paint to incised area

Lightly rub on a small amount of oil stick, just around the perimeter of the defined frame line.

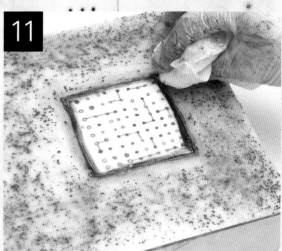

Remove excess and re-fuse

With a paper towel, gently remove the excess paint. Re-fuse to complete.

DIPTYCH

A diptych is a painting that combines two separate works to suggest the look of one. The individual pieces are either literally connected, as with this project, or designed to be displayed side by side. The beauty of using these Claybords is that Ampersand takes custom orders, making it possible for you to use an endless variety of sizes and combinations. For this diptych, I'm using 8" × 8" (20cm × 20cm) and 8" ×10" (20cm × 25cm) Claybords. The piece comes together playfully and uniquely to show off the versatility of the format.

WHAT YOU'LL NEED

8" × 10" (20cm × 25cm) Claybord

8" × 8" (20cm × 20cm) Claybord

Medium

Heat gun or other fusing tool

Paintbrush

Patterned paper

King's Blue wax paint (R&F)

Mica powder

Black oil paint stick

Paper coffee cup

Silver star-shaped stickers or other embellishments

Tea bag, unused and dry

White wax paint

Gel medium

Wood glue

Matches or butane torch

Paper towels

Razor blade

Rubber gloves

Scissors or craft knife

Shellac

Stylus

White transfer paper

Fine-grit sandpaper (optional)

1

Adhere paper to first board

Use gel medium to adhere a piece of patterned paper to a clean 8" × 10" (20cm × 25cm) board. Smooth the paper down, being careful not to get any gel medium on top of the paper. Let it dry. Then trim off the excess paper using a razor blade.

2

Sand paper, if desired, then apply medium

If your paper has a gloss to it that may resist wax, eliminate it with a quick sanding with a fine-grit sandpaper. Apply a coat or two of wax medium, using a textured application. Fuse between each layer.

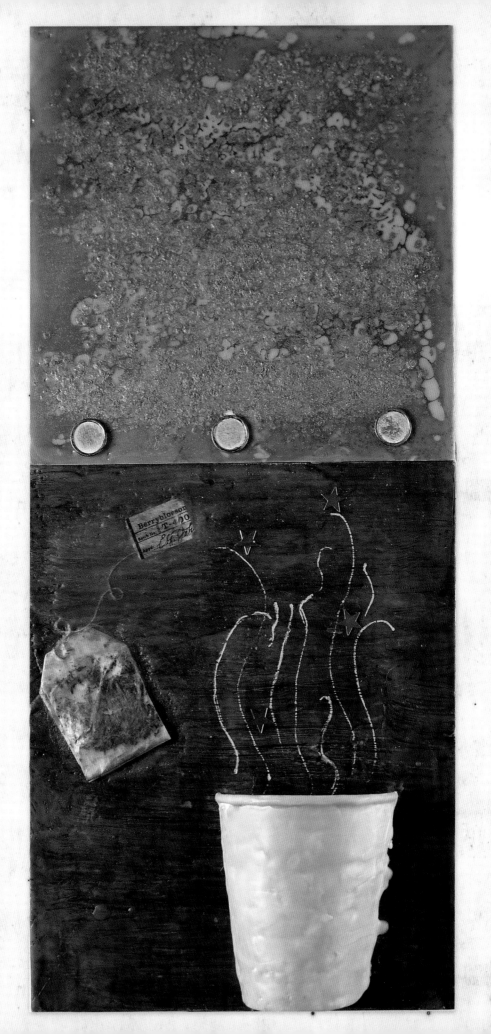

Add black oil paint

Wearing rubber gloves to protect your hands, rub a black oil paint stick over the surface of the papered, primed board. Where you applied the medium texturally with visible brushstrokes, the oil paint will create an interesting, similarly textured appearance.

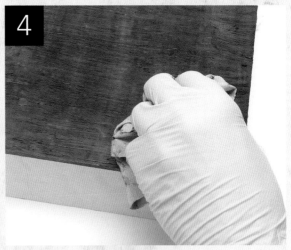

Remove excess oil paint

Use a paper towel to remove excess oil paint.

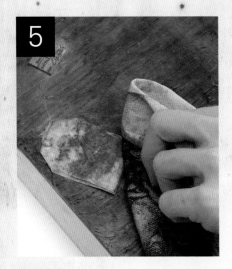

Add and paint tea bag

Use a puddle of clear medium to adhere a tea bag to the surface. Using the same paper towel you used to remove the black paint, rub just a bit over the bag and the tag to incorporate them into the background, then rub off the excess.

Coat cup with colored wax

Use scissors or a craft knife to cut the coffee cup in half vertically. If it isn't already plain white, coat one half of it with white encaustic paint first to prime it. Then paint it with wax tinted with Kings Blue. Let it dry.

Add cup to composition

Set this cup onto the board, add a bit of clear medium to adhere it securely to the surface and fuse it.

Sign up for the free newsletter at CreateMixedMedia.com.

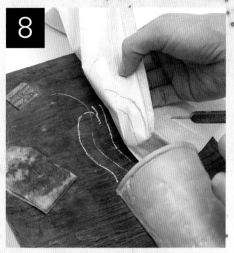

Create steam lines

Positioning the white transfer paper over the cup, use a stylus to draw decorative lines of steam.

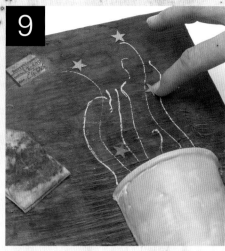

Add star embellishments

Push a few silver stars or other embellishments into the wax surface to add interest.

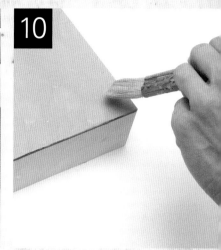

Begin second board

Prime the 8" × 8" (20cm × 20cm) board. Apply a layer or two of King's Blue encaustic paint.

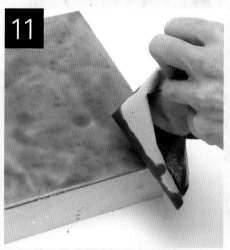

Apply shellac

Over the surface of the blue board, dab on a coat of shellac.

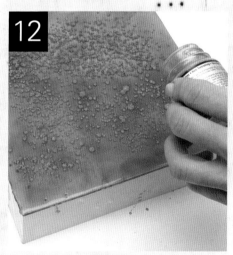

Add mica powder

Sprinkle silver mica powder into the wet shellac. Light the shellac on fire with a match or butane torch. Allow the shellac to burn until it goes out on its own. Add any additional elements you'd like to the surface to complete this piece. (I added just a few paper buttons to enhance the composition.)

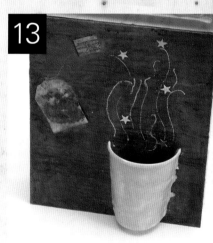

Assemble and adhere pieces

Apply wood glue to the first side, then stack the second on top of it. Finish the edges any way you'd like, or not at all.

Visit CreateMixedMedia.com/encaustic-painting-techniques for bonus content.

TRIPTYCH

A triptych employs the same principle as the diptych, only it's made of three panels instead of two. Here I am combining different techniques in interesting ways—using embedded objects, oil bar glazing, image transfer, rub-ons and collage—to pull three 5" × 5" (13cm × 13cm) Claybords together as a unified piece.

WHAT YOU'LL NEED

5" × 5" (13cm × 13cm) primed Claybords, 3 medium

Heat gun or other fusing tool

Paintbrush

Buttons or other embellishments

Patterned paper

Oil paints

Oil paint sticks

Rub-ons

Texture-making tools (a straight pin and a perforation tool are used here)

Toner or laser photocopies of numbers and/or any other imagery

Gel medium

Rubber gloves

Paper towels

Razor blade

Sandpaper

Scissors

Spoon or burnishing tool

Water

Wood glue

Imbed elements in first board

Start with a primed board and lay your elements, such as the buttons I am using here, into the warm surface. When the elements are arranged to your liking, drizzle clear medium over them. Fuse. If you want to achieve a smooth finish around the elements, you'll want to overfuse. Here I applied several layers of medium, fusing between each, in order to level the wax with the elements. Let it cure. (While you are waiting, feel free to skip to step 3 and return to step 2 later.)

Add image transfer

Once your piece has cured, enhance the depth of the piece by adding an image to the surface layer of wax. Here I placed a photocopied image of a compass rose and transferred it into the wax.

the open road smooth sailing port all you can eat
sun soaked relax **ADVENTURE** carefree cabin **TOURIS**
motion sickness camping hiking tent trail ahead
so who brought the matches? **SOLITUDE**
campfire roasting marshmallows **IN THE WILD** fishing
birds squirrels fresh air hunting
outdoor adventure bait lake mountain stream
adventure escape **LIVING OFF THE LAND** starry night
backpack the great outdoors surfing crashing waves
picnic sun, sand and surf beach hang ten **FUN**
IN THE SUN buried in umbrella
flip-flops swimming suits sunburn beach
YOUR PROPERTY water bar y
seash trip
cabin holiday it of
re treat
stunning spectacular sunset
sunrise relax retreat restore **TAKE IT EASY**

4
321

Adhere paper to second board

Adhere patterned paper to what will be the second board of your triptych with gel medium. Smooth the paper to remove any bubbles, but be careful not to let any gel medium ooze onto the top of the paper or it will act as a resist. Let it dry completely. (You can also adhere it with wax instead, if you wish.)

Trim paper flush with board

Trim the excess paper from the edges of the board with a razor blade.

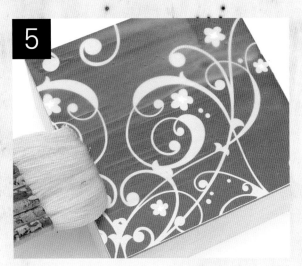

Prime and fuse surface

Paint a layer of encaustic medium over the paper. Treat this first layer as the priming layer, and fuse it smooth to ensure additional layers will have a level base.

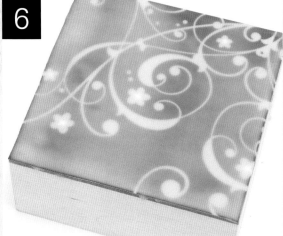

Layer medium thickly

Continue adding medium layers to the papered board, fusing between layers.

Continue until desired effect is reached

Work in this manner until the look of the paper is diffused by the thick medium. Five layers created the muted dimensional effect shown here. Let it cure. (Feel free to skip to step 15 while you wait, returning to steps 8–14 later.)

Create embellishment for second board

Print an image from your computer that you would like to feature on your piece. If it's a number or a letter, like I chose here, be sure to print it in reverse so that when it is transferred the image will be accurate. Cut it out with scissors.

Begin image transfer

Heat the surface of the board, then set the photocopy facedown into the wax. Burnish it with a spoon, being sure to rub every bit of the image. Pour a small amount of water onto the paper. Let it absorb.

Complete transfer

Burnish the back of the wet copy with the spoon once again. Once the paper begins to pulp, use your fingers to rub away the paper and reveal the transfer.

Visit CreateMixedMedia.com/encaustic-painting-techniques for bonus content.

Fuse, add medium and transfer second image

Re-fuse the transfer layer. Apply one coat of clear medium over the transfer, then repeat steps 8–10 with a second image to make a second transfer over that layer. Repeat this to add as many layers of transfers as you'd like.

Incise surface

Incise a design into the top layer using a metal tool with a fine tip. (Here I'm using a straight pin to create a series of small circles and a line.)

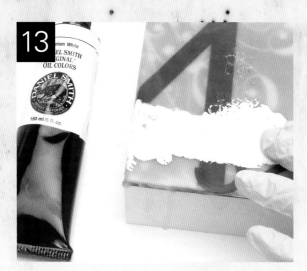

Apply oil paint to incised area

Wearing rubber gloves to protect your hands, apply oil paint in the color of your choice over the area you incised in the previous step. Here I'm using Titanium White.

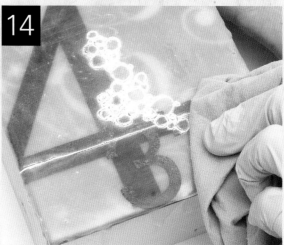

Work paint into marks and remove excess

Work the paint thoroughly into the incising. Remove the excess with a paper towel.

Begin third board

Begin the third board by repeating steps 3–5 using a different patterned paper. You can go on to repeat steps 6–7 to tone down the look of the paper, or leave the medium at just one layer, as I did here. Let the surface cure. Then burnish a rub-on transfer of your choice over the surface.

Add texture

Add some texture lines with a perforation tool or another tool of your choice. Or, if you prefer, you can incise the surface free-hand as in step 12.

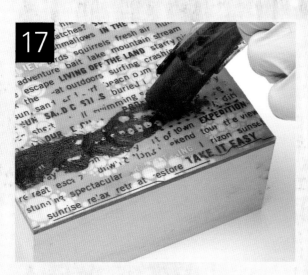

Add oil paint to impressions in medium

Rub an oil stick over the incised area, or apply oil paint straight from the tube if you prefer.

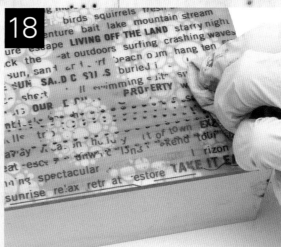

Work paint into marks and remove excess

Work the paint thoroughly into the incised area. Then rub the excess paint off with a paper towel.

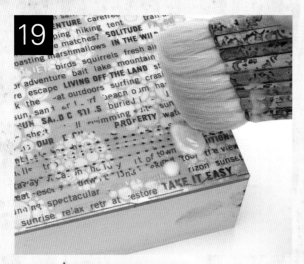

Prepare to add final embellishment

Decide where you'd like to add an object to the composition of this board, and apply a puddle of wax to that area. Here I've decided to add a large button in the lower right-hand corner.

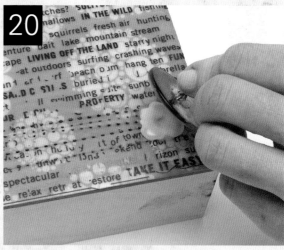

Adhere embellishment and fuse

Gently press the button in the warm puddle of wax so it will adhere completely. Fuse it gently and allow the surface to cool completely.

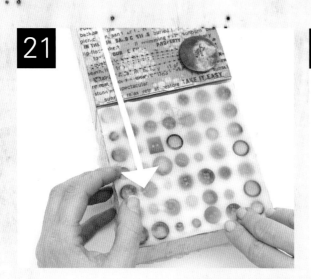

Align boards and overlap embellishment

Align the first and second boards for the triptych. Use a rub-on embellishment, such as this arrow, to overlap both boards and tie the composition together. Burnish it into place on both boards.

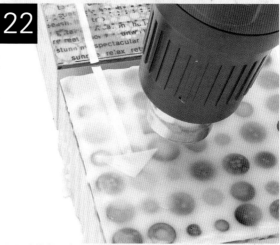

Cut embellishment, add medium and fuse

Using a razor blade, cut the arrow at the joint of the two boards. Brush clear medium over both boards, and fuse them.

Remove wax from sides

On the edges of all three boards where they will meet, clean the sides by heating them on the warm palette and wiping clean with a paper towel. Then sand the sides to remove any remaining wax residue and ensure good adhesion when the triptych is assembled.

Assemble and adhere triptych

Apply wood glue to the first side, then stack the second on top of it. Repeat for the third and set the whole triptych aside to dry. Finish the edges any way you'd like (see the Show It Off chapter), or not at all.

brush up

When combining techniques, don't set too many rules for yourself to follow. The more layers of wax you apply, the less the initial layering or techniques will become evident—so if you don't like the look of something, you can simply cover it with additional layers.

ACRYLIC PAINT

I ordinarily do not support falling into temptation. But when it comes in the form of art, creativity and artistic creation, I embrace it fully in the anti-law of no- no's! Acrylic and encaustic are not thought to play well together; the two just don't have enough in common to stay together for any length of time. Although many artists have worked their way around this mismatched duo and found a way to keep them together, I've never wandered into that camp. Yet I did try it recently, and I discovered such wonderful success that I have to spread the word. How does one go from "never go there" to "look what I did!"? Well, what happens when you need that "just right" color but can't find it among your stash? You search every wax tin, go through your travel stash and even check the palette's drip pans to no avail. I had this problem and, in a frustrated huff, glanced toward my GOLDEN Fluid Acrylics stacks. The bold and beautiful Quinacridone Magenta nearly leapt off the shelf and onto my painting! It glowed red hot with a "Choose me!" siren song. I couldn't resist and reasoned that I could always remove it if it was a disastrous marriage. So I went at it with a determined vengeance, and guess what? I've not turned back. I found myself venturing into other paintings, other surfaces and other applications for acrylic in my encaustic. I'm hooked! I hope to cast my convincing line your way and hook you as well.



WHAT YOU'LL NEED

Encausticbord

Acrylic paints

Rubber stamps

Masking tape

Encaustic medium

Paintbrush

Heat gun

Stencils

PanPastels

Sponge applicator for pastels



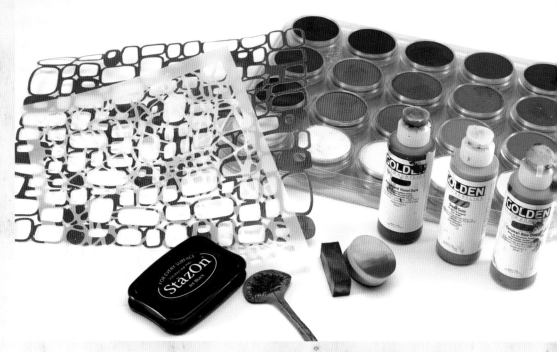

TOOLS OF THE TRADE

PanPastels, Golden Fluid Acrylics, Mary Beth Shaw stencils to die for, StazOn ink and Stamping Bella stamps. All used to create the fun in acrylic and encaustic!

118

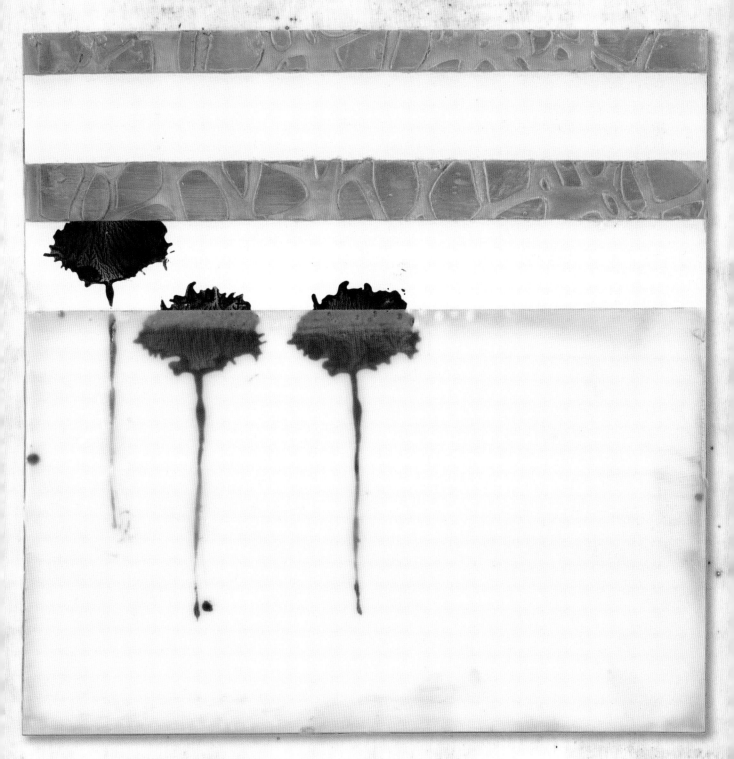

RACHEL'S GARDEN

1

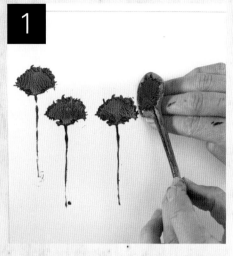

Stamp acrylic on board

Apply acrylic paint to the rubber stamp and apply the stamp to the Encausticbord. Set aside to dry completely.

2

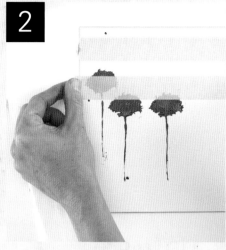

Apply masking tape

Apply masking tape to the board. Here I've chosen to apply two strips of tape across the top third of the piece.

3

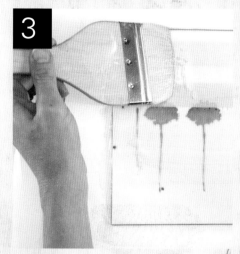

Warm board and apply medium

Warm the board with the heat gun and apply a layer of medium. Fuse this layer; allow to cool. You will repeat this step as you add multiple layers of wax.

4

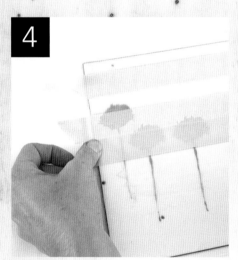

Add tape to selected areas

Apply a third strip of masking tape. I'm masking off different areas to produce different depths of wax, which will become obvious once the piece is painted and the masking is removed.

5

Press stencil down

Press the stencil into the still-warm wax.

6

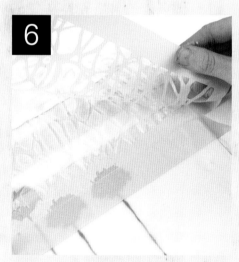

Apply layers of wax and remove stencil

Apply several layers of wax over the stencil to build the dimension of wax around the design. While the wax is still warm, remove the stencil.

7
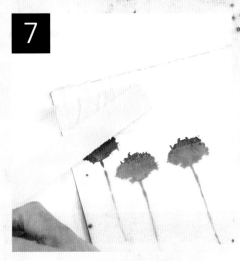

Remove masking tape
Continue to reveal the waxen dimension by removing the masking tape while the wax is still warm. This will ensure crisp, sharp lines. Set aside to cool.

8
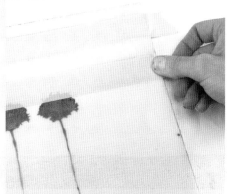

Apply fresh tape
Apply new tape strips, adhering them to the same areas as in step 2.

9
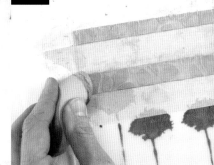

Sponge pastels onto stenciled area
Using the applicator sponge, apply the PanPastel to the surface of the piece, across the stenciled area. Here I've chosen to apply it to the raised top third of the piece only.

10
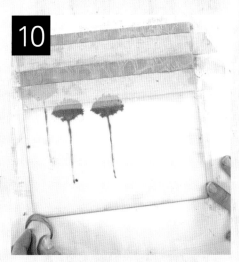

Apply pastels around edges of board
Continue applying the PanPastel along the edges to "blush" the frame around the piece.

11
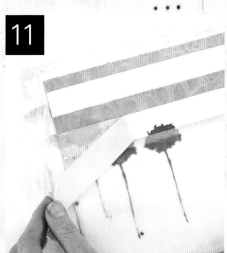

Remove tape
Remove the masking tape.

12
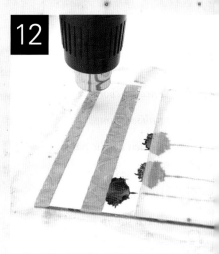

Fuse medium and cool
Fuse the pastel to the wax with the heat gun, and allow the piece to cool completely.

ACRYLIC ON WAX

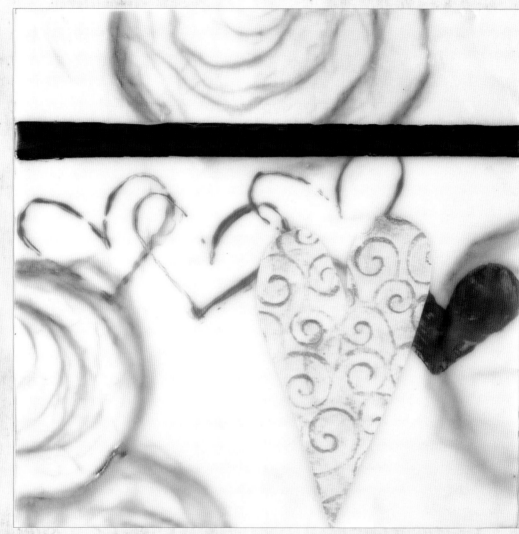

WHAT YOU'LL NEED

Decorative paper

Encausticbord

Rubber stamps

Golden acrylic paints

Embossed paper cut-out

Inked stamps

Paintbrush

Masking tape

Brilliance fast-drying pigment ink

"The only way to resist temptation is to yield to it."
OSCAR WILDE

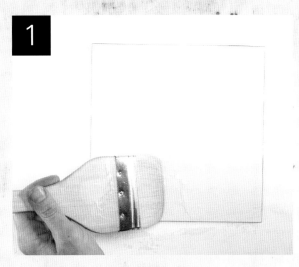

Heat board and apply medium

Heat the encausticbord with a heat gun, then apply the medium.

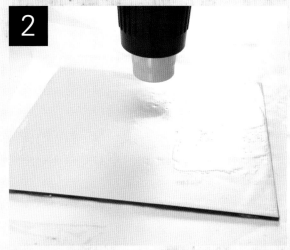

Fuse medium

Fuse the medium to the board with the gun.

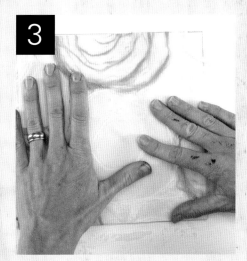

Apply decorative paper

Press the decorative paper into place.

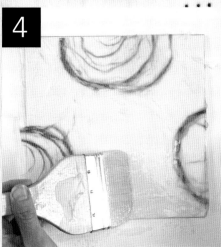

Apply medium

Apply a layer of medium.

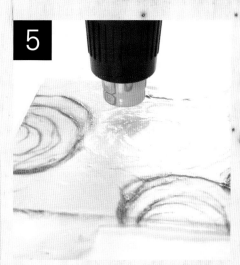

Fuse medium and cool

Fuse the layers of medium. Set aside to cool.

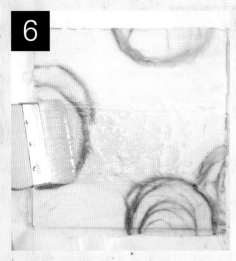

Add several layers of medium

Apply several more layers of wax.

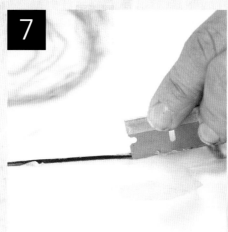

Remove excess wax

Run a razor blade along the edges of the board to remove excess wax and paper.

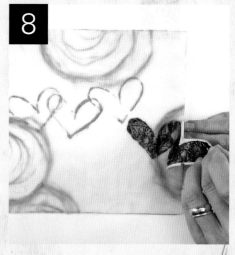

Stamp on acrylic paint

Apply acrylic paint to the rubber stamp. Stamp the designs onto the surface of the board.

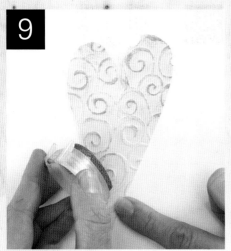

Stamp ink on paper cut-out

Apply the inked stamp over the embossed paper cut-out.

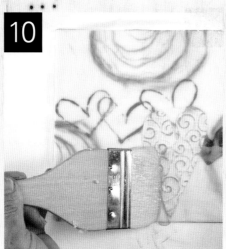

Apply cut-out to board using wax

Place the cut-out on the surface of the board and apply medium over the entire surface.

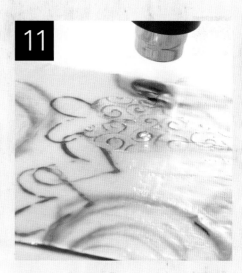

Fuse layers

Fuse the wax layers with the heat gun.

124

12

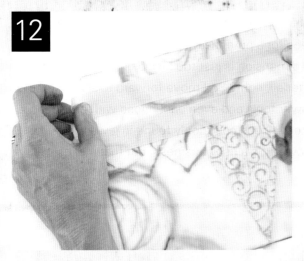

Apply masking tape in sections
Use two strips of masking tape to section off an area on the board.

13

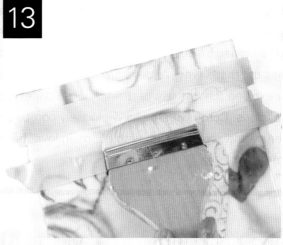

Apply medium between tape
Apply medium to the area of the board that has been sectioned off by the tape.

14

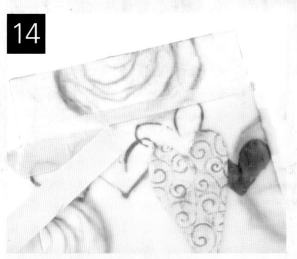

Remove tape while warm
To achieve sharp, clean edges, remove the tape while the wax is still warm.

15

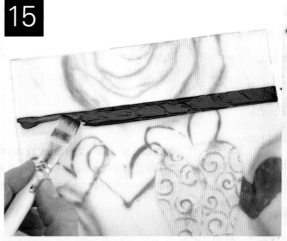

Brush acrylic paint on exposed area
Using the paintbrush, apply acrylic paint to the exposed areas. Set aside to dry completely.

FLOCKING

Drilling into a beautifully composed encaustic painting may seem like risky business; why would you want to risk losing the beauty of a completed piece for a potentially interesting, yet not assured, added dimension? Because the reward of this added dimension is just too luscious and desirable to pass up, that's why! And we are experimenting after all, right? So I move forward to share some extra-exciting fun: the use of resin, flocked paper, power tools and even panty hose with encaustic. So delicious. Come with me as we loosely combine techniques commonly found in jewelry design, carpentry and scrapbooking with our main love, beeswax. It's a risky business, but that makes it all the more fun!

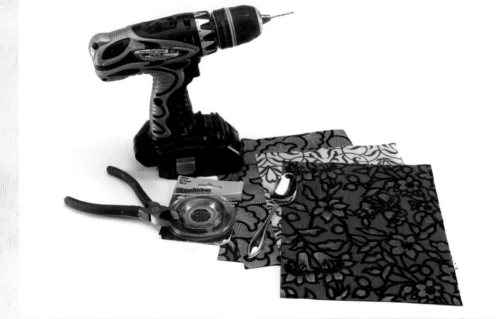

TOOLS OF THE TRADE

The "fluff" of flocked paper is used alongside power tool drilling and wiring to give this painting a feminine as well as masculine interpretation.

WHAT YOU'LL NEED

Wood panel

Heat gun

Encaustic medium

Paintbrush

Flocked paper

Burnisher (spoon or craft stick)

Drill

Wire

Wire cutters

Resin embellishment

Panty hose and glue embellishment

"The greatest mistake you can make in life is to be continually fearing you will make one."

ELBERT HUBBARD

126

LEATHER AND LACE

1

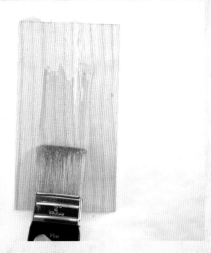

Warm panel and apply medium
Use a heat gun to warm the wood panel and then apply medium.

2

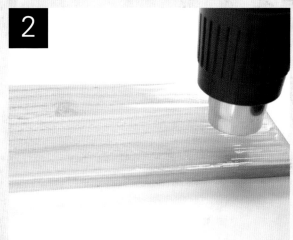

Fuse medium
Fuse the medium to the board using the heat gun.

3

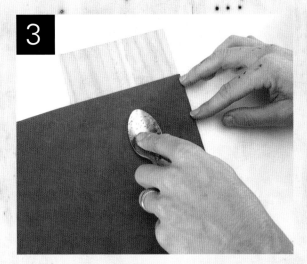

Burnish flocking on wax
Place slightly warm flocked paper facedown over the bottom portion of the waxed board. Rub the back of the paper with the burnisher.

4

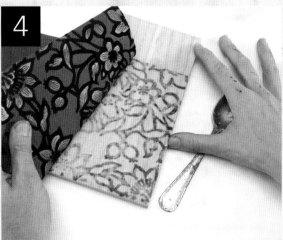

Remove flocked paper
Peel away the paper; the flocking will have transferred from the paper to the wax.

5

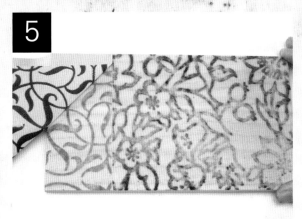

Apply more flocking and repeat

Apply a second piece of flocked paper to the top section of the waxed board and repeat steps 3 and 4.

6

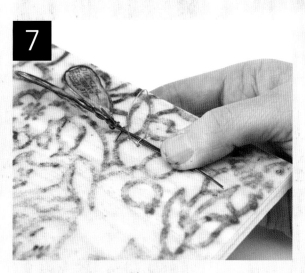

Drill holes for embellishment

Drill two holes in the board where you will be placing your resin embellishments. (You can leave them on the board for reference.)

7

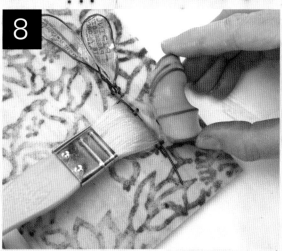

Secure embellishment with wire

Thread the wire through the holes, then twist the wire together on the back side of the board to secure the embellishments to the board.

8

Adhere more embellishments using wax

Dab a little wax on the surface of the board where the panty hose and glue embellishment will go, and adhere the embellishment to the board.

Visit CreateMixedMedia.com/encaustic-painting-techniques for bonus content.

SHELLAC

Shellac may be my very favorite addition to encaustic painting. It began with a very controlled, safe burn of the dried shellac on wax and has evolved into an all-out extreme indulgence of everything amber-rich and fired up—just what you see here! Shellac strikes encaustic purists as an odd partner for wax. As a sealant or finish, shellac is completely unnecessary; encaustic is its own final finish. But putting aside its messiness and caustic state, shellac blends beautifully in the wax. Why caustic? We are setting it aflame! Do this only in the open air (I use my driveway on a rain-free day), and never lean over the surface as you watch it burn—unless you hate your hairstyle! You can go beyond the amber shellac if you do not have the same affinity for it that I do. Use clear shellac instead, but before taking any steps, color it as you desire with dry pigments, Pearl Ex Powdered Pigments or even dry pastel scrapings. The result will be your own custom-colored shellac.

WHAT YOU'LL NEED

Claybord

Encaustic medium

Paintbrush

Heat gun

Alcohol inks

Shellac

Paper towels

Fire-retardant surface

Propane or butane torch

Masking tape

Gesso

Razor blade

Encaustic paint: Sap Green

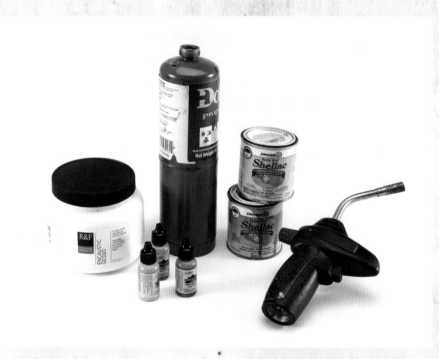

TOOLS OF THE TRADE
Yes, we're getting creative with a propane torch, shellac, ink and gesso!

"Imagination is the beginning of creation. You imagine what you desire, you will what you imagine and at last you create what you will."

GEORGE BERNARD SHAW

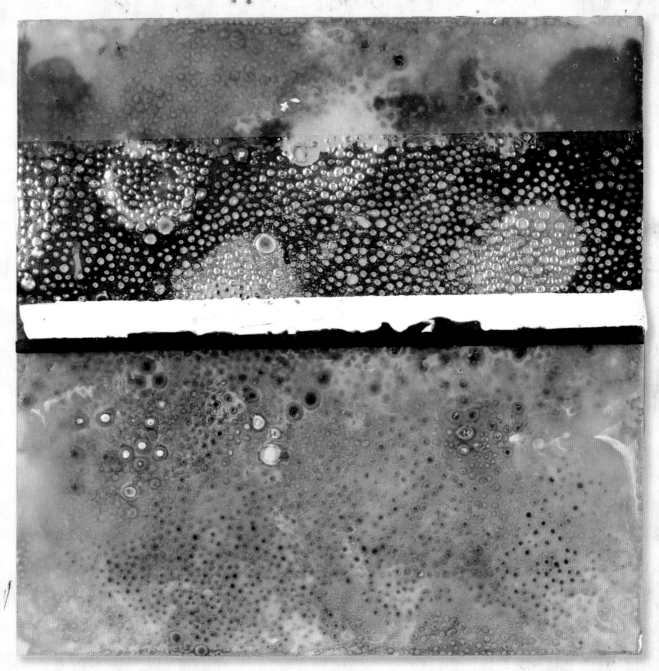

SHELLACITY

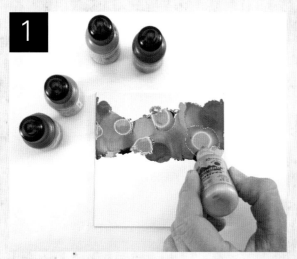

Apply alcohol inks on Claybord

Apply alcohol inks to the surface of the Claybord and let dry.

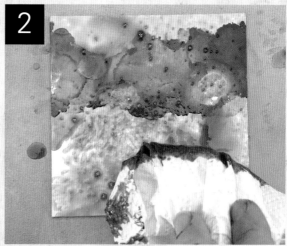

Apply shellac to board

Apply shellac to the surface of the Claybord using a paper towel.

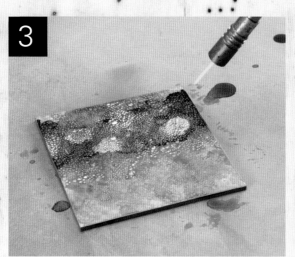

Burn shellac while wet

Place the board on a fire-retardant surface. Then, using the torch, immediately burn the shellac, lighting it on fire while it is still wet. Then allow the board to cool and dry. The combination of ink and shellac in this burning technique causes neat effects on Claybord: It bubbles up through the inks.

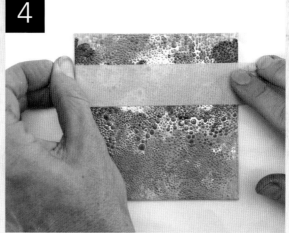

Apply masking tape

Apply masking tape over the bubbled alcohol-inked area to leave this portion free of encaustic.

brush up

I choose to use paper towels rather than a brush so there is no solvent cleanup required. Pouncing the shellac onto the surface yields a thicker application than wiping the shellac onto the surface.

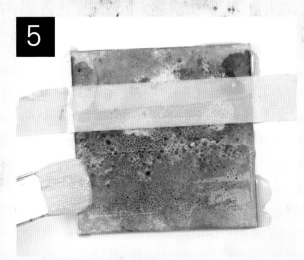

Apply encaustic medium

Heat the surface of the board with the heat gun and apply a layer of encaustic medium.

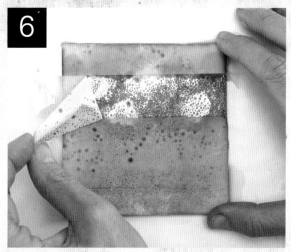

Remove tape

While the board is still warm, remove the masking tape.

ALTERNATE APPROACH

An alternate approach to steps 2 and 3 is to apply shellac over encaustic. Here I applied it over encaustic paint.

WHAT YOU'LL NEED

Lighter ✶ *Encaustic paint: Indian Yellow*

Apply encaustic paint and fuse

Apply a layer of encaustic paint (here, Indian Yellow) and use a heat gun to fuse the paint to the surface.

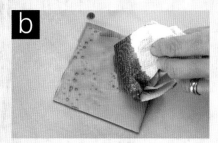

Apply shellac

Apply shellac to the surface with a paper towel.

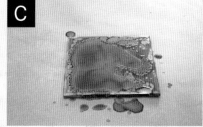

Burn shellac and cool

Light the shellac on fire. The fire will burn out as soon as the alcohol burns off. The melting wax below will shift and pool, leaving behind an organic design. This piece will likely take longer to dry, usually overnight.

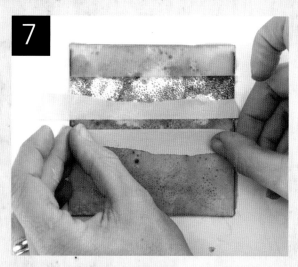

Mask another area of board

Mask off another area on the board to leave it with a lesser depth of encaustic, thus creating differing dimensional layers in the composition.

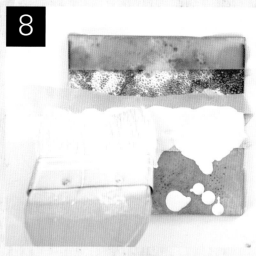

Apply gesso and fuse

Apply gesso between the pieces of masking tape. Fuse once applied.

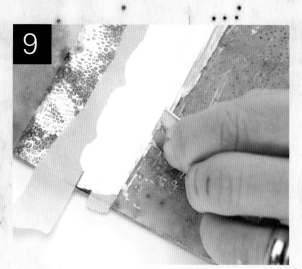

Remove excess gesso

Scrape off the excess wax with a razor blade as needed.

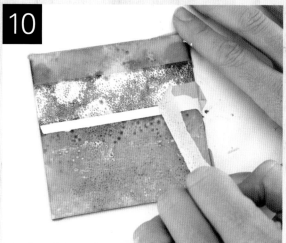

Remove tape while warm

Peel up the masking tape. (The wax should still be warm.)

brush up

An alternative to applying gesso is to apply encaustic paint between the masked areas. This results in a flatter, more opaque strip that contrasts well with the luminous encaustic medium.

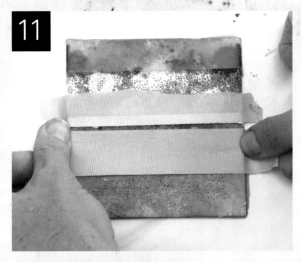

Apply masking tape
Apply masking tape to another area of the board.

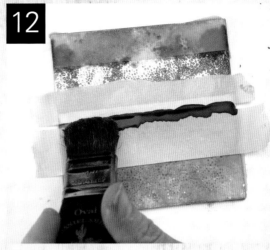

Add encaustic paint and fuse
Apply a layer of encaustic paint (here, Sap Green) to the board, within the area taped off. Fuse once applied.

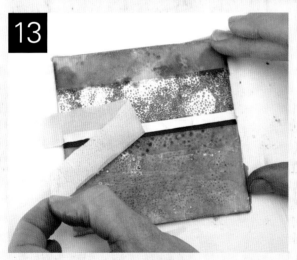

Remove tape and excess wax
Peel up the masking tape while the wax is still warm and scrape off any excess wax with a razor blade.

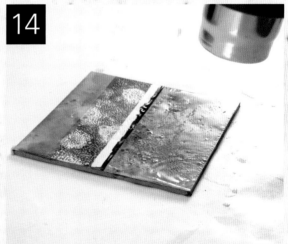

Heat board to smooth
Heat the Claybord with the heat gun to smooth out any rough edges or brush marks if you desire.

LACE RESIST

Abstract painting allows me freedom of emotional expression through color, texture and pattern. Perhaps it was easier to work abstractly with four boys invading my work space, but nonetheless, it is my calling. Yet sometimes I will want something pictorial or more intricately detailed in my work. I've discovered a few ways of achieving this over the years, and one of my favorites is using resists. Not only can I satisfy my desire for more detail, but I can also pull in color; oil paints, pigment sticks and ink combine wonderfully with textured resists. Applying a resist design to the substrate before the wax, and then removing it once the wax has been applied, leaves a sharp-edged design. This can be left as is or enhanced further with wax. Pre-made stencils are always an option, as are homemade stencils. But look around you, at home or when you're out shopping at the hardware store or fabric store—this lace resist was pure inspiration at the fabric store.

TOOLS OF THE TRADE

Lace, rub on letters, Brilliance fast-drying pigment ink and stamps. Great for adding intricate details.

WHAT YOU'LL NEED

Encausticbord

*Rubber stamps
(Stamping Bella)*

Ink pad stamps (StaZon)

*Homemade rub-on letter
(Grafix Rub-on transfer
film)*

Lace

Stylus/burnisher

"The principle goal of education is to create those who are capable of doing new things, not simply of repeating what other generations have done—those who are creative, inventive discoverers."

Jean Piaget

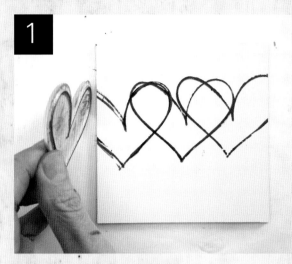

Stamp on Encausticbord

Ink the rubber stamp. Stamp directly on the Encausticbord with the rubber stamp.

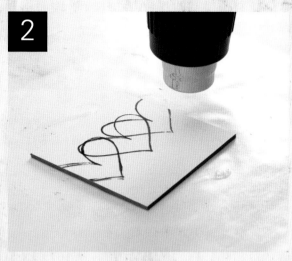

Warm board

Warm the board with the heat gun.

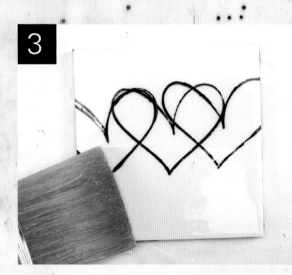

Apply encaustic medium

Apply a thin coat of encaustic medium.

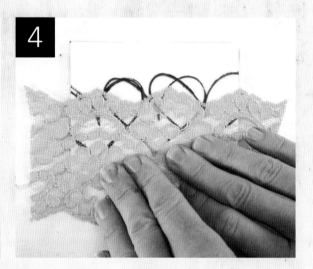

Press lace into wax

Apply lace resist to the bottom portion of the board. Gently, but with enough pressure to imprint the wax.

Sign up for the free newsletter at CreateMixedMedia.com.

5

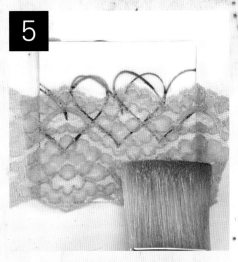

Apply medium over lace
Apply another coat of medium to the board, over the lace.

6

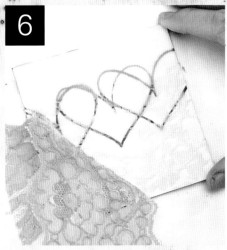

Remove lace and cool
Peel away the lace resist while the wax is still warm. Set the piece aside to cool.

7

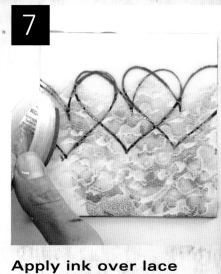

Apply ink over lace pattern
Using the ink pad stamp, apply ink over the surface where the lace resist left a pattern.

8

Burnish letters
Burnish the rub-on letters onto the wax.

9

Remove rub-on paper
Peel off the rub-on paper.

10

Fuse layers
Use the heat gun to fuse the layers together.

WOOD ICING AND STENCILS

Oh, what a treat! I discovered this yummy product just a month before shooting the photos for *Encaustic Mixed Media*, and even at that late-in-the-game stage, I knew it had to be included! Mary Beth Shaw, the popular and wonderful acrylic artist and author of *Flavor for Mixed Media*, has developed a delicious line of stencils manufactured to stand up to all kinds of mixed-media abuse. Not only do the designs make me sing happy songs, but the durability of the material has drawn silly-girl smiles on my face since the first trial run with wax. And wood icing! I thought I'd tried everything available from the shelves of The Home Depot, but no. This happy partner to the aforementioned delicious stencils is not to be missed. Oh, the joy of putting these two wonders together in encaustic painting.

WHAT YOU'LL NEED

Encausticbord

Heat gun

Encaustic medium

Paintbrushes

Encaustic paint: King's Blue

Spray adhesive

Stencil (here, by Mary Beth Shaw)

Trowel

Wood icing

PanPastels

Sponge applicator

Masking tape

Razor blade

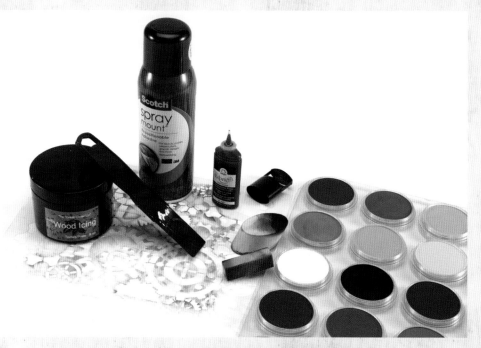

TOOLS OF THE TRADE

PanPastels are the best in the pastel world. Here I've paired them with Mary Beth Shaw stencils, wood icing and beeswax; it's like a party!

"Do not follow where the path may lead. Go instead where there is no path and leave a trail."

HAROLD R. McALINDON

NOT recommended in wilderness.

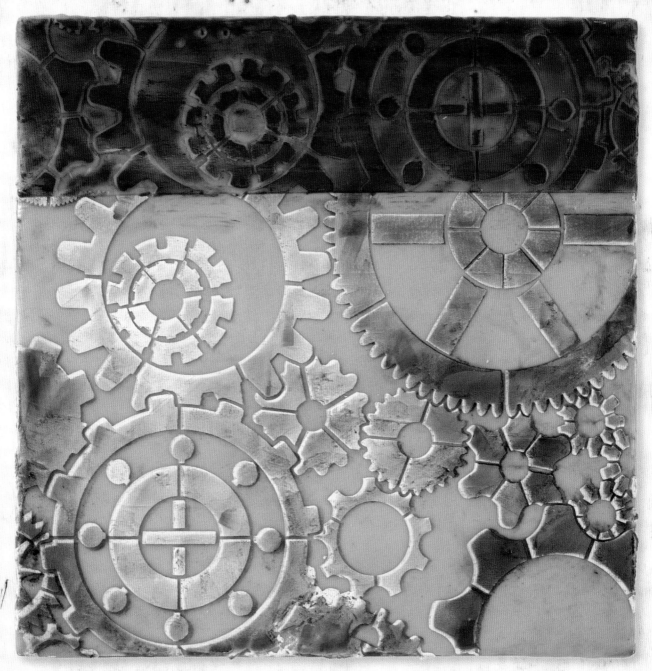

GEARED

1

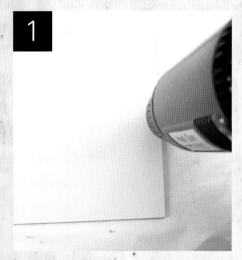

Warm board
Warm the Encausticbord with the heat gun.

2

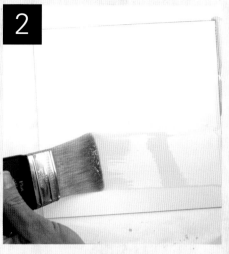

Prime board
Prime the board with a coat of encaustic medium.

3

Fuse medium
Fuse this layer to the board with the heat gun. Overfusing will make the finish smooth and even.

4

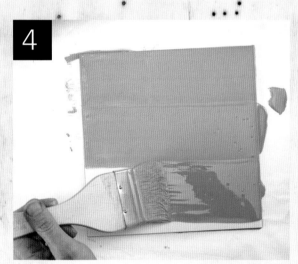

Apply encaustic paint
Apply a layer of encaustic paint. Here I applied King's Blue.

brush up

Don't worry if your encaustic paint bubbles up a bit while fusing—there's an easy fix for that! Just pop the bubble with a sharp tool, fill the bubble in with just a drop of encaustic paint and re-fuse.

5

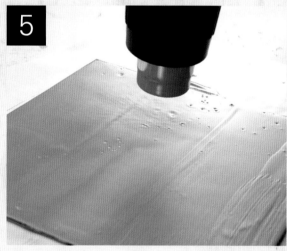

Fuse layers
Fuse with a heat gun to eliminate brush-strokes and to bond the layers together. Let cool.
NOTE: Apply additional layers of paint, fusing between applications, until you are satisfied with the overall depth of foundational wax. There is no limit to depth other than your creative vision.

142

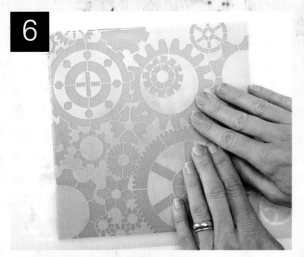

Apply stencil to board

Spray adhesive on the back of the stencil and press the stencil into the surface.

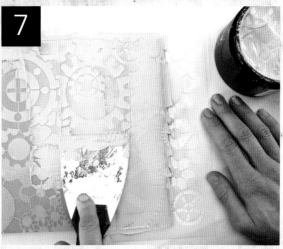

Layer wood icing on stencil

Using a trowel, apply a layer of wood icing over the stencil.

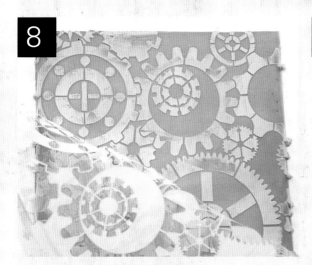

Remove stencil and dry

Immediately pull up the stencil. Set the piece aside to dry.

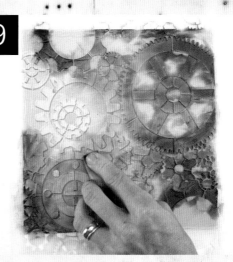

Re-apply stencil and add PanPastels

When the piece is dry, lay the stencil back on the board, lining it up with the previous positioning. Apply PanPastels evenly over the stencil to tint the wood icing design.

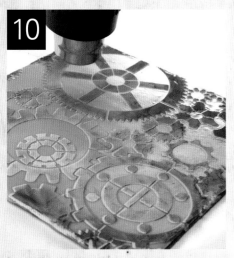

10

Add encaustic medium, remove stencil and fuse

Add a layer of encaustic medium. Remove the stencil. Fuse the new layer of medium and the pastel to the surface using the heat gun.

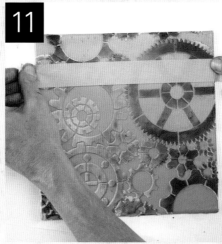

11

Apply masking tape

Apply masking tape. To accommodate the uneven surface of the stenciled area, press the tape into the valleys between the raised stencil areas. This prevents medium from bleeding under in the next step.

12

Apply encaustic medium

Apply a layer of encaustic medium to the area above the masking tape. You are building depth by doing this, giving the painting different depths for the eye to travel through.

13

Remove tape and cool

Remove the masking tape while the medium is still warm. Set the piece aside to cool.

NOTE: Peeling away the masking tape while the wax is still warm will help keep edges crisp, but wax can still be delicate, so peel carefully.

14

Apply tape in another area

Apply masking tape to the surface again, this time a few inches below the last application of tape.

15

Apply encaustic medium

Apply encaustic medium to the area above the tape.

16

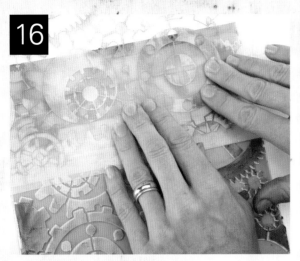

Reapply stencil
While the wax is still warm, reapply the stencil.

17

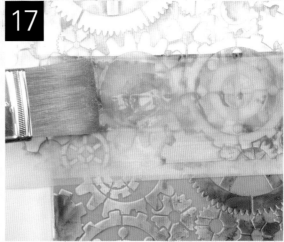

Apply medium over stencil
Apply another layer of encaustic medium over the stencil area.

18

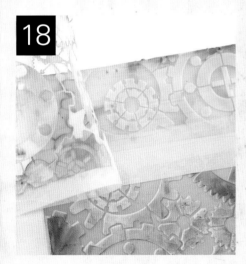

Remove stencil
Peel away the stencil while the wax is still warm.

19

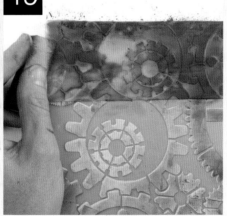

Remove tape and apply PanPastel
Remove the masking tape, allow the project to cool and apply PanPastel to this upper portion.

20

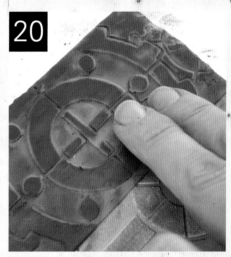

Distress areas and clean edges
Rub the edges of the stenciled design with your finger. This will lift some of the pastel pigment and give the edges a distressed look. Clean the piece's edges as needed with a razor blade and heat gun to remove any wax overflow.

CELLUCLAY

Celluclay has been in the craft world for decades, going through a number of name changes and design alterations. It is a claylike product of which the base material is paper pulp. It renders easily-shaped 3-D creations that are lighter in weight, more malleable and easier to work with than traditional clays. Celluclay can also be tinted with paint or ink. Simply add a few drops of ink, dye or acrylic paint when mixing to the desired consistency. I love it because it's paper (one of my favorite things on earth!), and it can adhere to (and in) encaustic for an added degree of dimensionality in your pieces. This dimension allows me, a timid-at-best 3-D experimenter, to take my paintings to a whole new level. I shy away from 3-D simply because my eye has never seen this way. Yet, when given a clear, bright white piece of watercolor paper, Claybord or Encausticbord, my nerves tingle at the possibilities! To be able to enter the 3-D arena and still remain comfortably ensconced in my 2-D world is a thrill. I can manipulate the aforementioned nerve-tingling surface with Celluclay, rendering a hint at 3-D, returning with encaustic painting to maintain my desired 2-D. It's blissful to stand on both sides of the dimensional fence!

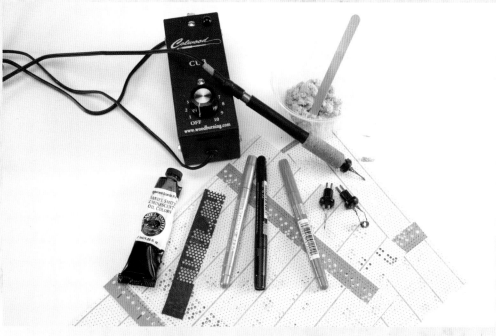

WHAT YOU'LL NEED

Cradled Encausticbord

Encaustic medium

Paintbrush

Heat gun

Stencil (or here, 1" × 1" [3cm × 3cm] claybord squares)

Wood-burning tool and tips

Masking tape

Water-based pigmented marker

Celluclay

Disposable cup

Craft stick

Pieces of rusted Wholey Paper

Oil paint: Daniel Smith Iridescent Scarab Red

Rubber gloves

Paper towels

TOOLS OF THE TRADE

My current favorite new find comes into play here: a wood-burning tool purchased from a decoy design website. And do you know about Wholey Paper? Oh my . . .

"The prize is in the process."
BARON BAPTISTE

PERIODIC TABLE

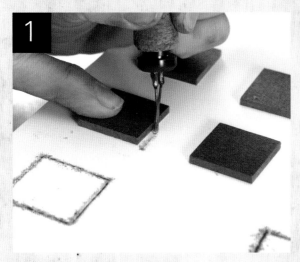

Burn designs into board

Burn your design into the Encausticbord with a wood-burning tool. I used 1" × 1" (3cm × 3cm) claybords as templates (back side up), burning around the edges with the feathering tip of the wood-burning tool.

Burn second design into board

Apply a second design with the wood-burning tool for additional appeal. Switch tips—remove the feathering tip and install a circle tip—and burn the design into the surface.

Apply tape and add writing

For added appeal, apply masking tape to the surface of the board for purposes of alignment, and write or draw a design across the surface using a marker. Remove the tape.

brush up

I love the consistency of Celluclay—it's malleable enough to push into any shape, but it will hold its form. It will shrink a little as it dries, which is an effect to be aware of—I like how it pulls away from the burned outlines.

Mix Celluclay

Mix Celluclay in a disposable cup according to package directions.

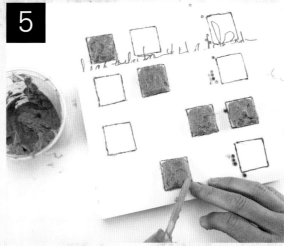

Apply Celluclay to board and dry

Lump the Celluclay onto the surface of the board where desired, and use your fingers and a craft stick to shape it. Set the board aside and allow it to dry. **NOTE:** The thicker you apply the Celluclay, the longer it takes to dry. I set this piece aside to dry overnight.

Protect ends of board with tape

Use masking tape to protect the edges of the cradled board, which will be finished later.

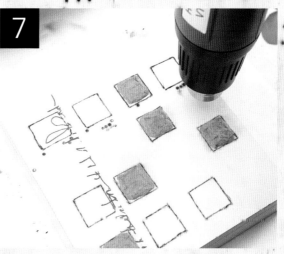

Warm board

Warm the board with a heat gun.

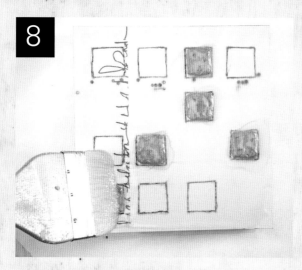

Apply encaustic medium
Apply a layer of encaustic medium.

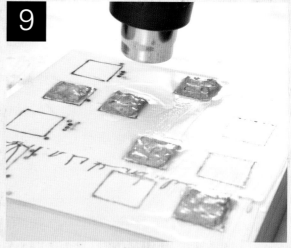

Fuse wax
Fuse the wax to the surface using a heat gun.

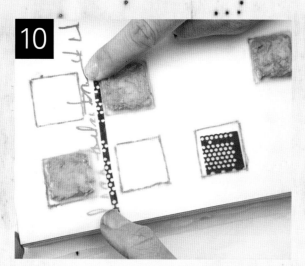

Apply rusted Wholey Paper
While the wax is still fluid, place pieces of rusted Wholey Paper as desired.

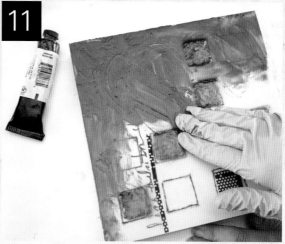

Apply oil paint
Apply oil paint over the entire surface of the board with gloved fingers. This will tint the wax or "glaze" it with color.
NOTE: Pigment sticks and tubed oil paints are nearly identical in effect. I generally prefer the sticks. If I find a perfect color in tube form—like I did here—then I go for it!

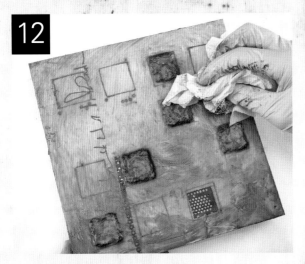

Rub in color

Use a paper towel to thoroughly rub the color into the wax, as well as to remove excess oil paint.

Remove tape from edges

Remove the masking tape from the edges of the cradled board.

Stain edges of board

Apply oil paint to the sides of the cradled board to "stain" the wood.

Remove excess paint and dry

Use a paper towel to rub the color into the wood and to remove excess paint. Set the project aside to dry.

PLASTER

Just over a year ago, I began working with substances that would offer an interesting foundation in encaustic; enter plaster. I began with the dry mix-it, blend-it, try-to-get-a-good-consistency plaster of Paris. I discovered that, for my purposes, plaster of Paris was not what I'd hoped it would be. I quickly moved on to the much easier-to-use plaster spackles, joint compounds and patching plasters. Talk about cost-effective, easy to use and wonderfully results driven! These finds first captured my attention in the hardware store aisles during my ten-month stint as a full-time sign artist. I've been hooked on hardware store staples ever since, and I work with joint compound whenever I can. Unlike plaster of Paris, it does not require mixing to get the consistency I desire. I choose to work this product on natural wood panels for the most part. Sometimes I use Encausticbords, but my most-favored results with plaster come from the contrast of the white plaster against wood. It is best to start working with plaster several hours—if not a full day—ahead of when you plan to move to wax; it must have time to dry in order to offer the best adhesion.

WHAT YOU'LL NEED

Art wood panel or scrap wood

Encaustic medium

Paintbrush

Heat gun

Repositionable spray adhesive

Punchinella

Masking tape

Trowel

Joint compound or patching plaster

Fire-retardant surface

Propane or butane torch

Metallic microbeads

Razor blade

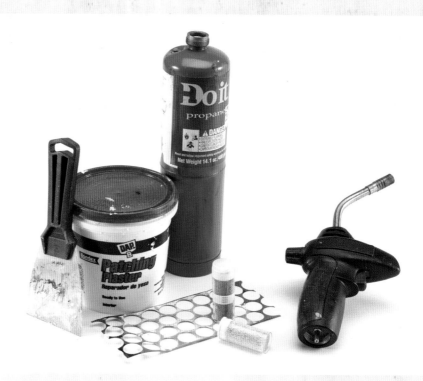

TOOLS OF THE TRADE

Punchinella (also called "sequin waste") takes center stage alongside hardware store plaster.

"Most of the things worth doing in the world had been declared impossible before they were done."

LOUIS D. BRANDEIS

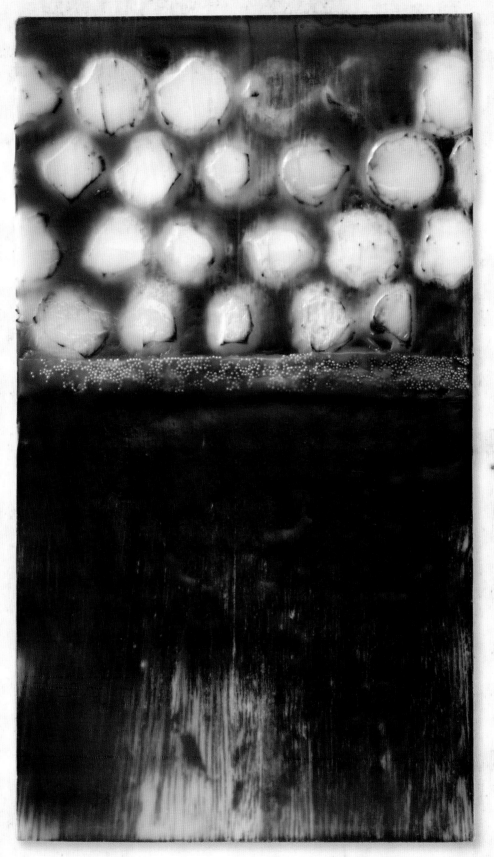

STORMY NIGHT

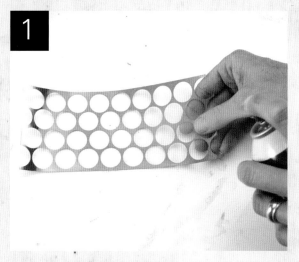

Spray adhesive on punchinella
Spray the back of the punchinella with adhesive to help prevent seepage.

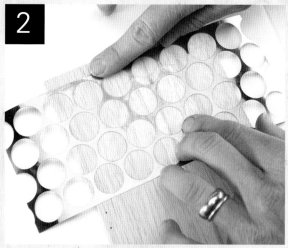

Apply punchinella to board
Press the punchinella onto the board.

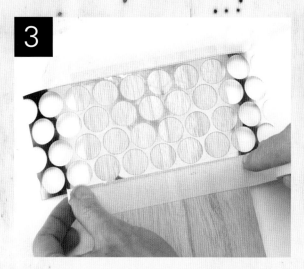

Apply masking tape
Apply masking tape above and below the area you intend to cover with plaster. This helps with alignment and prevents plaster from seeping under the punchinella stencil.

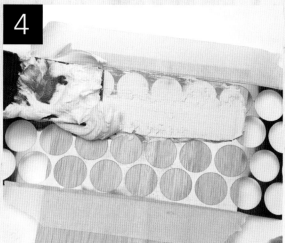

Apply plaster over stencil and dry
Using a trowel, apply the plaster to the taped and stenciled area.

154

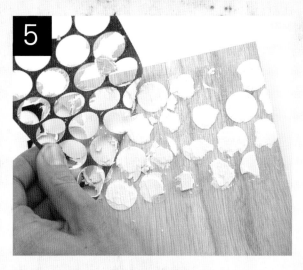

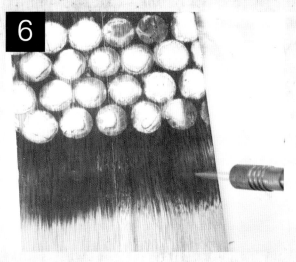

Remove stencil and tape

When the piece is completely dry, peel off the masking tape and the punchinella stencil. This will create a chunky, broken texture effect. **NOTE:** The stencil can be removed while the plaster is still wet for a smoother, more precise design.

Fire plaster and board, cool

Place the board on a fire-resistant surface. Fire the plaster and board with your torch, and then set the board aside. It needs to cool before you apply the medium. The flame "toasts" the plaster, giving it an amber-tinted blush while scorching the wood to a rich black.

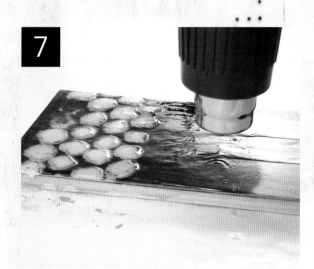

Apply wax and fuse

Add a layer of medium and fuse.

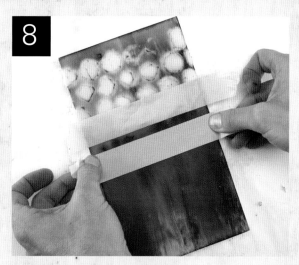

Apply tape and warm board

Mask off a stripe on the board, just below the punchinella-plaster area. Warm the board with the heat gun.

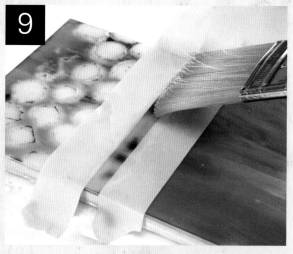

Apply medium between tape

Apply a thick brush full of medium to the masked-off strip to create a foundation for the metal beads to adhere to.

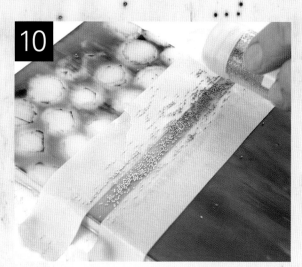

Add beads

Carefully shake beads into the medium.

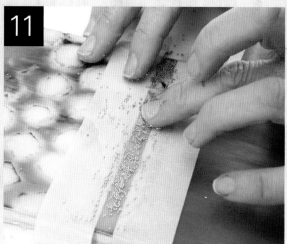

Imbed beads in medium

Press the beads into place.

12

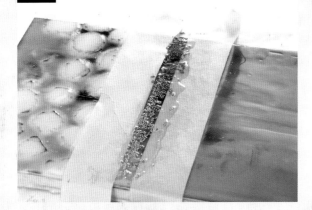

Fuse medium and beads

Fuse the medium and beads using the heat gun. Start with the heat gun held high so the beads don't blow away. As they sink into the medium, move the heat gun closer.

13

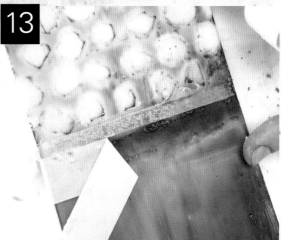

Remove tape and cool

Remove the masking tape. Set the piece aside to cool.

brush up

When applying a masking tape resist to the surface, make sure the tape extends off the sides of the board. It'll be easier to find and pull the end when you want to remove the tape.

14

Clean edges of board

Clean up the surface and sides using the heat gun and a razor blade. Scraping with a razor blade over the punchinella-plaster area can level out the wax and expose plaster if such an effect is desired.

Visit CreateMixedMedia.com/encaustic-painting-techniques for bonus content.

PLASTER WITH MASKING TAPE "STENCIL"

Masking tape

Trowel

Patching plaster

Paper towels

Wood glue

Wood board or panel

Propane or butane
Torch

Fire-resistant surface

Gloves

Pigment sticks (R&F)

Razor blade

Straightedge (another
panel or board)

Sign up for the free newsletter at CreateMixedMedia.com.

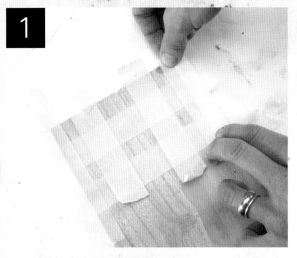

Apply tape in pattern

Apply the masking tape in a pattern to the surface of the board—the masking tape serves as a stenciling medium.

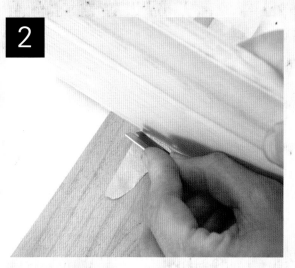

Trim tape

Use a straightedge (such as another board) and a razor blade to trim excess tape from the bottom portion. It doesn't matter if the tape extends off the edges of the panel, but you want a clean edge as part of the composition.

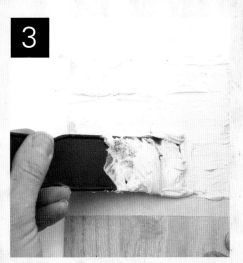

Apply plaster

Using the trowel, apply plaster to the sectioned-off areas.

Remove tape

Remove the tape "stencil" while the plaster is still wet. Doing it this way will ensure sharper edges to the plaster with no chipping. Allow the plaster to dry.

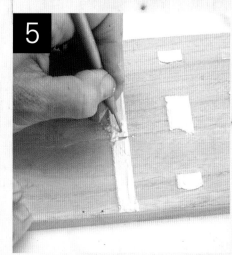

Scratch designs into plaster

Using a sharp-pointed tool, scratch designs into the dried plaster to create a sgraffito effect.

NOTE: For this effect, ensure the plaster is completely dry and that the tool you are using is very sharp. You don't need to press the tip of the tool all the way through the plaster, though I often will do so.

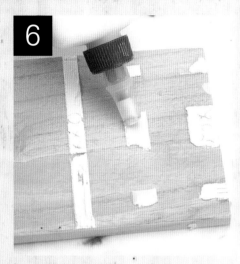

Apply glue on plaster

Apply a heavy layer of glue to the plaster—but, be careful! You don't want to get any of the glue on the unfinished wood.

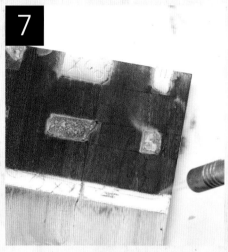

Fire glue and wood

Place the piece on a fire-resistant surface. Using your torch, fire the glue as well as the wood in the area that was previously covered by the tape. Set aside to let cool.

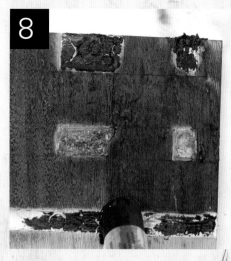

Apply pigment stick to plaster

Apply the pigment stick to the plastered areas as desired. For example, on this piece, I decided to pigment some—but not all—of the plastered elements.

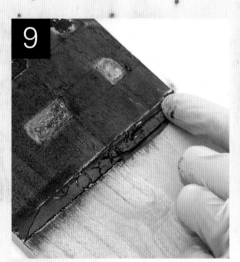

Rub pigment into plaster

Rub the pigment into the plaster with gloved fingers. (I wear gloves while working with pigment sticks to keep the pigment from absorbing into my skin.)

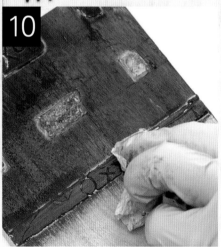

Rub pigment with paper towel

Continue rubbing with a paper towel. You want to use it almost like you would sandpaper against the edges of the plaster.

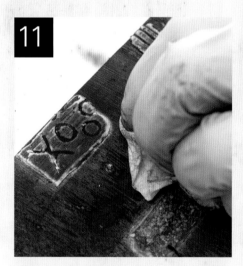

Remove excess pigment

Using a clean paper towel, remove all excess pigments from the plaster and the board.

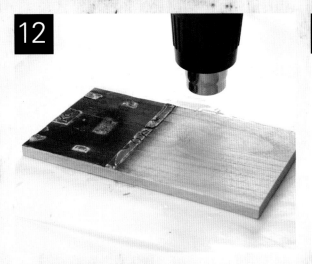

Warm board

Use the heat gun to warm the surface of the entire board.

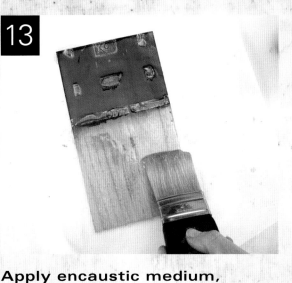

Apply encaustic medium, fuse and cool

Brush encaustic medium over the surface of the entire board. Then fuse the medium to the board with the heat gun, and set the board aside to cool.

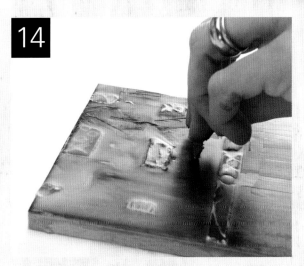

Scrape off areas of excess wax

To thin the layer of wax, if desired, use a razor blade to scrape off some of the wax.

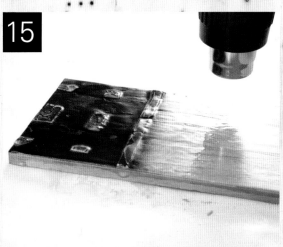

Warm wax to remove razor marks

Smooth out the razor marks with the heat gun. You may even want to overfuse so the wax really soaks into the surface. Set aside to cool.

TAR

I knew I could find texture in the white, light backdrop of plaster, so why not try it in the deep, dark backdrop of tar? This medium can be manipulated in much the same way plaster can—with masking off, stenciling and burning. But as you can imagine, this is where the similarity ends. Tar, I've discovered, has a good friend in Claybord. For this technique, even though I love Encausticbords, I return to my first love of Claybord. The surface has a magical quality that emerges when combined with a wood-burning tool, and the contrast of black tar on white Claybord can't be beat.

WHAT YOU'LL NEED

Claybord

Encaustic medium

Paintbrushes

Heat gun

Masking tape

Pigment ink stamp

Wood-burning tool and tips (used for making duck decoys; I found it on the Internet)

Punchinella

Trowel

Asphalt patch or tar

Sandpaper

Razor blade

Stencil

Encaustic paint: Payne's Gray

Linseed oil

Disposable cup

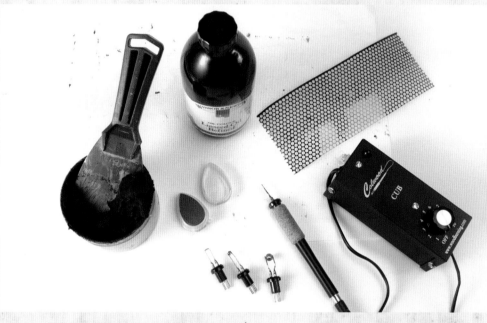

TOOLS OF THE TRADE
Tar, a wood-burning tool and craft elements come together to bring beauty and brawn to beeswax.

> "Creativity is allowing yourself to make mistakes. Art is knowing which ones to keep."
> **SCOTT ADAMS**

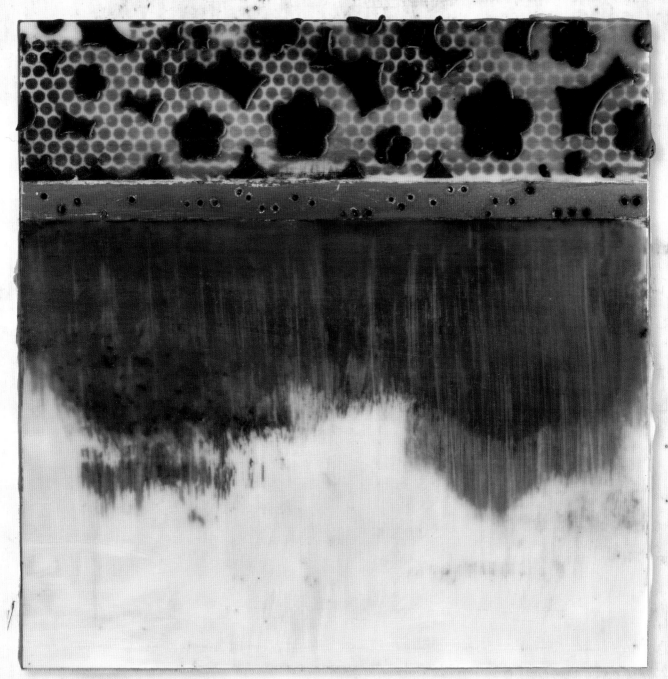

INDUSTRIAL LACE

1

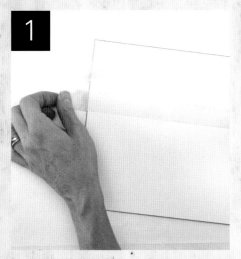

Apply masking tape

Mask off a strip of the board. (These masks are simply for alignment; they won't be used as a resist.)

2

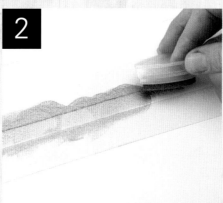

Ink between tape

Apply ink to the taped-off area using a pigment ink of your choice.
NOTE: Watercolors, ink or pastel can all be used interchangeably here.

3

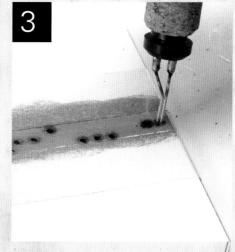

Burn circles

Use a wood-burning tool to burn circles into the wood. Use tongs to change tips on the burner when it is hot (tongs generally are included with the tool). Knock the board against a table to remove any ash. (Rubbing the ash away will discolor your board.)

4

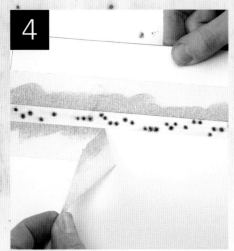

Remove tape

Remove the masking tape from the board.

5

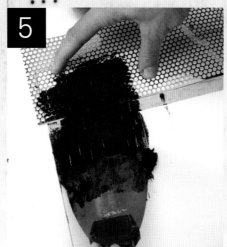

Add resist and apply tar

Mask over the inked-and-burned line to protect it, then place a resist (here, punchinella) over the top portion of the piece. Using a trowel, apply tar over the resist and pull some tar down into the lower portion of the board.

6

Remove resist

Pull up the resist before the tar hardens. If the tar is allowed to dry before the resist is removed, it may be stuck permanently in the tar.

7

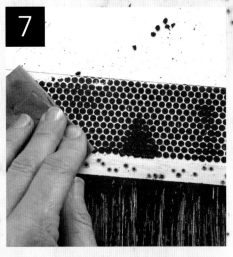

Sand tar

Allow the tar to dry completely. Sand the sides and along the top of the board to remove loose bits of tar and to give the tar different tones of black.

8

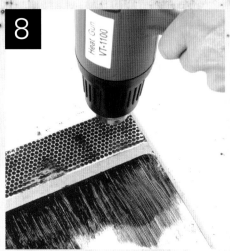

Mask areas and heat board

Mask the inked-and-burned line again; this time you'll be building up encaustic layers on either side to provide a sense of depth. Heat the board with the heat gun.

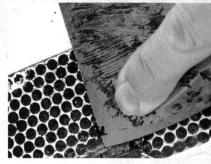

brush up

To remove the tar, you could also scrape it with a trowel to achieve a similar effect, but it might pull up more than you'd like. A trowel will also leave staining behind, resulting in a mellow look with less contrast.

9

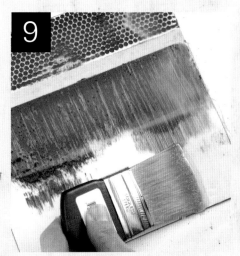

Apply wax

Apply encaustic medium over the entire surface.

10

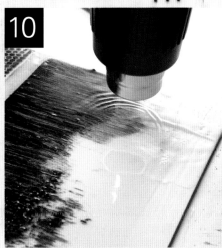

Fuse medium

Fuse with the heat gun and smooth out any texture resulting from the application of the medium. Repeat steps 9 and 10 until you are satisfied with the overall look and thickness of the wax.

11

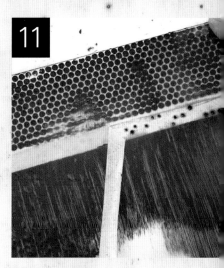

Remove tape

Remove the masking tape while the wax is still warm.

Visit CreateMixedMedia.com/encaustic-painting-techniques for bonus content.

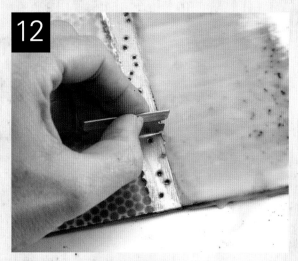

Scrape off excess wax

If medium bleeds under the tape, scrape it off the inked-and-burned area with a razor blade.

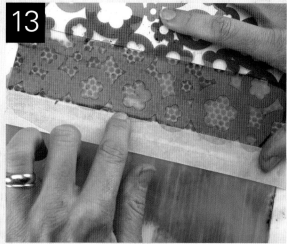

Tape stencil in place

Tape a stencil over the top part of the board. Taping the stencil will help keep edges clean and hold the stencil down.

ALTERNATE APPROACH

An alternate approach to steps 13 through 15 entails incising around the stencil and applying a pigment stick.

WHAT YOU'LL NEED

Awl or stylus ✳ *Pigment stick* ✳ *Paper towel*

Trace stencil into wax

Lay the stencil into the warm wax. Use an awl or stylus to trace around the stencil. You may get burrs, but you can just brush those off once the wax has cooled.

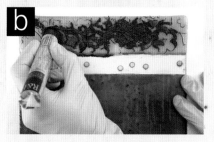

Rub pigment into stenciled area

Apply a pigment stick over the cooled, incised wax. Rub the pigment into the surface with gloved fingers (to prevent pigment from absorbing into skin).

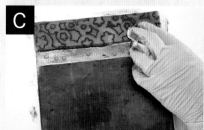

Wipe excess color

Wipe away excess color with a paper towel.

Sign up for the free newsletter at CreateMixedMedia.com.

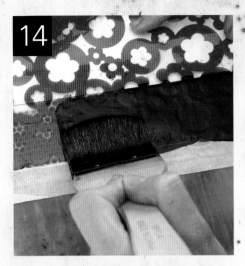

14

Paint over stencil
Paint over stencilled area with Payne's Gray encaustic paint.

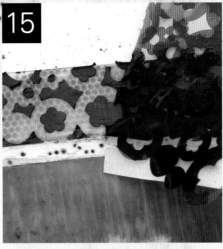

15

Remove stencil
Immediately peel away stencil.

16

Fuse paint
Fuse this layer with the heat gun.

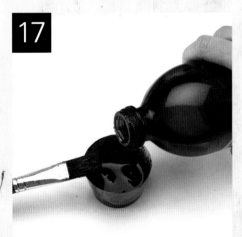

17

Mix tar and linseed oil
To create a rich, dark stain that can be used to tint the painting for a vintage feel, mix a small dollop of tar with some linseed oil in a disposable cup. **NOTE:** This mixture can be set aside to dry and left for months, and it will still be viable—just add fresh linseed oil.

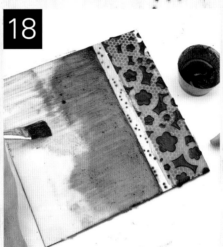

18

Apply tar and oil mixture
Apply the tar and linseed oil mixture with a paintbrush. (You could use oil paint, but I liked the continuity of tar in its different manifestations.)

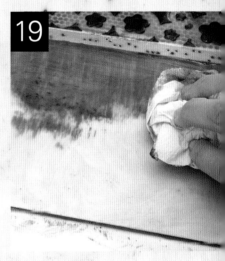

19

Rub stain into wax
Rub this stain into the wax using a paper towel or rag. Because of the linseed oil, the piece will need a couple of days to dry.

WATERCOLOR

I began my foray into art via mixed media on watercolor and printmaking papers. I adore the texture, absorbency and tooth of these papers and was enchanted by the play of fluid colors over the surfaces. As a result, I have a pile of paintings reaching to the tip of my one-year-old niece's nose! I was determined to whittle the pile away. But how? I couldn't toss the paintings; they were too pretty. I couldn't frame them; they weren't quite "there." I knew I wouldn't continue to work on them; I was fully invested in encaustic. In keeping with this project's quote, I went with a hunch. I took that pile, and I began to tear. Harkening back to my fiber art days, I wove the torn strips into interesting designs. Unable to stop there, I took the torch to them. The result was a very satisfying, truly yummy repurposing of these mixed-media masterpieces into foundations for encaustic inspiration. Yum yum!

WHAT YOU'LL NEED

Claybord

Encaustic medium

Paintbrush

Heat gun

Cut or ripped strips from an old watercolor painting

Gel medium

Fire-retardant surface

Propane or butane torch

Rigid wrap embellishments (see page 209 for mini demo)

Rub-on transfers

Annealed steel wire

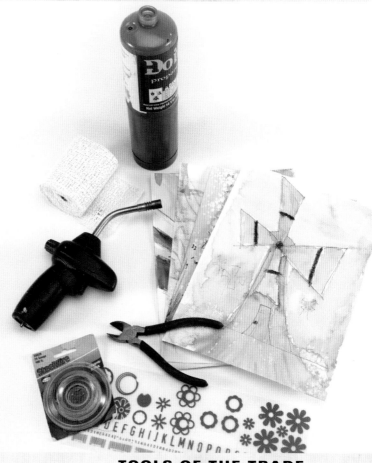

TOOLS OF THE TRADE

Pulling other mediums into encaustic in a unique repurposed way is exciting! And of course, putting the torch in to play . . .

"A hunch is creativity trying to tell you something."
FRANK CAPRA

168

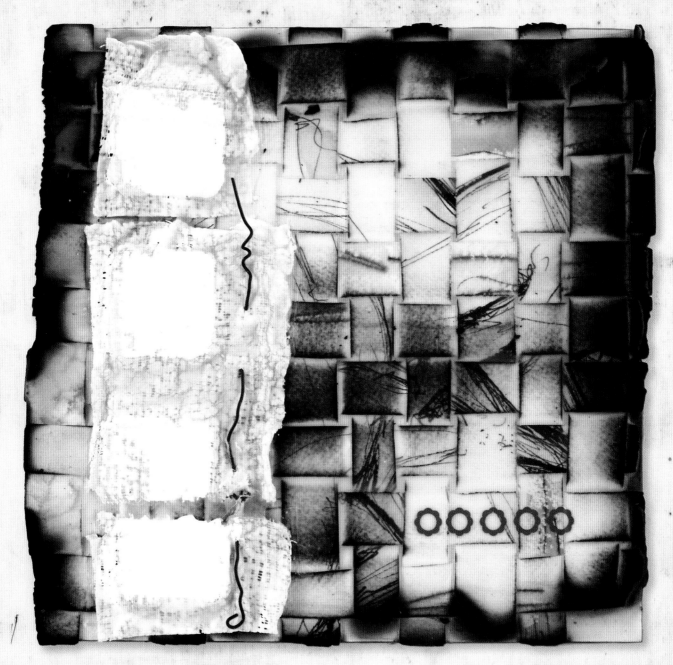

CASTING ABOUT

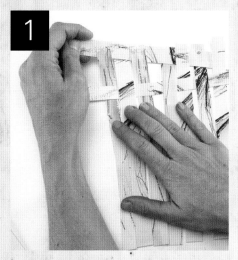

Weave painted paper together

Weave the strips of painting together, first arranging the vertical strips, then weaving the horizontal strips through the vertical strips.

Apply gel medium to board

Apply gel medium to the board using a paintbrush to evenly coat it.

Adhere paper to board and dry

Lay the woven painting over the board. Press it into the gel medium, then weigh the painting down and let it dry, preferably overnight.
NOTE: Before you proceed to the next step, make sure the gel medium is completely dry. You don't want moisture below the layer of wax you will apply.

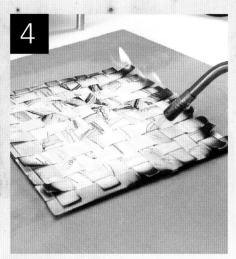

Burn areas of painting

When dry, lay the piece on a fire-retardant surface. Using a butane or propane torch, burn select areas of the painting.
NOTE: I left the woven edges overhanging when adhereing so I could burn them back in a more loose and inexact way.

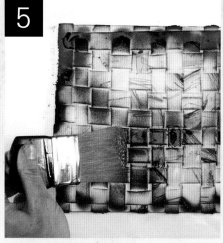

Apply encaustic medium

When the piece has cooled off some (but is still warm to the touch), apply encaustic medium.

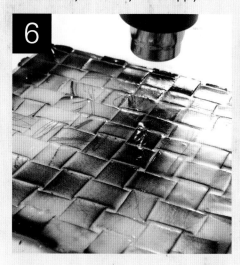

Fuse wax

Fuse the wax layer using the heat gun.

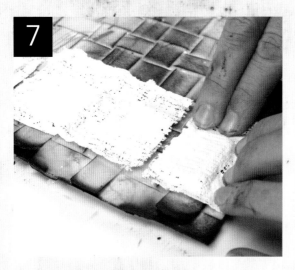

Apply rigid wrap embellishments

Place and press the rigid wrap embellishments into the still-warm surface.

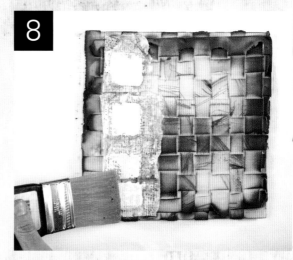

Brush on encaustic medium

Add a layer of encaustic medium over the forms.

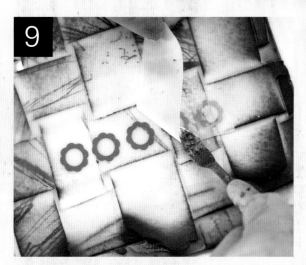

Add rub-ons

Use homemade or craft store rub-ons to embellish the painting. Simply rub them onto the cooled wax.

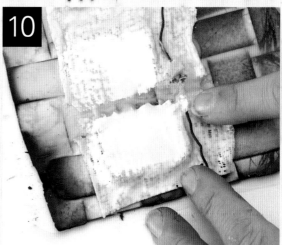

Thread wire through wrap forms

I felt the piece wasn't quite done, so I chose to thread a length of wire through the rigid wrap forms while the wax was still warm.

CORK

I can remember cork lining many of the shelves in my childhood home. I think it began as a means to safely secure dishes and glasses that might otherwise slide perilously on a slick cupboard shelf. Whatever the intended purpose, the person who first considered the possibilities for cork in the world of arts and crafts deserves a commendation! I adore the look of it in encaustic. The mottled tan texture of adhesive-backed cork "paper" is a welcome addition that can be manipulated with hole punches, craft punches or, best yet, a Sizzix die-cut machine. This cork "paper" rolls through the die-cut machine with little effort and rewards determined crafters with a delightful variety of embellishments to embed in their next encaustic creations.

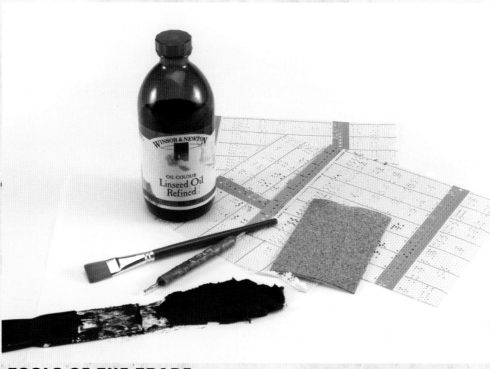

TOOLS OF THE TRADE

Wax, resin, cork, rusted paper: truly mixed-media extraordinaire!

WHAT YOU'LL NEED

Cradled Encausticbord

Encaustic medium

Paintbrushes

Heat gun

Masking tape

Die-cut self-adhesive cork embellishments

Disposable cup

Tar

Linseed oil

Paper towel

Rusted Wholey Paper

Resin embellishment

Scraper or double-ended stylus

"Every act of creation is first an act of destruction."

PABLO PICASSO

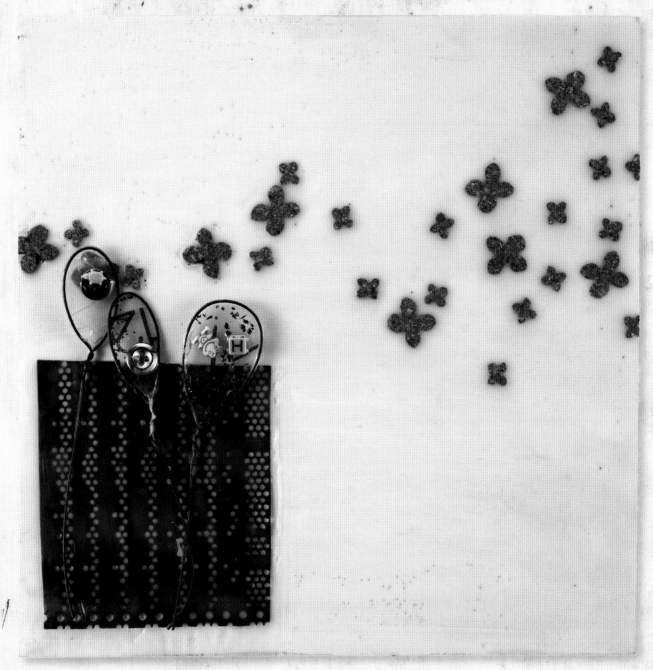

BUTTERFLY CATCHING

Tape edged of board

Tape the edges of the cradled board with masking tape. This will protect the edges from wax drips.

Apply cork embellishments

Apply the die-cut cork embellishments to the surface.

NOTE: Most cork I've seen is self-adhesive. If yours is not, don't worry. Simply adhere the cork embellishments to the surface with gel medium.

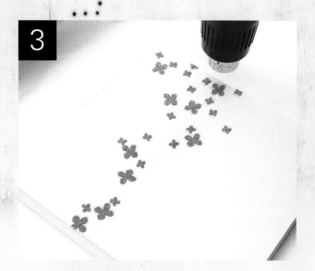

Warm board

Warm the board with the heat gun.

4

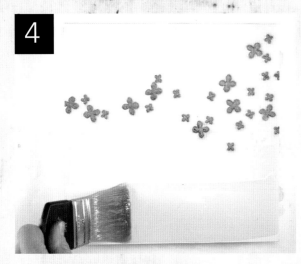

Apply medium

Apply medium in even strokes over the entire surface.

5

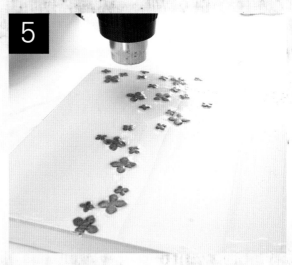

Fuse medium and cool

Fuse this medium layer and allow it to cool.

6

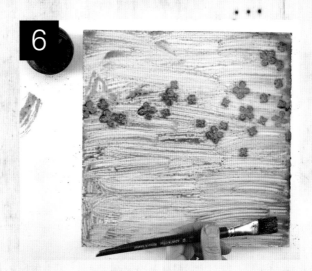

Apply tar paint to surface

In a disposable cup, mix the tar with linseed oil. Apply a layer of tar paint over the entire surface to tint the wax.

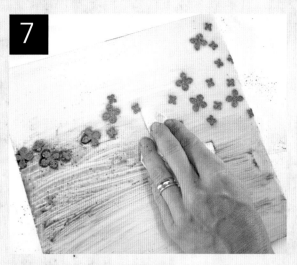

7

Remove excess tar
Remove any excess tar tinting with a paper towel.

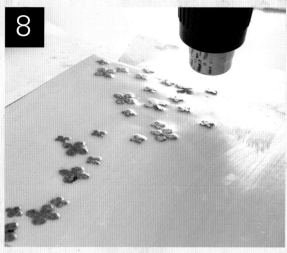

8

Fuse surface
Use the heat gun to fuse this added layer.

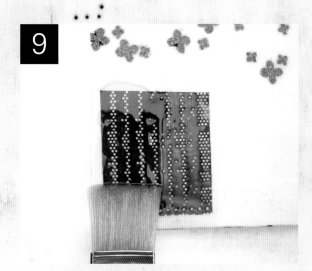

9

Apply Wholey Paper and encaustic medium
Press the rusted Wholey Paper into the still-warm surface, and then apply a layer of medium over the Wholey Paper.

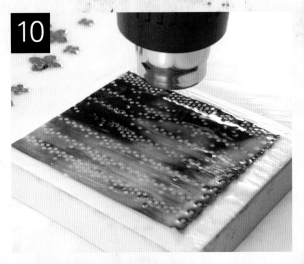

Fuse wax and paper
Fuse the wax and Wholey Paper to the surface with the heat gun.

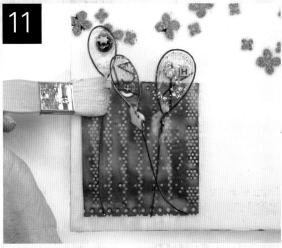

Secure resin embellishments
Place the resin embellishments on the surface and dab wax over the stems to secure.

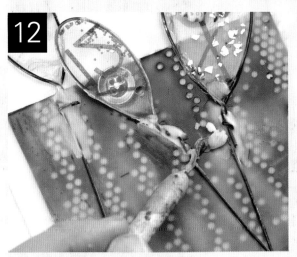

Remove excess wax
Use a double-ended stylus or scraper tool to remove any excess wax from the embellishments if desired.

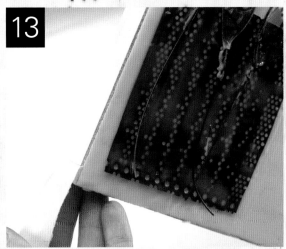

Remove tape and cool
Remove the tape from the edges and set the piece aside to cool.

FABRIC

Since seventh-grade home economics, I have been infatuated with the sewing machine. It was then that I learned straight-seam sewing and took on the arduous task of making my own dress for the dance. It was a Gunne Sax–inspired number with yards and yards of long flowing skirt. I succeeded in completing it and wore it proudly. It still resides in a box in my attic. I've scaled down my sewing since then; first in clothing for my four boys when they were toddling about, and now in doll-sized patterns to stitch and embed in wax. Combining such a long-beloved medium and encaustic is a goose-bumping thrill. I was unequivocally giddy when I developed this series I call "Apron Strings" while on an extended stay at Sitka Center for Art and Ecology on the Oregon coast. The gloriously unstructured time devoted entirely to creating and the inspiring rustic space (I warmed myself over the wax palette and wood stove interchangeably) helped produce these delights. The series continues to evolve, but I couldn't resist sharing my first discoveries here. You, too, should be inspired to try thread, fabric, felts and anything else in the fabric store that catches your eye.

WHAT YOU'LL NEED

Cradled Encausticbord

Encaustic medium

Paintbrush

Heat gun

Home decorating–weight fabric cutouts in dress and apron shapes

Thread (optional)

Tweezers or tongs

Masking tape

StazOn ink pad

Rubber stamps

Stylus

Pigment sticks

Rubber gloves

Paper towels

Paper embellishments

Small finishing or decorative nails of your choice

Small beads (will serve as spacers)

Hammer

Needle-nose pliers

Mini clothespins

Gel medium

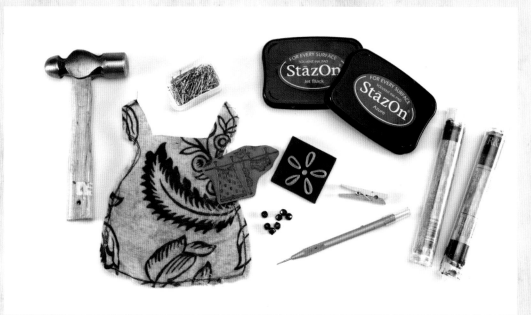

TOOLS OF THE TRADE

An interesting array of tools: fabric cutout, pigment sticks, hammer and nails. This piece satisfies my inner seamstress, handyman and artist!

"It is threads, hundreds of tiny threads, which sew people together over a lifetime."

SIMONE SIGNORET

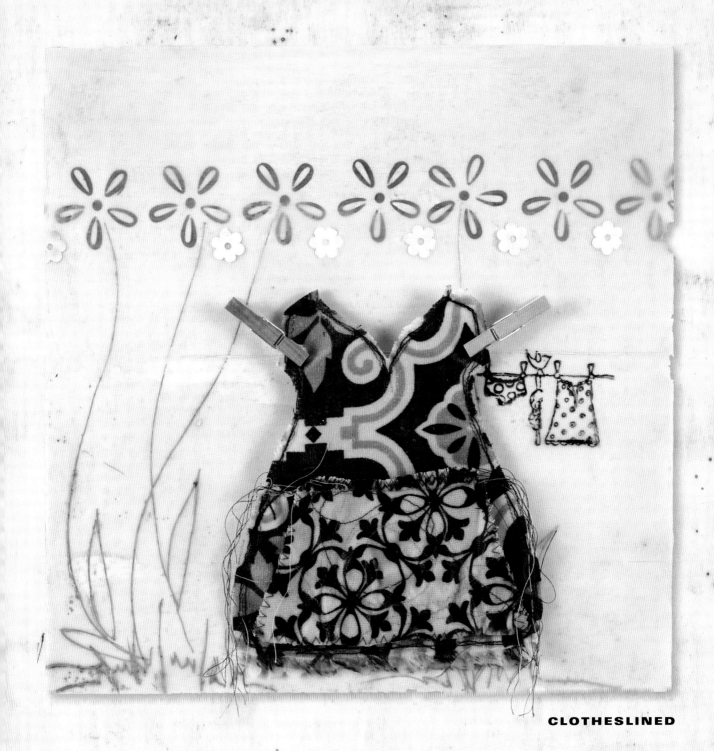

CLOTHESLINED

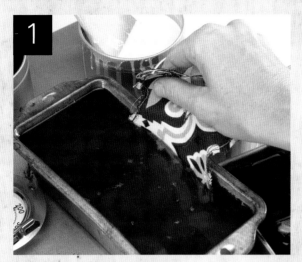

Dip dress into wax

If you like, you can add stitched details to the dress and apron shapes using complementary-colored thread. Then gently dip one side of the dress into the medium, using tweezers or tongs. **NOTE:** I chose to dip the cutout for the beauty of the effect, but the process can be skipped without losing anything.

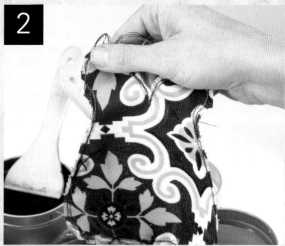

Let excess wax drip off

Lift the dress from the medium and let the excess drip off.

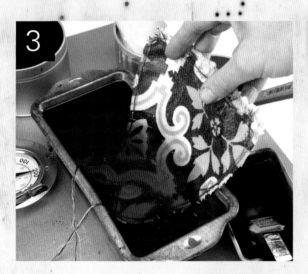

Dip other half of dress in wax

Gently dip the other side of the dress into the medium using tweezers or tongs to hold it. Set it aside to cool. Repeat steps 1 through 3 for the apron and set it aside to cool.

Protect sides of board with tape

Cover all sides of the cradled board with masking tape to prevent them from being splashed or dripped with wax.

brush up

Silks and synthetics (like polyester and rayon) will darken, practically to black when dipped in wax. This can still look great, but don't let yourself be surprised. Run a quick test: Submerge a scrap of your chosen fabric in water. The color you see when the fabric is wet is the color you'll get (permanently!) after it's dipped in wax.

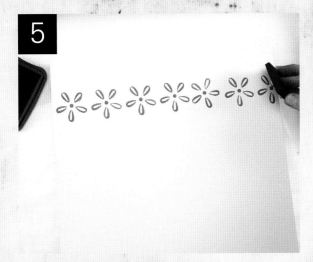

Stamp design on board

Apply ink to a flower stamp and stamp the design across the board.

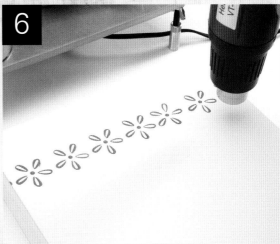

Warm board

Warm the board with a heat gun.

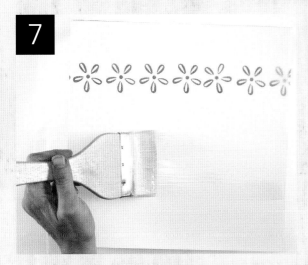

Apply encaustic medium

Apply the medium over the surface of the board in even side-by-side strokes.

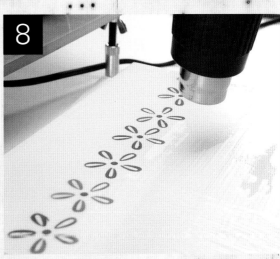

Fuse wax

Fuse the wax to the surface of the board.

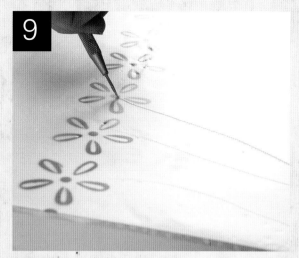

Incise wax while warm

Incise the wax with a stylus, adding stems to the stamped flowers. To prevent cracking, this should be done while the wax is still warm. Set the piece aside to cool completely.

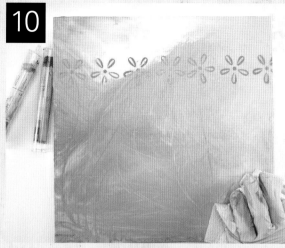

Rub pigment onto surface

Using a pigment stick, apply color over the cooled surface. I used two colors here: Burnt Sienna and Neutral White. Rub the color into the wax with your gloved fingers, then pull up excess color using a paper towel.
NOTE: Use vegetable or linseed oil with a paper towel to aid in color removal if desired.

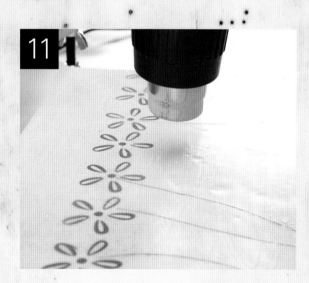

Fuse pigment

Fuse the pigment into the encaustic medium with a heat gun.

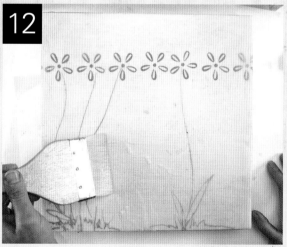

Add another layer of medium

Apply another layer of encaustic medium over the surface of the board. Some movement of pigment may occur; if you'd like to avoid this, allow the pigment to dry thoroughly—a day or two—before moving to this step.

brush up

Refresh your paper towel often to get the best results when removing pigment.

Sign up for the free newsletter at CreateMixedMedia.com.

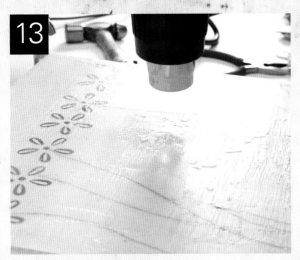

Fuse medium

Fuse this new layer with a heat gun.

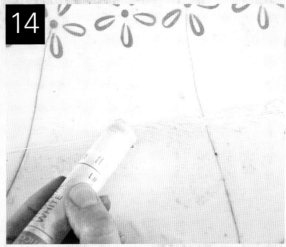

Incise clothesline and add pigment

Incise a line in the warm wax for the clothesline, and then apply Neutral White pigment stick over the line.

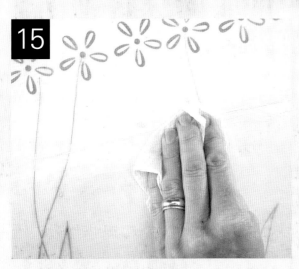

Remove excess pigment

Use a paper towel to remove excess pigment. **NOTE:** Wax is very forgiving—you can scrape it off, heat it off or wipe it off. You can even come back years from now and make adjustments to it if you want.

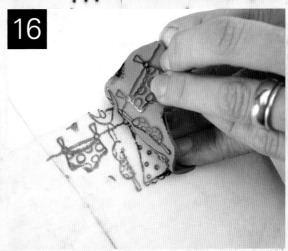

Apply clothesline stamp

Ink a clothesline stamp and apply the stamp to the surface of the board, onto the wax.

Apply and fuse embellishments

Press the paper embellishments (here, flowers) onto the surface and cover with encaustic medium. Fuse with a heat gun.

Add bead spacers

Push a nail through the top corner of the apron and slide a bead onto the nail. The bead will serve as a spacer. Repeat on the other side of the apron shape.

Nail apron into place

Position the dress (with clothespins) over the clothesline. Line up the apron and nail everything into place, using needle-nose pliers to hold the nail in place.

Secure clothespins

Use gel medium to secure the clothespins to the surface.

brush up

It can be very difficult to pound the nails through the Encausticbord because it has hardboard, as opposed to wood, as its base. Typically for this type of project, I work on a wood panel. If you choose to work with Encausticbord, it might be helpful to drill holes into the board before nailing the dress into place.

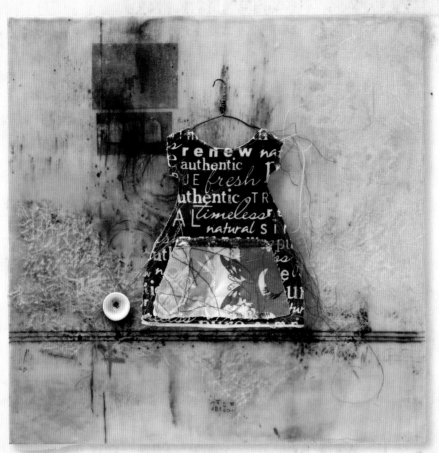

APRON STRINGS IN THE PANTRY AND NATURAL HABITAT

Both of these evolved from my time at Sitka and are part of the Laundry Day in Apron Strings *series.* Apron Strings in the Pantry *utilizes a pounded metal wire hanger with burn elements and charcoal on raw board.* Natural Habitat *shows off a punchinella dry-brush center and computer hard drive components.*

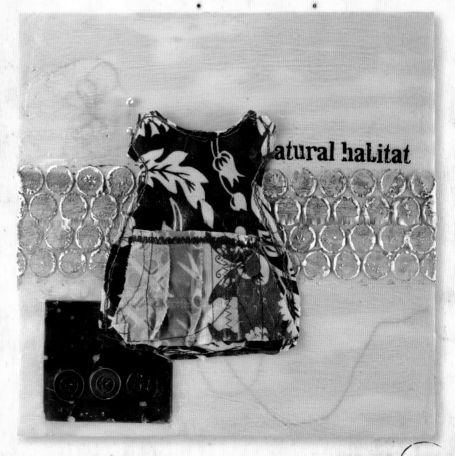

CLAYBORD BOX WITH LID

I'm all about versatility. Blame it on having four boys in six years or on having moved a dozen times in my life or perhaps just on my middle-child positioning in the family lineup. Regardless, versatility and flexibility reign in my life. It's fun to realize that a favorite manufacturer or product line feels the same way I do. Discovering that my favorite surface, Claybord, came not only in the traditional panel, but also in assorted shapes and dimensions was enough to intrigue me; discovering this same delicious surface in a box top sent me over the moon! It's been fun to bring the beauty of beeswax to something besides a traditional wall-hung art piece. For the box tops, I've enjoyed staying with established encaustic techniques, letting the beautiful shape speak just as loudly as the encaustic painting on top. The sides are a fun place to experiment with other mediums; my good friend shellac is great for added punch! The letterpress set is from my dad, who was a mechanical engineer. It was used to press serial numbers into metal. You can find similar letterpress stamps at craft stores in the scrapbooking aisle.

WHAT YOU'LL NEED

Claybord box

Encaustic medium

Paintbrushes

Heat gun

Straightedge

Wood-burning tool

Razor blade

Metal letterpress stamps

Oil paint stick in black

Rubber gloves

Rusted felted floral tape

Paper towels

Gel gloss medium

Glass disk embellishment

TOOLS OF THE TRADE

Part of me wishes I was more of a pack rat so that I'd have kept more of the tools and found objects that my parents and grandparents left behind. Nonetheless, I am blessed to still possess this old machinist's letterpress set from my dad—just don't tell my oldest brother. He may think it's still in his tool stash!

"Creativity is the ability to see relationships where none exist."

THOMAS DISCH

RANDOMS RUST

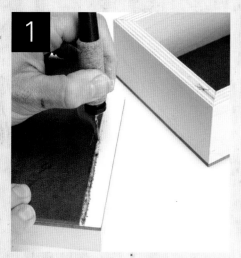

Burn line into lid

Using a straightedge (I use another Claybord as my straightedge) and a wood-burning tool, burn a line into the Claybord lid.

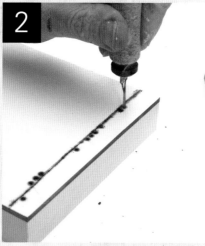

Add burned embellishments

Continue burning until you are satisfied with the look of your lid. Here I placed irregular marks along either side of the burned line.

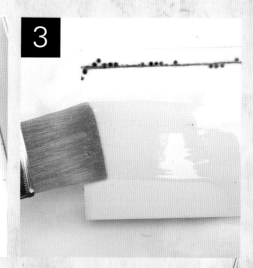

Brush on encaustic medium

Apply encaustic medium to the lid in even strokes.

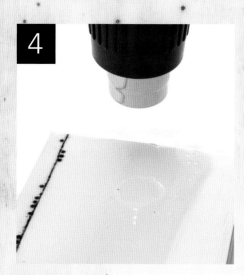

Fuse medium and remove excess

Fuse with the heat gun. Scrape any excess wax from the edges of the lid using a razor blade as needed.

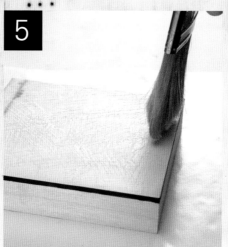

Add another layer of medium

Apply another layer of medium to the lid, allowing the brushstrokes to show for a more textural layer.

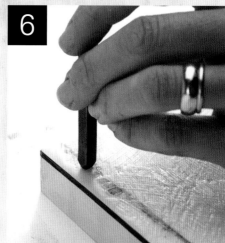

Press letterpress stamps into wax

Press metal letterpress stamps into the slightly warm wax.

Sign up for the free newsletter at CreateMixedMedia.com.

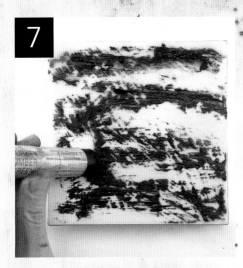

Smear paint stick on lid

When the wax is completely cool, smear a paint stick across the surface of the lid.

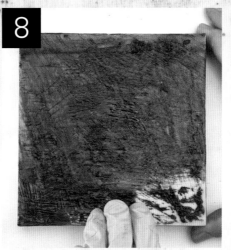

Rub paint into wax

Rub the paint into the wax layer with your gloved fingers.
NOTE: When working with oil paints, it's best to wear gloves, because your skin can absorb some of the pigment.

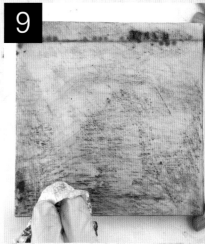

Remove excess paint

Rub with a paper towel to remove any excess color.

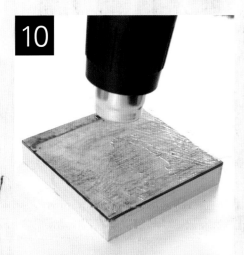

Fuse paint

Fuse this oil layer to the wax below with a quick hit from the heat gun.

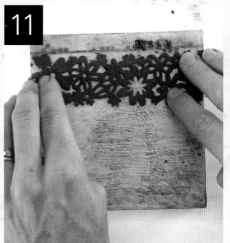

Press floral tape into wax

Press the rusted felted floral tape into the still-warm wax. Use a razor blade to trim the edges of the tape.

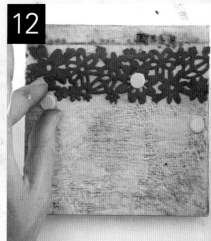

Add embellishments

Apply gel medium to the backs of the glass disk embellishments, then place them on the surface of the lid as desired.

Visit CreateMixedMedia.com/encaustic-painting-techniques for bonus content.

SHADOWBOXES

Pull up a chair! Moodling happens here (see quote below)! Just imagine the delightful thoughts that would roll through your brain as you lounge in these retro comforts. I discovered these miniature chairs when I went looking for doll-sized dress forms (which the manufacturer also supplies). To my delight, they fit just perfectly into Ampersand shadowboxes, and it was all I could do to stop at just one. So I didn't. I went for a collection instead! Utilizing pebble-textured paper to hint at retro wallpaper and foil leafing to play into the decorating sense indicative of the 1960s and 1970s, I fully indulged in just how delightful these miniatures are and how much fun it is to incorporate them into encaustic. In the end, I have a group of nine boxes, grouped together to show off their retro goodness. Here you see four of the remaining delights. Makes me want to go back in time just to sit for a spell.



WHAT YOU'LL NEED

Shadowbox

Gel medium

Heat gun

Paintbrushes

Pebble-embossed decorative paper

Scissors

Masking tape

Encaustic paints: Indian Yellow, King's Blue, Quinacridone Magenta, Titanium White

Scissors

Gold leaf (Simple Leaf)

Drill and ³/₁₆" (5mm) drill bit

28-gauge steel wire

Wire clippers

Miniature display item (here a miniature replica 1960s chair)



TOOLS OF THE TRADE

Retro tools for a retro project. Note the pebble paper; oh, those 1970s wallpaper patterns!

"So you see, imagination needs moodling—long, inefficient, happy idling, dawdling and puttering."

BRENDA UELAND

190

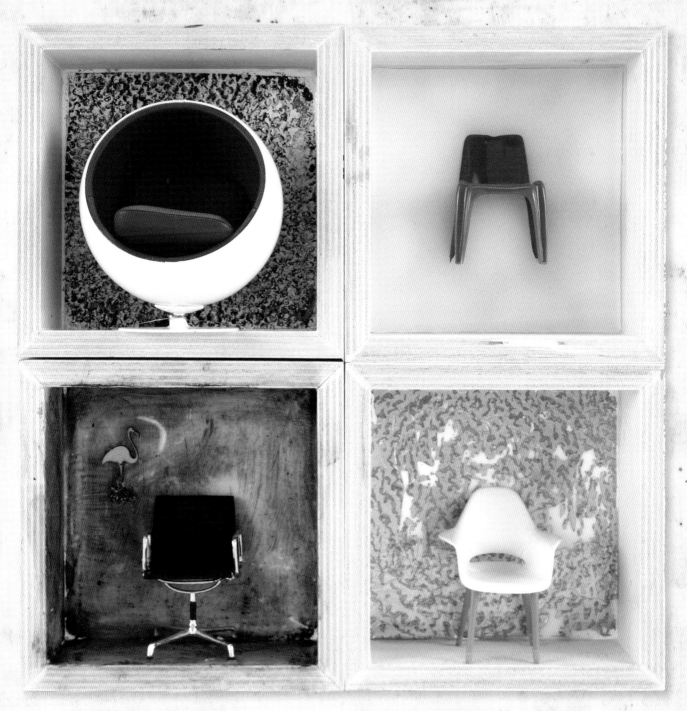

EVOLUTION AND STYLE

I brought this funky collection of items together by grouping them and giving the group a collective title. Not all the chairs were wired in; two were embedded in wax and one was glued with gel medium.

Brush on gel medium

Apply gel medium evenly over the back surface of the shadowbox using an old brush.

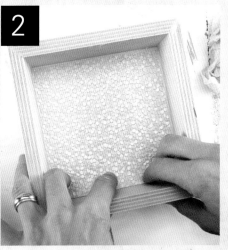

Adhere paper to gel medium

After cutting the pebble-embossed paper to size, press the paper into the gel medium.

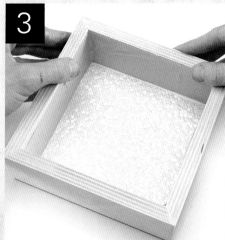

Protect sides with masking tape

Apply masking tape to the interior edges of the shadowbox. This will help keep them clean while you're applying encaustic paint. (Because you will hit the sides, no matter how careful you try to be!)

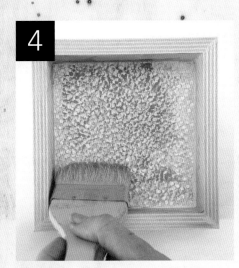

Apply encaustic paint

Because you will be creating a dry-brush effect, leave the surface cold; don't heat it. Remove your brush from the Indian Yellow encaustic paint, scraping as much paint from the brush as possible. Lightly run it over the embossed paper. The wax will catch on the surface of the embossed design, but it won't seep into the crevices. Apply the second layer in the same manner, using King's Blue.

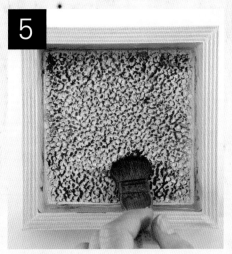

Apply thin layer of paint

Continue using the dry-brush technique to apply the third layer of encaustic paint, this time Quinacridone Magenta. **NOTE:** Keep applying more layers of these three colors to achieve a complex, multilayered look.

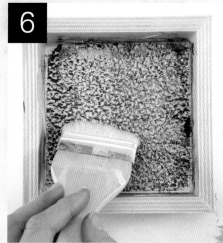

Apply final layer of paint and cool

Use the dry-brush technique to apply a final layer of encaustic paint, this time Titanium White. Set the piece aside and allow the wax to cool completely.

7

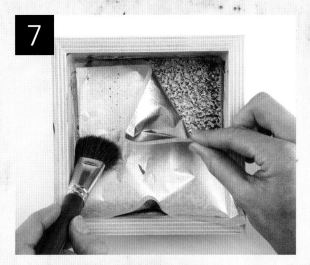

Apply gold leaf

Lay the gold leaf over the embossed surface, foil side down, and pounce the back with a soft-bristled paintbrush to transfer. When you remove the sheet, just a touch of leafing will have transferred onto the raised area of the embossed paper.

8

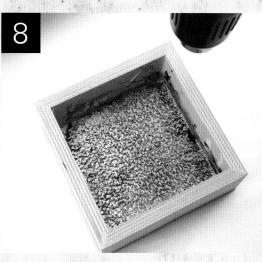

Warm surface

Warm with a heat gun so the warm wax will hold onto the gold leaf.

9

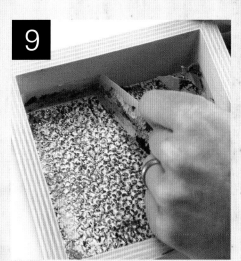

Remove tape

Remove the masking tape.

10

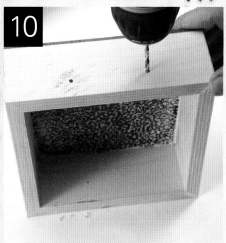

Drill holes for chair

Mark the placement of the chair's base on the underside of the shadowbox; drill two holes using a $^3/_{16}$" (5mm) drill bit.

11

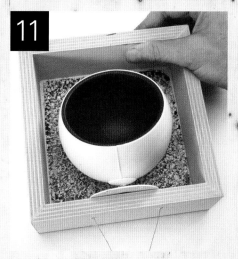

Add chair using wire

Clip a length of wire. Thread it through one hole, wrap it around the base of the chair to secure it and thread it through the second hole. Twist the ends of the wire together and clip any excess.

ARTIST TRADING CARDS

Since beginning in encaustic—in mixed-media work, as a matter of fact—I have been in love with Ampersand Claybord. Although this surface is not every encaustic artist's choice for substrate, I could find a love for no other and steadfastly stood by its beauty. I feel this faithful allegiance has been rewarded as Ampersand and R&F Handmade Paints paired up to create Encausticbords. This board marries the best of the best: encaustic gesso and a unique, effective application process. The result is a gorgeous smooth, white, absorbent delight. I frequently take the boards out of their packages and just let them sit in a row on the table for a day before applying wax; they are just that pretty! And now this surface is available in a multitude of shapes and sizes. One of my favorites is the trendy and popular Artist Trading Cards. The possibilities with business-card-sized boards are endless! However you go about painting on these ATCs, I hope you find them as thrilling as I do.

WHAT YOU'LL NEED

Claybord ATCs

Encaustic medium

Paintbrush

Heat gun

Masking tape

Chipboard shapes

Spray ink

Contact paper stencil

Encaustic paint:
Quinacridone
Magenta

Metallic powder

Stylus

Decorative paper, cut
into strips

Paper punches

Razor blade

TOOLS OF THE TRADE
Chipboard letters, metallic powder, spray ink, decorative paper and stencils. It's ATC magic!

"Creativity is not the finding of a thing, but the making something out of it after it is found."

JAMES RUSSELL LOWELL

ALPHABET SOUP

1

Connect all ATCs with tape

Using masking tape, join all the ATCs together along the back of the boards so you can paint them as a single unit.

2

Arrange letters on ATCs

Flip the taped boards over. Arrange chipboard shapes (I used letters) over the surface; try to ensure that no ATC is untouched.

3

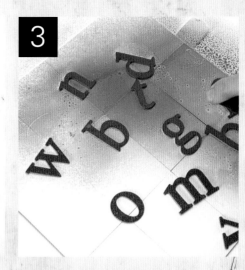

Spray ink on surface and dry

Spray ink over the surface and allow to dry.

4

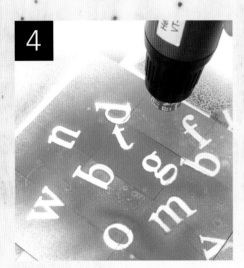

Remove shapes and warm boards

Remove the chipboard shapes. Warm the boards using a heat gun to prepare for the application of medium.

5

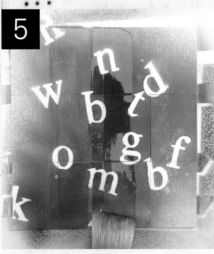

Apply medium

Apply medium over the boards.

6

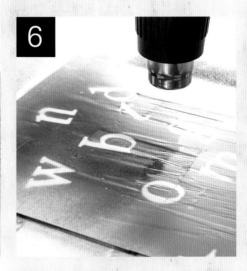

Fuse medium

Fuse the medium to the boards using the heat gun.

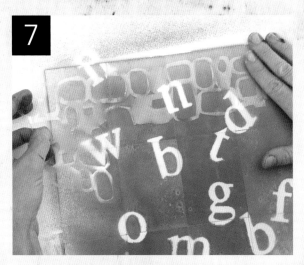

7

Apply stencil and adhere
Apply the contact paper stencil over the boards, pressing gently to adhere.

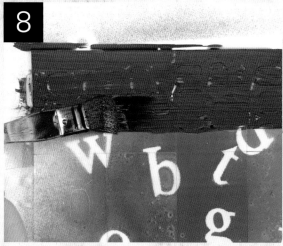

8

Apply encaustic paint
Paint Quinacridone Magenta encaustic paint over the stenciled area.

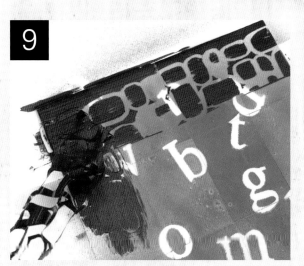

9

Remove stencil immediately
Immediately peel up the contact paper stencil.

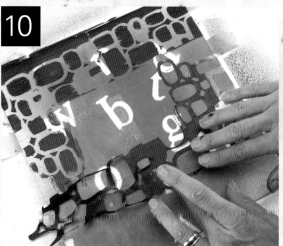

10

Reapply stencil elsewhere
Reapply the stencil to the board in a different position.

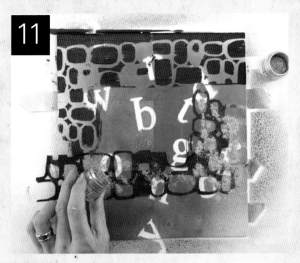

Sprinkle metallic powder

Sprinkle metallic powder over the surface of the stenciled area.

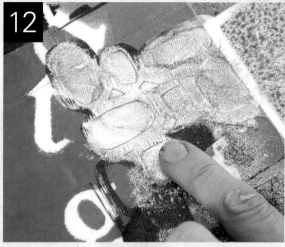

Spread powder with finger

Spread the powder over the surface using your finger.

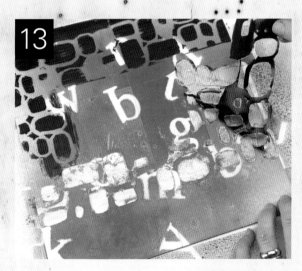

Remove stencil

Peel up the contact paper.

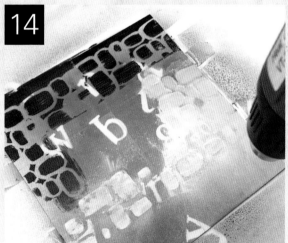

Fuse powder and wax

To fuse the powder and wax, you'll need to hold the heat gun higher up so the powder will adhere to the melting wax without blowing away. As the powder adheres, you can move the heat gun closer to the surface.

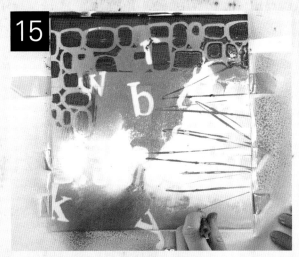

Incise wax with stylus

Scratch through the warm wax layers with a stylus for a textured effect.

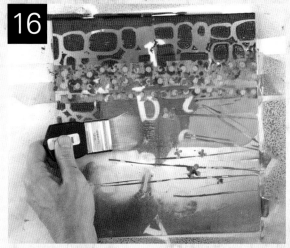

Add decorative cutouts and encaustic medium

Use a paper punch to cut out shapes from the decorative paper strips. Apply the paper strips and cutouts (flower-shaped cutouts in this instance) to the surface. Apply medium over the papers and cutouts first, then over the entire piece.

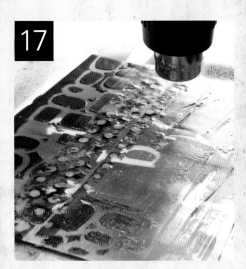

Fuse medium

Fuse the new layers of medium to the board.

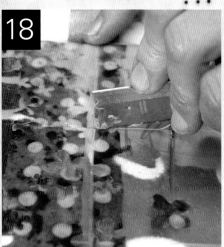

Score edges of ATCs

Cut through the paper, tape and wax by scoring the surface with a razor blade along the edges of the individual ATCs.

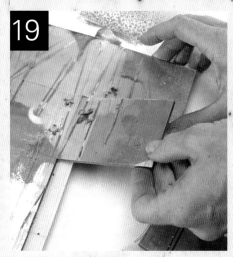

Remove boards from tape

Gently lift each board from the tape.

WOOD PAGES

Escape into a good book in an entirely different way. Indulge in uniquely luminous pages. Flip through to find the delight in the story of each. Reinvent your creative inspiration when you take these small wonders into the studio. Judy's Stone House Designs brought me to these projects by way of pre-made book forms of birch panels. I've had a great deal of fun exploring the possibilities of wood burning, mark making, book binding and more with the various book-form designs offered by Judy's. I encourage you to indulge as well by escaping into a good book!

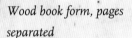

WHAT YOU'LL NEED

Wood book form, pages separated

Encaustic medium

Paintbrushes

Heat gun

Punchinella

Encaustic paints: Indian Yellow, Quinacridone Magenta, King's Blue, Titanium White

Encaustic-dipped wire and paper bead embellishment

Burned paper pieces

Found-object embellishment

Spray ink

Rusted felted floral tape

Stylus

Yupo embellishments

Markers

Charm embellishments

PanPastels with sponge applicator

Gold leafing (Simple Leaf)

Craft stick

TOOLS OF THE TRADE

Beads, rusting, gold leaf, embedding, die cuts: All the best embellishments come together in this book-form showcase.

"A great book provides escapism for me."

WENTWORTH MILLER

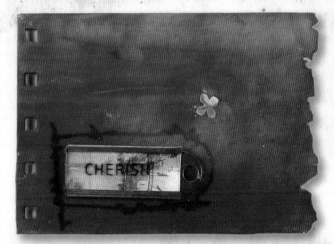

A GOOD BOOK

PUNCHINELLA

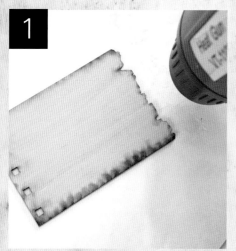

Warm board
Warm the wood page with the heat gun.

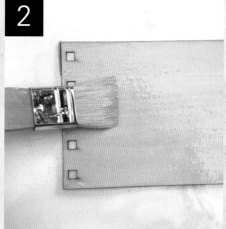

Brush on encaustic medium
Apply encaustic medium to the surface.

Fuse wax
Fuse with the heat gun.

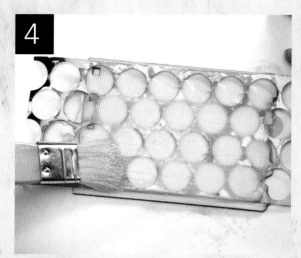

Add punchinella and wax
Place the punchinella stencil over the page and apply a layer of wax.

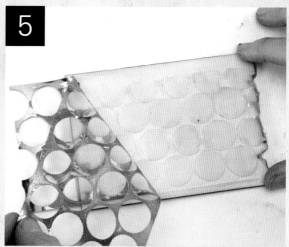

Remove stencil
Remove the punchinella stencil.

brush up

The dry-brush technique adds subtle texture to the wax. You want your brush to be only lightly loaded with medium, and the surface should be cool, not warm. Because heat would soften the wax and cause it to spread, you want the wax to be firmer to hold the shape and texture of the brushstrokes.

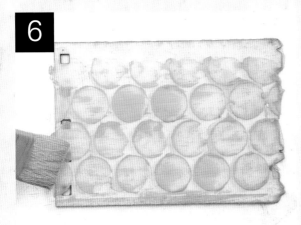

Add yellow encaustic paint
Drybrush the surface with Indian Yellow encaustic paint.

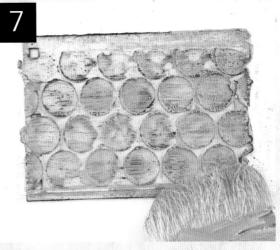

Add more layers of paint
Drybrush more layers of encaustic paint over the surface (here, Quinacridone Magenta and King's Blue).

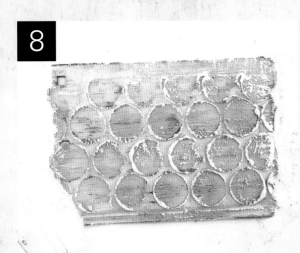

Apply white paint
Apply a final layer of Titanium White encaustic paint in this same dry-brush technique.

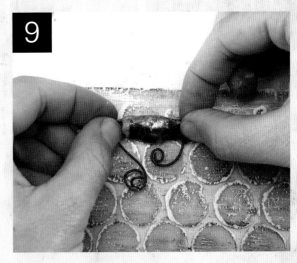

Push bead into wax
Press the wire and paper encaustic-dipped bead into the surface. If the surface is still warm enough from the drybrushing, it should adhere. Otherwise, fuse with the heat gun.

GLUE-PAPER BURN

1
Warm wood page
Warm the wood page with the heat gun.

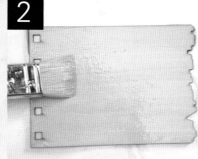

2
Apply medium
Apply encaustic medium to the surface.

3
Fuse medium
Fuse with the heat gun.

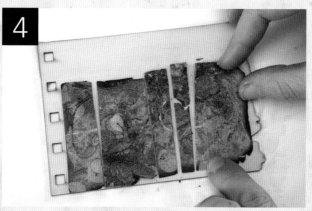

4
Place burned paper on wood
Arrange the burned-paper pieces on the pages. Lightly press them into the wax.

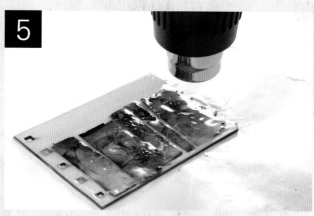

5
Apply medium and fuse
Apply medium to the board. Fuse with the heat gun.

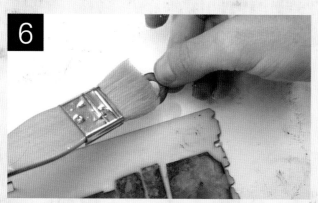

6
Add medium to embellishment
Place a dab of medium on the back of the found-object embellishment.

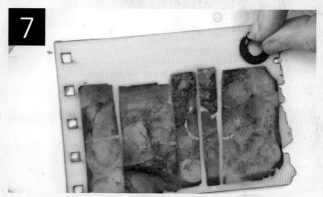

7
Add embellishment and fuse
Position the found-object embellishment on the burned-paper page and fuse the page with the heat gun.

RUSTED FLORAL RIBBON

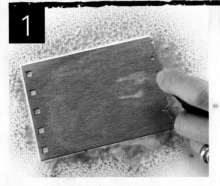

Spray ink and dry
Spray the page with ink. Allow it to dry.

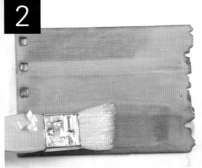

Apply medium
Warm the inked page with a heat gun, and apply a layer of medium.

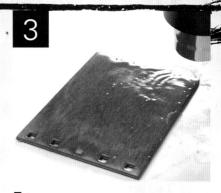

Fuse wax
Fuse with the heat gun.

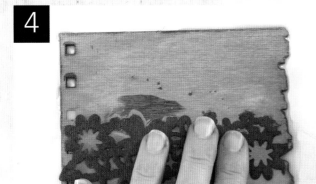

Place floral tape on board
Place the rusted floral tape on the page and press it lightly into the warm wax.

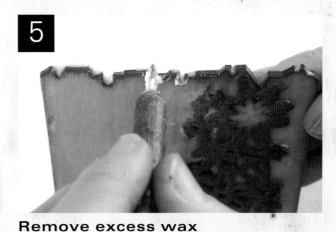

Remove excess wax
Use a stylus to remove excess wax from any parts of the page that you can't easily reach with a razor blade.

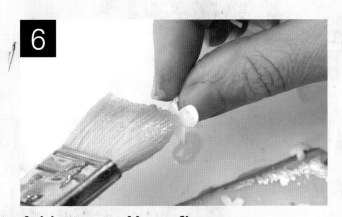

Add wax to Yupo flowers
Dab medium to the backs of the Yupo flower embellishments.

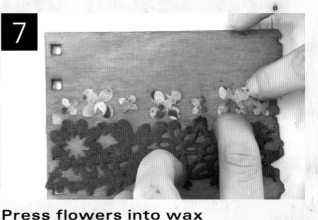

Press flowers into wax
Press the flowers onto the surface of the blue-inked wooden page.
NOTE: If your wax layer is deep enough, you can lightly press the die-cut embellishments into the warm surface and eliminate the need for step 6.

CHARM EMBELLISHMENT

Warm board
Warm the wood page with the heat gun.

Apply encaustic medium
Apply encaustic medium to the surface.

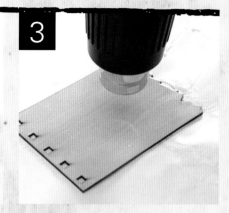

Fuse medium
Fuse with the heat gun.

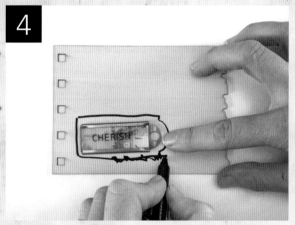

Position charm and outline it
Position the charm where you want it permanently placed on the page and trace around it with a marker.

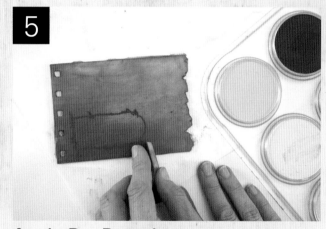

Apply PanPastels
Apply PanPastels to the charm-embellishment page.

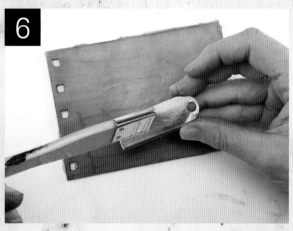

Brush medium on charm
Apply medium to the back of the charm.

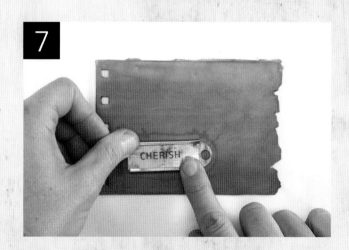

Press charm to board
Place the charm in the outlined area and press lightly.

Sign up for the free newsletter at CreateMixedMedia.com.

GOLD LEAF

1

Warm board
Warm the wood page with the heat gun.

2

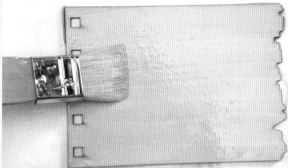

Apply encaustic medium
Apply encaustic medium to the surface.

3

Fuse medium
Fuse with the heat gun.

4

Write on board
Write a design or message across the page using a marker.

5

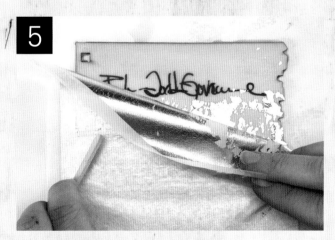

Burnish gold leaf in areas
Place the gold leaf paper facedown over the handwritten wood page. Use a craft stick to burnish the leaf onto the page. I like the sketchy application shown here.

6

Fuse gold leaf
Fuse the gold leaf into the wax using the heat gun.

EMBELLISHMENTS APPENDIX

The embellishments in this section and used throughout the book are just a smattering of the play and experimentation I've been partaking in over the past months. These embellishments represent the best of my successes as well as my very favorite products. The Yupo paper has been a studio go-to favorite for decades. My first 1st-place award was for a water-media painting on Yupo. As you can imagine, such a win solidified my love for this surface! Distressing Yupo was the logical next step as I moved years and techniques beyond water media. I discovered that the beautiful felt floral ribbon reacted beautifully to rusting thanks to input from Random Arts. What a treat to pull this into encaustic and see how nicely they work together.

And although I embrace these homemade embellishments far and beyond store-bought, I never pass up an opportunity to check out the latest ditties from craft, art and hardware stores. I rarely leave them as I find them. Decorative papers becoming torn strips, heavily glued to an almost unrecognizable form in delightful beads; rigid wrap is glued and burned, just the way I like it. It becomes something new and innovative, so conducive to waxy mixed media. So I continue to browse the store aisles and invest in inspiration: mixed media made completely unique through distressing, altering and enhancing in encaustic. Could there be a better path to trod? Indulge yourself in these embellishment suggestions and see how joining them with encaustic can be, as Henry Ford states in the quote below, truly a success.

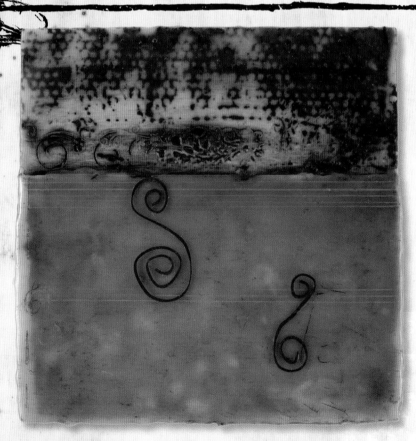

DULY NOTED

"Coming together is a beginning.
Keeping together is progress.
Working together is success."

HENRY FORD

208

Sign up for the free newsletter at CreateMixedMedia.com.

DEMO: RUSTED EMBELLISHMENTS

The idea of using rusted found objects as well as rusting interesting materials and partnering them with encaustic has turned out to be a very delicious, intriguing adventure. Here I've demonstrated with Random Arts felted floral tape, but the same technique can be applied to nearly any material that crosses your path.

WHAT YOU'LL NEED

Foam brush or sponge applicator ✳ *Iron paint (Modern Masters)* ✳ *Felt floral ribbon or Wholey Paper (as desired)* ✳ *Rust activator (Modern Masters)*

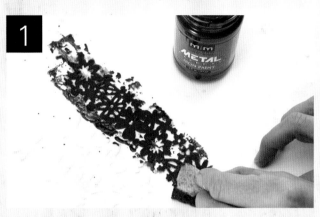

Add iron paint to surface
Brush or sponge the iron paint onto the surface of your choice and allow it to dry. Here I'm using felt floral ribbon.

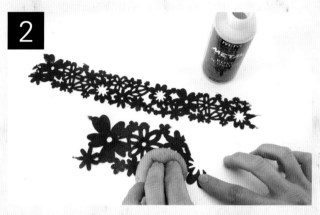

Dab rust activator on paint
Dab the rust activator onto the painted surface with a foam brush or sponge applicator. Allow it to dry. Now your embellishment is ready to use in projects.

DEMO: RIGID WRAP EMBELLISHMENTS

Rigid wrap, better recognized as cast material from your doctor's office, is a fantastic material for encaustic foundations as well as embellishments. I enjoy slumping the rigid wrap over forms to mold and cast it, but even more, I enjoy pushing the boundaries to see just how well it can support other encaustic experimentation.

WHAT YOU'LL NEED

Rigid wrap ✳ *Water* ✳ *Metal forms* ✳ *Cooking spray*

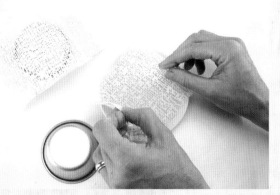

Cut rigid wrap and dip in water
Cut pieces of rigid wrap to the desired size and dip them in water.

Drape pieces over forms, dry
Spray the forms with cooking spray so they won't stick. Drape the rigid wrap pieces over the forms and allow them to dry. Pop the rigid wrap off the form and use it in your encaustic.

DEMO: DIE-CUT EMBELLISHMENTS

I admit that I'm not the biggest fan of punch-and-place objects, but this Sizzix machine won me over when I realized I could not only die-cut, but emboss as well. And not just with paper, but also with cork, wood veneers and fabric.

1

Place template and paper on press
Place the die-cutting template, with your paper over the top, on the press.

2

Cover with glass plate and run press
Place the glass plate over the top. Run it through the Sizzix. Remove the die-cut elements from the press.

3

Reposition paper and repeat
Reposition the paper and repeat steps 1 and 2 until you have the desired number of die-cut elements.

WHAT YOU'LL NEED

Decorative paper * Sizzix die-cutting machine * Die-cut templates

DEMO: EMBOSSED PAPER EMBELLISHMENTS

What else can you do with this Sizzix machine? You can make your own beautiful embossed papers. The embellishment I created in this mini demo is featured in the Wood Glue project in the Break the Rules chapter.

Place wood paper on template
Place the wood paper on the template.

Place paper between glass
Place the template between the glass plates.

Run press
Run everything through the Sizzix machine.

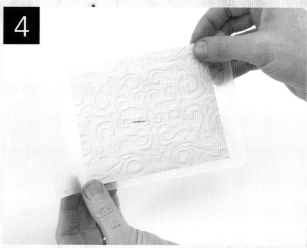

Remove paper
Release the paper from the template.

WHAT YOU'LL NEED
Decorative wood paper ✶ *Sizzix die-cutting machine* ✶ *Embossing plates*

DEMO: GLUE-AND-PAPER BURNED EMBELLISHMENTS

I had a student direct me to this technique, suggesting it looks like leather when done on brown paper bags. I have yet to feel I've achieved such results, but I enjoy it so much I've tried it on just about every paperlike surface I could find. Feel free to experiment and see where it takes you.

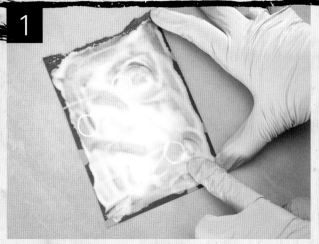

Smear glue on paper

Apply a thick layer of glue on the surface of the decorative paper and smear evenly over the entire surface.

Burn glue with torch

Put the glue-covered paper on a fire-retardant surface and run the torch over the surface. You can stop early for a light golden burn or continue to burn and blacken in parts; it's all about your creative choice.

tissue paper

brown paper bag

decorative art paper

Yupo

Tyvek

WHAT YOU'LL NEED

Wood glue or white glue ✳ *Various pieces of paper or plastic, such as tissue, brown bag, decorative, Tyvek or Yupo* ✳ *Fire-retardant surface* ✳ *Propane or butane torch*

DEMO: YUPO EMBELLISHMENTS

I have been a big fan of Yupo since my early days in water media, and I have a sizable supply stashed in a corner of my studio. I love having rediscovered it here and put it to task in the world of encaustic. **NOTE:** Once shrunk, these embellishments can be rusted as per the rusted embellishments demo.

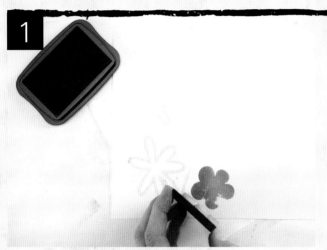

Stamp design on paper
Ink up the rubber stamp and press onto the Yupo paper.

Cut out designs and punch center holes
Roughly cut around the edges of the stamped flowers—no need to be exacting or particular. Using a hole punch, punch out the center of each flower where the stamen would be.

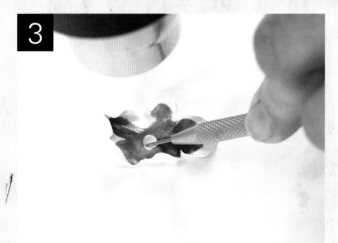

Apply heat to shrink design
Place the tip of the stylus near the center of the flower to keep the flower from blowing away. Use the heat gun to shrink the flowers. Treat the gun almost like a styling tool, moving it around the flower so the petals curl up individually as they shrink.

WHAT YOU'LL NEED
StazOn ink pads �֍ *Rubber stamp (Stamping Bella)* �֍ *Yupo paper* ✖ *Scissors* ✖ *Single hole punch* ✖ *Stylus* ✖ *Heat gun*

DEMO: RESIN EMBELLISHMENTS

No, resin and encaustic are not the best of friends. But they can be made to play well together. Here is the most basic technique for creating interesting bobbles and doodads for inclusion in your encaustic works of art.

Create closed wire shape

Create a shape out of wire. Make sure your shape includes a closed space that can hold the resin.

Mix resin

Pour equal parts of the resin ingredients into a disposable cup and stir with a craft stick.

Drizzle resin

Tear tissue paper to fit the wire shapes and place it over the top of the shapes. Dribble the resin over the tissue paper.

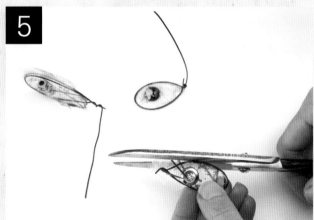

Add embellishments and dry

Add glitter, beads and buttons as desired to the wet resin. Use a paintbrush to position the elements, if necessary, then set the piece aside to dry.

Trim off excess resin

When the resin shapes have dried, trim the excess resin away from the edges with scissors or a razor blade.

WHAT YOU'LL NEED

Dark annealed steel wire ✳ Wire cutters ✳ Needle-nose pliers and/ or jeweler's pliers ✳ Resin, such as EnviroTex Lite Pour-On High Gloss Finish ✳ Disposable cup ✳ Craft stick ✳ Patterned (or plain) tissue paper ✳ Beads, buttons, glitter, microbeads ✳ Paintbrush ✳ Scissors or razor blade

214

DEMO: PANTY HOSE AND GLUE EMBELLISHMENTS

Many materials can be used to acquire the look of gut, or skin. The embellishment of these in mixed-media work—and especially in jewelry and wire sculpture—has become very popular. I love the look of this material and employ it with ease into my encaustics.

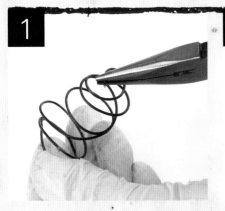

1 Create wire form
Create the wire form by twisting the wire into a spiral shape with pliers.

2 Enclose wire in hose
Tuck the wire form into the panty hose piece and wrap the hose around the shape.

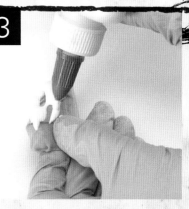

3 Cover hose in glue
Apply a layer of the glue to the entire structure.

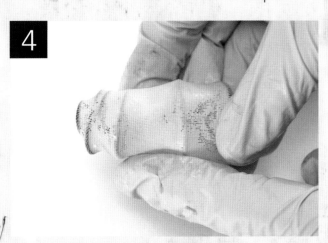

4 Smear glue and dry
Smear the glue, tucking the excess panty hose material into the wire form. After the first coat is applied, set the structure aside to dry.
NOTE: If the panty hose unfurls when you set the piece aside to dry, secure it to the wire form with a clothespin. You shouldn't have to use the clothespin on subsequent layers.

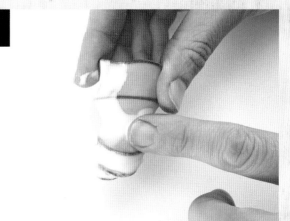

5 Add more glue as desired
Apply as many layers of glue to the piece as you'd like. (This is the third layer of glue in this photo.)
NOTE: Wood glue will give the final piece a yellowish antiquated look, and it works just as well as white glue. Keep that in mind if it will suit the look you wish to achieve.

WHAT YOU'LL NEED
*Dark annealed steel wire * Wire cutters * Needle-nose pliers and/or jeweler's pliers * Cut-up pieces of panty hose * White glue * Clothespin (optional)*

Visit CreateMixedMedia.com/encaustic-painting-techniques for bonus content.

DEMO: WIRE AND PAPER ENCAUSTIC-DIPPED BEADS

These simple creations add a delightful punch to many encaustic paintings and other dimensional works. Let your imagination run wild in choosing wire, papers and placement.

Cut and shape lengths of wire

Cut as many lengths of the wire as desired. Use needle-nose or jeweler's pliers to twist the ends of the wire into loops.

WHAT YOU'LL NEED

Dark annealed steel wire

Wire cutters

Needle-nose pliers and/or jeweler's pliers

Decorative papers

Colored wire or thread (optional)

Encaustic medium

Heat gun

Metallic microbeads

Metallic powder

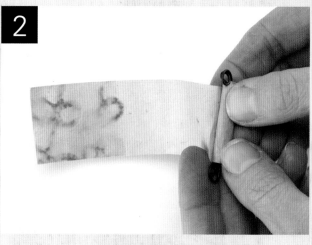

Wrap paper strip around wire

Rip or cut strips of paper to fit the width of the wire base. You can make these strips as long as you like; longer strips will make thicker beads. Wrap the paper around the wire.
NOTE: For this purpose, you can use any kind of paper. Light-weight decorative paper will yield the best results because it's easiest to roll around the wire. It's also unlikely to have a mind of its own and unwrap when dipped in the wax. I also love the look of newspaper for this project.

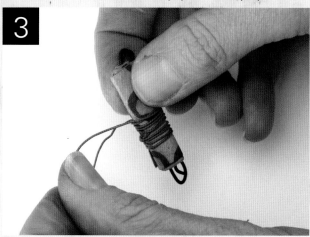

Secure paper with wire

If you like, you can wrap the bead with wire or thread.

216

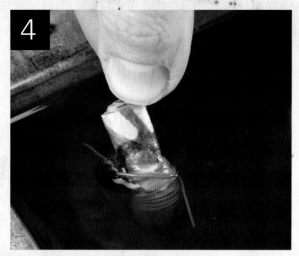

Dip bead in wax
Dip the bead into the medium.

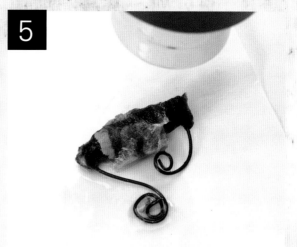

Remove excess wax
Use a heat gun to remove some of the wax from the bead, if you feel the wax layer is too thick or if you would like to melt the wax away from the curlicue ends of the wire.

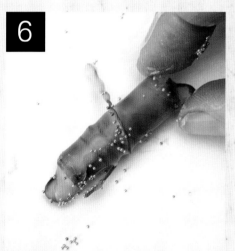

Roll bead in microbeads
While the wax is still warm, roll the bead in the metallic microbeads, pressing them into the wax as needed to ensure they adhere.

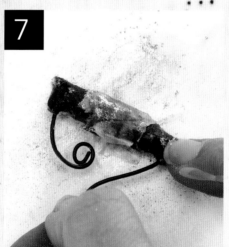

Roll bead through powder
Sprinkle some metallic powder on your work surface and roll the still-warm bead through the powder.

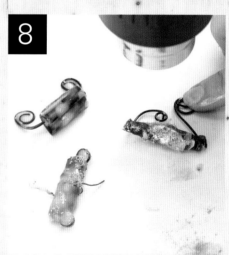

Heat bead to fuse
Heat the bead with the heat gun to further adhere the metallic microbeads and/or metallic powder as needed.

Index

From Encaustic Workshop

ACKNOWLEDGMENTS

Without the support and encouragement from Ampersand Art Supply, Daniel Smith Finest Quality Artists' Materials and R&F Handmade Paints, the energy behind this book would never have been ignited. Deepest thanks to them for their generous and heartfelt support.

Thanks also to North Light Books and the team who brought this unknown, untrod path of publication to light for me. So much joy in a dream realized!

"My business is not to remake myself, but make the absolute best of what God made."
Robert Browning

DEDICATION

I believe part of my business is to share with enthusiasm and passion the things I've come to learn and discover on earth. Therefore, it is my hope that this book carries the absolute best of me and that some of the passion I carry for this medium will be passed to you. And so, this book is first and foremost dedicated to you, my readers!

To the best four redheads in the whole wide world—Conner, Daniel, Brian and Patrick—who continue to believe that having an artist for a mom is a cool thing.

To mom and dad: For allowing me to doodle on surfaces not always designed for such creative expression.

To my painting pals: Loving support is a gift and a blessing!

To John: Love unconditionally. Life is too short.

 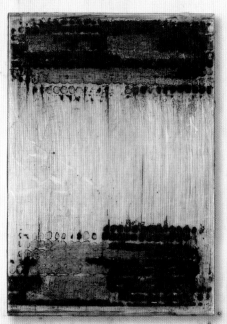 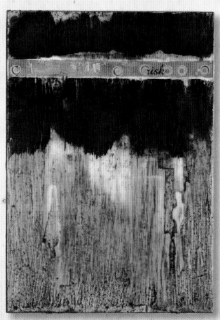

FRATERNAL TRIPLETS

From Encaustic Mixed Media

ACKNOWLEDGMENTS

It cannot be overlooked, the necessity of a staff behind the production of a publication. A book is not born of a good idea but only conceived. In order to be hatched into the world at large, a team of forward-thinking visionaries is very much necessary!

North Light Books is the force extraordinaire behind the realization of *Encaustic Mixed Media*, in all its glory; I take credit only for the inspiration, artwork and the unedited version of the written word. With greatest thanks and gratitude, this book is born from the exceptional photography of Christine Polomsky, the editorial genius of Vanessa Lyman and Kristy Conlin, the vision of acquisitions editor Tonia Davenport, and the numerous F+W staff members who supported the development of this tome through trust, vision and tolerance to waxy noise and good smelliness wafting throughout the production studio for a week last August!

Much gratitude!

DEDICATION

To the mighty souls who, through God's grace, stand by me, thereby creating in me this authenticity:

To God and John with eternal love. Without one, the other would not be.

To my four redheads. Much bigger, bolder and more independent since the first book dedication, but still in my heart and always my babies.

To Katie, Karon, Kirsten and Christine, the blessed friends who stuck by me, bolstering my confidence when my own sense of self was flagging.

To workshop participants worldwide, because you continue to support the enthusiastic instructors who come to you out of passion and who continue in it because of the love you return to them in spades.

"The whole is greater
than the sum of its parts."
ANONYMOUS

"If you are determined to gather life, to stick your hand into the hive again and again, to be stung so many times that you become numb to the pain, to persevere and persist till those who know you become unable to think of you as normal, you will not be called mad; you will be called authentic!"

SARAH BAN BREATHNACH

 Other fine North Light Books are available from your favorite bookstore, art supply store or online supplier. Visit our website at fwmedia.com.

17 16 15 14 13 5 4 3 2 1

DISTRIBUTED IN CANADA BY FRASER DIRECT
100 Armstrong Avenue
Georgetown, ON, Canada L7G 5S4
Tel: (905) 877-4411

DISTRIBUTED IN THE U.K. AND EUROPE BY F&W MEDIA
INTERNATIONAL Brunel House LTD, Newton Abbot, TQ1
4PU, England
Tel: (+44) 1626 323200, Fax: (+44) 1626 323319
Email: enquiries@fwmedia.com

DISTRIBUTED IN AUSTRALIA BY CAPRICORN LINK
P.O. Box 704, S. Windsor NSW, 2756 Australia
Tel: (02) 4560 1600
Fax: (02) 4577 5288
Email: books@capricornlink.com.au

ISBN-13: 978-1-4403-3194-7

Edited by Mona Clough and Amy Jones
Designed by Aly Yorio
Cover Design by Bethany Rainbolt
Production coordinated by Greg Nock

METRIC CONVERSION CHART

To convert	to	multiply by
Inches	Centimeters	2.54
Centimeters	Inches	0.4
Feet	Centimeters	30.5
Centimeters	Feet	0.03
Yards	Meters	0.9
Meters	Yards	1.1

ABOUT THE AUTHOR

I do not profess to be excellent; far from it. But then, what is the definition? Is excellence a once-and-done goal to be reached, or is it something we strive toward in each and every moment of our lives? Over and over again, seeking to be excellent in this awakening, excellent in this hello, excellent in this next encounter, excellent in this next task.

So in this definition, I am excellent because I repeatedly strive to make excellence a habit of my day.

And today I give to you a bit of this excellence. Today I give to you the piece of me that strove to be the best encaustic artist and author for this book, *Encaustic Painting Techniques*. Today I give to you the excellence of my habit to prove the versatility and malleability of beeswax to be above all else.

I will have moved to a new place by the time you pick up this book and read my words. I will have moved into a new habit of excellence and begun to work toward a new level of experimentation or encouragement or excellence. I will look to the words and works of this book, in its most excellent form at release, and see the change that has occurred since then; surely being much too discriminating and determining it not at all the excellence I'd thought on this day of writing!

But that is the beauty—or the bane—of excellence. If one is to truly be so, to strive for this habit in character and performance, one has to be prepared to look back from a newly achieved level of excellence and accept the place that was called excellent the day or week or year before.

So it is with humble pride, tremendous gratitude and weary release that I give you *Encaustic Workshop*, *Encaustic Mixed Media* and *Encaustic Painting Techniques*. Putting all of my current heart, soul and effort into making it all that it can be; the excellence that is its potential and knowing that there will be a new level to share with you as I grow in my habit to be and become most excellent.

In Love,
Trish

> "We are what we repeatedly do. Excellence, therefore, is not an act but a habit."
>
> **ARISTOTLE**

Trish (aka Patricia) is first and foremost the blessed wife of a compassionate and gracious man, the proud mom of four beautiful redheaded young men and one precious young woman, and the follower of one awesome and magnificent God. When not investing her time and talents in discovering her unique path in this life, Trish travels throughout the world teaching encaustic painting and has recently been called to start a business to bring encaustic to a broader, more far-reaching audience through Encaustikits and Encausticamp. She is most passionate about the connection and inspiration that happens each time she is gifted the opportunity to cross paths with eager participants. Look for her online at pbsartist.com.